Fierce Poise

Also by Alexander Nemerov

Summoning Pearl Harbor

Soulmaker

Silent Dialogues

Wartime Kiss

Acting in the Night

Icons of Grief

The Body of Raphaelle Peale

Frederic Remington and Turn-of-the-Century America

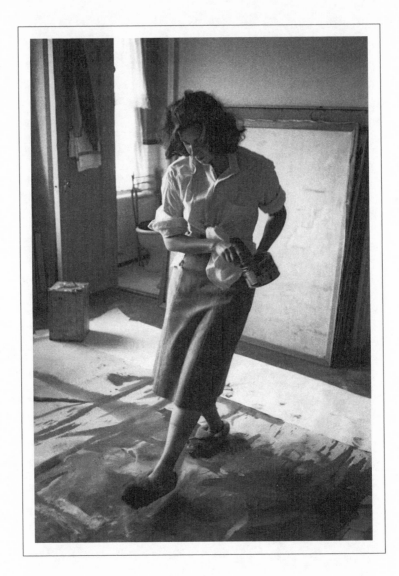

Fierce Poise

HELEN FRANKENTHALER
and 1950s NEW YORK

———

Alexander Nemerov

PENGUIN PRESS

NEW YORK

2021

PENGUIN PRESS
An imprint of Penguin Random House LLC
penguinrandomhouse.com

Grateful acknowledgment is made to the following:
Frontispiece: Photograph by Burt Glinn, courtesy of Magnum Photos,
© 2020 Helen Frankenthaler Foundation, Inc. /
Artists Rights Society (ARS), New York.
Page 2: Detail from *Mountains and Sea* (1952), Collection Helen
Frankenthaler Foundation, New York, on extended loan to the National
Gallery of Art, Washington, D.C. © 2020 Helen Frankenthaler Foundation,
Inc. / Artists Rights Society (ARS), New York. Photo courtesy of the
National Gallery of Art, Washington, D.C.
Page 122: Detail from *Jacob's Ladder* (1957), The Museum of Modern Art /
Licensed by SCALA / Art Resource, NY. © 2020 Helen Frankenthaler
Foundation, Inc. / Artists Rights Society (ARS), New York.

Pages 259–60 constitute an extension of this copyright page.

LIBRARY OF CONGRESS CATALOGING-IN-PUBLICATION DATA
Names: Nemerov, Alexander, author.
Title: Fierce poise : Helen Frankenthaler and 1950s New York /
Alexander Nemerov.
Description: New York : Penguin Press, 2021. | Includes bibliographical
references and index. |
Identifiers: LCCN 2020024394 (print) | LCCN 2020024395 (ebook) |
ISBN 9780525560180 (hardcover) | ISBN 9780525560197 (ebook)
Subjects: LCSH: Frankenthaler, Helen, 1928–2011. | Painters—United
States—Biography. | Women painters—United States—Biography. |
Art and society—New York (State)—New York—History—20th century.
Classification: LCC ND237.F675 N46 2021 (print) | LCC ND237.F675 (ebook) |
DDC 759.13 [B]—dc23
LC record available at https://lccn.loc.gov/2020024394
LC ebook record available at https://lccn.loc.gov/2020024395

Printed in the United States of America
1 3 5 7 9 10 8 6 4 2

Designed by Amanda Dewey

For my daughters,
Lucy and Anna

Contents

Introduction

At the start of the 1950s, Helen Frankenthaler was a young woman, just beginning as a painter. She was new to the New York art world, fresh from Bennington College and ready to make a name for herself among the male-dominated coterie of artists working in the new abstract expressionist mode. By the end of that decade, she had succeeded, setting the stage for the increasing recognition she would receive in a career that ultimately spanned more than half a century. A child of the Upper East Side, she was never an underdog. She had money, she had means, and she knew how to get ahead. But she needed skill, drive, savvy, charisma, and—above all—an extraordinary gift to make her way. That gift consisted in taking what was happening around her—inside her, too—and bringing it out in sudden, momentary pulsations of color and shape and line. The result was paintings as surprising and glorious as life itself, paintings that enshrine the living feeling of days like no one else's do.

The moments of a day's existence are often a homely combination: a pigeon waddling on the sidewalk, an overflowing trash can, the bright white shirt and black glossy hair of a passerby. Focused on bigger things, larger goals, we learn to ignore such ephemeral experiences. But who is to say that fragile sensations do not carry their own weight, that they do not amount to a rich record of who we are, who, indeed, we will have been? Helen devoted herself to portraying these ambient and fleeting impressions. Without theorizing it, she relied on her own protean sense of life to convey the buzzing, flashing world around her in New York and the landscapes beyond: rivers and streams, sunlight on sand, a gentle curl of surf. Her blots and swaths of bright color suggest private feelings and experiences, the movements of one person in time.

True to Helen, this book takes on the formative decade in her life and career in the form of days. Each chapter centers on a specific date, starting in 1950 and ending in 1960, eleven chapters in all. The singularity of a day offers me an unscientific precision—a fluid glimpse into a moment—like Helen's own. The date inscribed on the lower right corner of her most well-known painting, *Mountains and Sea*, 10/26/52, speaks to the importance of the diurnal round for this person so attentive to the flux and flow of daily existence. When she entered the studio she felt that all she was, every aspect of herself, down to some deep past, might find expression in a spontaneous and rigorous encounter with the canvas. Helen's colors and stains were her material and method. Mine in portraying her is the one she invented.

Getting to that place has taken a long time. I first thought of writing about Helen's paintings about twenty years ago. I loved her

pictures and sensed a deep connection to them that I knew was personal. My father, Howard Nemerov, was one of her teachers at Bennington—his first year there as an English professor, in 1948–49, was her senior year. I was born in Bennington some time later, in 1963—long after she had left, but her presence must have remained, apart from her periodic visits to the place, because I believe I knew of her before I ever said a word. Her world and mine were so close that I was not surprised to discover, doing research for this book, that her first serious romantic partner, Clement Greenberg, attended a dinner party with my father in North Bennington the day after I was born. The fact that I call her "Helen" in this book is a token of the proximity I feel. Though I never met her, I could not keep calling her "Frankenthaler" page after page— it would seem false. I knew I would need to come near, to dare closeness, and that this proximity would take time. Her paintings moved me those twenty years ago, but I was not ready for them. The big canvases, the colors, the shapes—the feeling that it all came from the artist's encounters with the world and with herself— showed that I, in proportion, lacked the same palette, the same brush. I was afraid, unwilling and unable to acknowledge the depths her paintings stirred in me, the person her art patiently waited for me to become.

And so I delayed, and kept on delaying. For the last ten years of Helen's life—she died in 2011—I taught at Yale, just a forty-five-minute drive from her Connecticut home. I had become a little more knowledgeable than when I first imagined writing about her art, more mature and maybe a bit more confident. I probably could have made arrangements to meet her at any point in those years.

But I did not. I knew that I still would have little to say, little to ask, and I suspected that even across a table from me she would have kept her distance. And so I never met Helen, which is a shame, since maybe she and I would have gotten along.

It is a small comfort, but my inadequacy before Helen's art was not only mine but that of our culture in recent decades—a limitation that, as much as anything, convinced me to write this book. The prevailing ways of seeing art over the past fifty years have made it difficult to comprehend the strength and sober delight of her kind of painting, her account of human experience. Over those fifty years—my timeline is approximate—our culture has become terribly skeptical of romantic art such as hers. Bright colors, deep breaths, the feeling of sun on our faces and the breeze at our backs— it all can sound trivial, the stuff of commercials and lifestyle magazines. But Helen's pleasure is not glib. It is the pleasure of someone who does not take life for granted. She saw things the rest of us miss: the neon sign's reflection in a wintry puddle, the cream of dirty white at the lip of the wave. She rhymed these sensations with her own feelings—the world she encountered was the world she *felt*. And though her moods ranged from exultant to deeply sad, she trusted the power of paint poured and stained into canvas to create indelible impressions that, in each case, asserted the validity of existence—her own, but more important, ours. A painting was for her the record of a personal experience exalted, transfigured, given staying power and enduring poise, so that the rest of us might be reminded of this special grace we often forget we, too, possess: namely, the feeling that we are alive.

That was Helen's high standard. No wonder that as she got older,

her paintings were increasingly met with scorn. By the time I was in graduate school in the late 1980s, grace and beauty had fallen out of fashion, replaced by skepticism and critique. Helen, holding fast to her convictions, epitomized the elitist and seemingly apolitical hauteur that my peers and I found troubling. Great streaks of bright color hardly seemed a sufficient response to the world we saw around us. An art of disquiet and challenge, of abrupt and shocking outcry, drew our interest instead. Helen's taste could not have been more different. In summer 1989, when North Carolina senator Jesse Helms and some of his colleagues were questioning the use of government money to fund exhibitions including the photographs of Andres Serrano (a crucifix submerged in urine) and Robert Mapplethorpe (men in leather and chains performing sex acts), she disagreed with Helms—but only up to a point. A member of the advisory council to the National Endowment for the Arts, she deplored government censorship, cautioning that what she saw happening around her was reminiscent of similar policies in Nazi Germany and the Soviet Union. But she also excoriated new artists such as Serrano and Mapplethorpe, calling them "mediocre," the makers of art she found of "increasingly dubious quality." As she put it, upholding the days when she herself was young: "I feel there was a time when I experienced loftier minds, relatively unloaded with politics, fashion and chic. They encouraged the endurance of a great tradition and protected important development in the arts. I recall spirited, productive discussions and arguments." She ended her essay with a salvo: "Raise the level. We need more connoisseurs of culture."

This was not bound to make Helen popular, not least with me.

I did not want to be a connoisseur of culture or of anything. I had moved from New Haven to Washington, D.C., in early June 1989, and one warm night shortly after my arrival I attended a slide show of Mapplethorpe's photographs projected by protesters on the facade of the Corcoran Gallery of Art, where a show of the artist's works had been summarily canceled following the Senate criticism. The young man watching that slide show was not a likely candidate to write about an artist who in those very months was opining that America was about to "spawn an arts monster." At Yale the previous year I had been one of an overflow crowd of Ph.D. students taking a seminar called "Postmodernism," taught by a brilliant critic dying of AIDS, who charismatically presided over a gloomy classroom filtered in the winter dusk. Anger and self-recrimination ran thick among us students. We attacked pleasure and joy and possibility with unnerving eloquence.

Had Helen entered that room, I suspect she would have been shouted down, though not without delivering a few stately barbs of her own. "My life," she told the art critic Deborah Solomon in 1989, "is square and bourgeois." She spoke as she sat on a couch upholstered with floral prints in the solarium of her Upper East Side town house. She wore a dark green sweater and a gray pleated skirt. To Solomon, she was like "a character from the old New York world of an Edith Wharton novel." Between that solarium and the gray days of New Haven, the worlds split—Helen and I could have nothing to say to each other. But I can now see that my attraction to her art was there, even in that seminar, even as I watched the Mapplethorpe slide show in Washington. My feelings for Helen's kind of grace were waiting for the moment when I could discover that joy was

itself serious, that prettiness had its edges, and that guilt, anger, and indignation were not the only games in town.

What made the change in me? The years passed; I grew up a bit. But a few things especially helped. Having kids. Looking into their eyes and understanding for the first time that life is precious. Growing to appreciate, long after he died in 1991, that my father's priestly regard for poetry—his sense that poems needed to make contact with life or they were nothing—was a great inheritance. Meanwhile, something else was happening that led me more directly to Helen's art. Around 2007, I finally got up the courage to start teaching the history of Western art from the Renaissance onward—the big painters, starting with Duccio and Giotto, and moving eventually to Picasso and others of recent times. This itself was not remarkable; all I needed was the nerve to do it. What was unusual was *how* I chose to do so. I abandoned my expertise. I let go of the skepticism I hid behind as a younger man. I left no scrim or safety net between me and the students, between me and the art, between me on the stage and the person I was alone. I began speaking—I don't know how else to say it—as a person moved. Call it, to make it sound less silly, a way of casting words into an auditorium to create a form of silence. Depending on a person's point of view, I had either become the comfortable art lover I had once despised—effectively joining Helen in her solarium—or I had simply acquired enough perspective (in my own sweet time) to see that the world is made of hatefulness that deserves to be called out *but also* a kind of lightness and peace that are themselves ethical forces. The students seemed to like it for the most part. Evidently our capacity to be moved by art remains intact.

INTRODUCTION

In many ways this is a young person's book. It is about the person Helen was when she was young. It is inspired by my young students and what they believe and feel. And writing it has made me think about who I was when I was young, about how the world moved me then, moved me as it could only in a young person's eyes, though it has taken me many years to realize how intensely I felt. You see, I never met who I was—I was too doubtful and lost for that. But Helen lived her twenties to the full; she invented herself at every turn.

And so I am finally able to tell her story. I thank Helen for having the patience to let me catch up to her. This book is a token of gratitude to her for giving me terms for my own life. I offer it also to you, reader, for whom I feel the story of Helen back in the 1950s, as she came of age as a creator, offers some wisdom. It was all so long ago, but not nearly as far away as we might think.

PART ONE

1

MAY 19, 1950

Hotel Astor: Arrival

She walked into the lobby of the Hotel Astor dressed as Picasso's *Girl before a Mirror*. Her costume was outlandish, like a Technicolor cartoon: a dyed mop on her head for yellow hair, pajamas for the feeling of the boudoir, a painted curtain wrap for a backdrop, a mirror in her left hand. Two nippled balloons floated on her arm and hip, displaced breasts set at crazy angles. By her side was Gaby Rodgers, her friend and roommate, impersonating a cover girl: sporting a blouse of black-and-white diamonds, as retiring as a racing flag, a red-dyed mop on her head, and the current issue of *Flair*, a new fashion magazine. The two young women, both fresh out of college, walked through the lobby to the elevator and took it to the ninth floor.

The door opened to reveal a vast ballroom, the largest in America. A din of alcohol-fueled conversation rose to the rafters. More than a thousand partygoers were celebrating Spring Fantasia, an artists' benefit costume ball. Large cut-out mobiles hung from the

ceiling, depicting schools of fish, a sunflower, a vast bird on a branch, a bodybuilder, the moon. A couple of revelers wore Vesalian anatomical suits showing nerves, blood vessels, and striated muscles. A man walked around dressed as a spider, complete with a fifteen-foot web and large fly. A trio wearing black and white called themselves "the Death of Color." A husband and wife, the makers of Christmas card art, dressed as Parisian pimp-and-prostitute "Apache Dancers." One reveler sported only a fig leaf, and another, calling himself "the Rain Maker," wore long strings of buttons that clacked together as he danced.

Helen and Rodgers joined the exultation, at home among the partyers, having fun. But they were also on a mission, keen to create names for themselves. Rodgers was intent on becoming a serious actress; Helen had her own plans. The ball was a benefit for the Artists Equity Association, an organization devoted to establishing rights for all artists. Its president, sixty-year-old painter Yasuo Kuniyoshi, in attendance that night, worked hard to achieve this noble goal. But Helen and her friend did not have their minds on equity. What if there were good artists and bad artists and, yes, great artists? What if it all was not fair and what if fairness was for losers? Then there was no equity, only a hierarchy based on ambition and talent and luck. A few people succeeded. Most failed.

The same with celebrity. The ceremonial emcee that night was Gypsy Rose Lee, thirty-nine, the famous stripper and author, who at that stage of her career had been performing striptease shows for a touring carnival—earning a vast income—and hosting two shows on the intriguing new medium of television. No doubt it was a thrill

to catch a glimpse of her. With her sparkling gown and crazed tiara—a swirl of hanging stars protruding from her head like a rack of celestial antlers—she cut a figure at the ball. Rodgers's rose-filled cover of *Flair*—a magazine that Lee had written for—maybe caught the star's attention.

But Helen and Rodgers aimed to be well-known themselves, unfazed by the older artists and entertainers who had seen so much more of the world than they. When *Life* magazine ran a feature on the Astor ball some three weeks later, the two unknown young women merited the only color photograph. Their outfits and personae drew attention, muscling some of the more earnest but less flashy costumes out of the limelight. It was a way of becoming public, of filling the stage—a contrast to how insecure they both really were. Two photographs taken at their lower Manhattan apartment a few hours earlier show them looking sweet and sedate, like adolescent girls before a night of trick or treating, with Helen standing above her friend, who sits in a butterfly chair. At the ball, however, the two young women grew larger than life, knowing well enough how to be a party's center of attention. The *Life* photographer pictures them from below, giving each a special stature. Magically, they assume the publication's house-style sexuality: pretty, white, wholesome, dishy, maybe available. Helen looks long and coltish. The irony of Rodgers holding a copy of a national magazine as she appears in a photograph for another national magazine turns out to be no irony at all. The cover girl and her cover girl friend knew how to draw interest.

Who cared if they had barely accomplished a thing by that night in May 1950?

———

It had been only the previous summer that Helen had graduated from Bennington College in southern Vermont. The school, founded in 1932 as a small all-women liberal arts college, was perfect for "Frankie," as her friends called her. It was known for encouraging independent thought and spirited comradeship among the students, many of them precociously bright, fiercely introverted, and socially daring at the same time.

Helen came there as both a confident and a wounded person. She was born on December 12, 1928, the youngest of three daughters of New York State Supreme Court justice Alfred Frankenthaler and his wife, Martha. Alfred's star ascended during Helen's girlhood; having worked for more than two decades in private practice after receiving his law degree with honors from Columbia in 1903, he was elected to the state supreme court in 1926. There he won wide praise for his rulings on what had been his expertise in private practice: litigation stemming from defaults on mortgage bond payments. A Democrat, Alfred was celebrated during the Depression for a series of unprecedented legal decisions that allowed investors to recover losses from failed title and mortgage companies. Martha, tall and beautiful, fourteen years younger than her husband, like him came from a German Jewish family. Alfred's father, Louis, had emigrated from Untereisenheim to New York in the 1850s, starting as a dry goods merchant before opening a ribbon business. Alfred was born in New York City in 1881. Martha Lowenstein, born in Igstadt in 1895, had immigrated to Manhattan with her family two years later. The couple married in December 1921, with Martha

already pregnant. Seven months after the wedding she gave birth to Marjorie. Fourteen months later came Gloria. Helen arrived five years later.

A photograph taken in Atlantic City around 1933 shows the five Frankenthalers, close-knit, beaming for their picture. Martha is at the top, one arm around Gloria, the other on her husband's shoulder. Marjorie, the eldest, kneels in the front. Alfred, in his tank-top bathing suit, balances little Helen on his knee as she grips his hand with her tiny fingers. At home, the family was just as spirited and close, and Helen had a place at the dinner table from the time she was two years old. Sometimes they would go to Alfred's favorite restaurant, Dinty Moore's, on West Forty-sixth Street, where the proprietor, Jim "Dinty" Moore, was a good friend of Mr. Frankenthaler's. It was a rare treat for Alfred, who worked hard, getting up at dawn and often staying late at the office. He would work during summer recesses of his court and it was said he rarely took a vacation. In his brilliance and dedication he could be disheveled, distracted. A story in the family is that on one icy winter day in the 1930s he slipped on the courthouse steps and fell to the sidewalk, where the only feature that distinguished him from the bums was his justice's robe.

Helen was Alfred's pride and joy. He marveled at her bright spirit, her curiosity and sense of adventure. Everything she did was wondrous. When she was a toddler and learning how to use the toilet, Helen finally succeeded on an evening when her parents were having a dinner party at the family's posh apartment. Coming into the dining room, she told her father proudly of her accomplishment. Just as proudly, he went to see, then insisted that the guests see, too. For Alfred, and for Martha, too, everything Helen made was a work

of art. When she got some modest recognition—winning one of several honorable mention prizes in a Saks Fifth Avenue drawing contest when she was nine—they saved the newspaper announcement. Meanwhile her less conventional artistic intelligence was emerging. In her bathroom when she was little, Helen would fill the tiny sink with cold water and dispense droplets of her mother's bloodred nail polish into the basin, watching the patterns spread before draining the water and studying the stains on the white porcelain. Only the maid's screams would disrupt her reverie. Outside, when it was time for her and her nanny to walk back from the playground behind the Metropolitan Museum of Art to the family's apartment eight blocks away, Helen would insist on drawing a continuous chalk line as they slowly walked the route. Pedestrians moved out of the way, giving ground to the little girl of such singular concentration. Sometimes as Alfred and Martha walked down the street on family strolls, their three daughters walking ahead of them, Helen would overhear her father's praise. "Watch that child," Alfred used to say to his wife. "She is fantastic."

In October 1939, not long before Helen's eleventh birthday, Alfred underwent an operation for gallstones at Mount Sinai Hospital. He spent the next several months convalescing at home but then suddenly became ill and died on January 7, 1940, at age fifty-eight. The pallbearers at his funeral included New York mayor Fiorello La Guardia, New York governor Herbert Lehman, and Judge Felix Frankfurter of the United States Supreme Court. He left an estate valued at more than $900,000 to his wife and their three daughters.

The financial security hardly made matters better. For the next several years Helen went into a tailspin. She began to suffer

migraine headaches. She convinced herself that she had a brain tumor. Panicking at school, she hesitated between asking to see a doctor and being afraid to do so. At Horace Mann and then at Brearley School in Manhattan, where she transferred in ninth grade, she spent hours in class ignoring the teacher while she tested her side vision, noting and fearing a wrinkly pattern she saw there—a pattern caused by the strain of her constant self-imposed vision tests. At home, when a migraine came on, she would "look at a chair, know it was a chair, know it had a word, know it was a word I used all the time, and would through some garbled way say to my mother to give me the name of what that thing was." When her mother would go to the grocery store, Helen trembled and cried, afraid she would never come back, and when her mother returned, Helen was scared to confide her fears and said nothing. She was gangly and awkward, her mouth full of braces. She did not emerge from this debilitating period until she transferred to Dalton, where a sympathetic headmistress mentored her. But the doubt and worry left their mark and never really went away.

At Dalton, Helen began to paint seriously. She excelled in the classes of Rufino Tamayo, a Mexican émigré painter of brightly colored cubist- and surrealist-inspired pictures. For Helen, the colors and fantasies of the man's paintings were not an escape and not a compensation. They offered instead some other reality in which she could get a fix on her own existence, these fields of blue and orange and ocher, with their singers and dancers and baying dogs. Tamayo gave Helen her first proper art training, teaching her how to mix varnish, turpentine, linseed oil, and tube pigments. He emboldened her to try big pictures—such as a life-sized portrait of the

Frankenthalers' maid. She emerged as the teacher's favorite, though she resented it when Tamayo corrected her pictures.

Going to Bennington was a natural choice. Marjorie, a gifted writer, had gone to Vassar to study journalism. Gloria went to Mount Holyoke, receiving a respectable education of the kind then deemed sufficient and uncontroversial for a young woman. Bennington was something different. "Those Bennington girls," Martha Frankenthaler had said, fretting about her youngest daughter's choice of a school. "They do wild things, they bring Greenwich Village into the house, they write things you can't understand." Martha was proud, but she also worried that people would think that Helen hated her family, or that she was sleeping with someone, or that she traveled with Communists, or all of these things. But Helen was set on her choice. A photograph of her taken during her Bennington years shows her standing and smiling, elegant in her fashionable trousers and camel-hair coat, loafers, and white socks. Behind her is the Commons Building, where up in the third-floor studio she spent days and nights at her easel.

Paul Feeley, Helen's art professor, taught her how to make paintings in the style of Picasso. As open and encouraging as Tamayo, he would tack color illustrations of modern and Old Master paintings on the studio bulletin board and invite the students to critique each work. Helen did not hesitate to talk. Her new best friend, Sonya Rudikoff, was equally sharp, equally opinionated. It did not matter that they were just starting out and that the artists they spoke of, almost all of them men, had already traveled the route from recognition to fame to would-be immortality, their pictures memorialized in the pages of *ARTnews* and *Art International*.

Evaluating their art inch by inch, Helen and Rudikoff did not shy from pointing out where it succeeded and where it failed. At the same time, Helen, like Rudikoff, felt herself part of a lineage established by these men, an artistic family at least as strong as her own. When Feeley stood at the students' backs, he did not mark on their pictures as Tamayo had done but would remark approvingly on their stylistic forebears: "Matisse is your daddy," he would say. "Picasso is your daddy."

At Bennington, the study and practice of modern painting was a part of the college's intensity, not an escape from it. Absorbing Feeley's teaching, looking around her, feeling a growing conviction in herself, Helen felt that art was more than a polite skill, a bit of polish and refinement, more than recipe making or getting married or a way to pass the time. She or any one of her close college friends would have argued that point with unseemly directness. Art at Bennington was nothing less than a transformative—even a religious— enterprise. It made life, shaped it, in the sense that you never truly saw a stream of mist curling over a green hill until you had thought about how you would paint it. The campus was politically active, primarily in the name of liberal candidates and causes—the commencement speaker at Helen's graduation in July 1949 was Democratic senator Hubert Humphrey of Minnesota—but the practice of art was a politics unto itself.

What did a vase really look like, for instance? In one sense it was just an object set on a table for a still-life painting class. But it was also a mysterious object, the more so the longer one looked at it, became absorbed by it, amid myriad painting sessions. Then it doubled and redoubled itself in shapes and rhymes such as those in

Helen's small *Untitled (Cubist Still Life)*, one of the paintings in her senior show in midsummer 1949. The vase is there—in white, against a rectangular black background—at the picture's center. But then it changes to black in an adjacent gray rectangle, and then into charcoal outlines at the edge of a table. Then on the other side of the central black rectangle, the vase morphs into something resembling a portrait of a woman with an L-shaped nose, a scooped dress front, and short hair. Below—in yet another variant—the vase changes into a shape like a Picasso guitar. And at the top, charcoal lines create stacked shapes that extend the angles and curves of the central mix of woman, vase, and table. Helen must have seen that white vase in her sleep, understanding its every mood and connotation. Like a poet or a composer, she turned variations on it with fluidity and precision.

Even so, the student art she was making just then fell far short of who she was and wished to be. Even as Feeley gave her master classes in the art of painting, it was Helen's pursuit of life outside the studio that most resembled the pictures she was to make. The intelligent joy of these escapades told of a life force she would soon bring to her art. In December 1948, the winter of her senior year, she and several friends carried a card table out onto the snowy Commons Lawn. A photograph shows them out there, playing poker bundled in winter coats and gloves. Cigarette packs, playing cards, and an ashtray strew the table—the players demonstrating with jaunty assurance that they can play a man's game. One of Helen's friends at Bennington was Miriam Marx, daughter of Groucho Marx, and something of the comedian's wise-guy humor played out not only in his daughter's college persona—Miriam had a

smart-alecky column in the student newspaper called "Re: Marx"—
but in her good friend. A cigarette dangling from her lipsticked
mouth, Helen studies her wintry hand in comic deadpan.

Helen believed in structured spontaneity. Not only in her own
antics but in studying the roles of others, she was exploring how
artists combined routine, discipline, and the unpredictable energies
that lay at the center of being a creative person. In spring 1948, at
the end of her junior year, she and her friend Cynthia Lee went to
New York to see *A Streetcar Named Desire* on Broadway. Awe-
struck after the show, they sought an impromptu interview for the
school newspaper with the beautifully handsome Marlon Brando,
playing Stanley Kowalski in Tennessee Williams's play. Only four
years older than Helen and Cynthia, Brando was creating a sensa-
tion by drawing on method acting techniques to deliver raw and
immediate performances that, at their best, hardly seemed acted at
all. Attracting the attention of a stagehand, the two Bennington
students secured their interview for a time before the Saturday
matinee.

Brando gave them an insider's view into an artist's life. He told
them that American movies were not governed by quality but "by
the dollar sign," just like most everything else in America. Apply-
ing his makeup, he let fall another dirty pearl: "People never con-
sider how successful an artist you are, but judge you by how much
money you make." Breaking into the acting scene in New York? It
was dumb luck. He had been digging ditches, then working as an
elevator operator, before he was discovered by the acting teacher
Stella Adler. Staying ahead? It was hard and filthy work, as a look
around the busy dressing room, all business, no privacy in sight,

clearly showed. Although their article is tongue in cheek—"A Brando Named 'Desire,'" ran the headline in the Bennington *Beacon*—the actor's lessons were not lost on Helen, who knew that she would be moving back to her home city after graduation and that she would keep painting.

Strength was needed, and Helen had it, thanks partly to Bennington. "Helen would have become Helen one way or another, but Bennington was an intellectual and artistic accelerant for her," says her nephew, the artist Clifford Ross, who became increasingly close to her starting in his own college years in the early 1970s. "It was at Bennington that she got out of the pocket of her childhood"—out from the coddling and adoration of her family, out of her role as the young star, the possessor of different stuff than her sisters, a role in which she could do little wrong. At Bennington, by contrast, she was taught how to paint, she had her mistakes rigorously corrected, and she learned from them. "For Helen Bennington was the equivalent of an apprenticeship for an early Renaissance painter."

At the same time, says Ross, Helen could not have learned so much at Bennington if she were not already an old soul. The college captivated her because she was ready to taste all that it had to offer, well beyond the studio. From her beloved sociology professor, the German émigré Erich Fromm, she learned during her senior year of 1948–49 about the ethical power of freedom, of following one's impulses. "Whether it be the fresh and spontaneous perception of a landscape," Fromm wrote, "or the dawning of some truth as the result of our thinking, or a sensuous pleasure that is not stereotyped, or the welling up of love for another person—in these moments we all know what a spontaneous act is and may have some

vision of what human life could be if these experiences were not such rare and uncultivated occurrences." Fromm's words gave Helen terms and directions for the person she aspired to be, indeed the person she already was.

Moving back to Manhattan, however, she faced a serious challenge. Her mother was a formidable woman. Elegant yet earthy, Martha Frankenthaler was a person of vibrant enthusiasms and impetuous moods. Recalling the sisters' childhood, Marjorie remembered the "childish expectancy" of their mother's face when she was excited about anything, "the party edge" that was "always there in her talk and in her eyes," the way their father would treat his wife "alternately as an adored goddess and a spirited child." Back then, it had been "wearing on a day-to-day basis to live with her high energy and excitement," and when Helen returned to Manhattan after her Bennington graduation, her mother's capriciousness was there as always. But so was a tough and imperious conventionality. Impractical herself, Martha exerted many practical demands on her daughters, and she doubted Helen's intention to become a painter. To this venerable woman of the German Jewish *haute bourgeoisie*, Helen's career choice was as mystifying as her aim to move to the West Side of Manhattan, a virtual foreign territory to a family ensconced on Park Avenue and environs.

A photograph taken two years earlier, in July 1948, back before Helen's senior year at Bennington, shows Martha's power in those days. Then fifty-three years old, she stands imposingly next to her nineteen-year-old daughter. The occasion is Helen's departure with

Gaby Rodgers on an ocean liner for Europe, a trip the friends took that summer. Martha has come to the girls' room to bid them farewell, and the cake Helen holds says "Bon Voyage Helen." The confection marks Helen's nascent independence—she is about to travel farther from her mother than ever before—but Martha's plump glamour crowds the room. Helen appears to hold the cake slightly to one side, as if worried that her mother might smear the frosting. The word "upstage" is not too strong to describe the presence of the Frankenthaler matriarch—whose March birthday, coming just before the annual St. Patrick's Day Parade, always made it appear to Helen when she was a child that the pageant took place in her mother's honor: a fantasy that Martha, vain and impetuous and imaginative, did not dispel.

Now in winter 1949–50, only slightly more than a year after the bon voyage photograph, Helen had come back from Bennington and directly into her mother's orbit. Martha's expectations likely had to do with the family name, the ongoing prestige of Judge Frankenthaler throughout Manhattan. The time when she and her husband had introduced their three young daughters to Sara Delano Roosevelt, the mother of the president of the United States, as she stood at the door of her Upper East Side brownstone—this was back in 1938—still represented the Frankenthaler family's social connections and aspirations. Becoming an artist was not necessarily in line with the family mythology.

Martha wanted Helen to be like her sisters. A photograph taken in 1949 or 1950 by Jerry Cooke, an Upper East Side society photographer, shows Helen with Gloria and Marjorie. All three black-haired sisters wear black sweaters, and a gleam shines alike on their

faces, highlighting both their individual uniqueness and their sisterly unity. Marjorie and Gloria were already married, Marjorie to Joseph Iseman in June 1947 and Gloria to Arthur Ross in January 1946. Both had immediately started families: the Isemans' first child, Peter, was born in 1948, and the Rosses' first, Alfred, in December 1946. The photograph, which perhaps Martha commissioned, implied that Helen might follow in their path—meet a man, have children; be herself, of course, but be also indistinguishable from her siblings.

Having none of this, intent on demonstrating that being an artist was a legitimate and not frivolous occupation, Helen enrolled in graduate courses in art history at Columbia University, aiming for an academic legitimacy that would impress her mother by showing that art had intellectual prestige. It was fall 1949, and there she sat in a packed and darkened auditorium, staring at the lantern slides projected on the screen as she listened to the quiet, almost whispered eloquence of the teacher, Meyer Schapiro, one of the world's most erudite art historians. "The beam of the projector was a searchlight on the world," recalled one of the master's students, the writer Anatole Broyard. "The students shifted in their seats and moaned" as Schapiro "danced to the screen and flung up his arm in a Romanesque gesture." But Helen was unimpressed. She realized that justifying her choice to become a painter by taking courses in art history was beside the point. Either she was an artist or not. She did not need credentials and she did not need to prove herself to anyone besides herself. She had learned enough for a lifetime at Bennington; she had no need to "learn anymore except in my own terms." With her family money, she had the financial independence

to take the next step in confidence. She stopped taking courses at Columbia and moved out of the family home into an apartment on West Twenty-fourth Street with Rodgers. The transition was not always smooth. The creak of the Eleventh Avenue freight train every night at 1:10 a.m. was an unaccustomed sound to the Upper East Side girl. But it was thrilling to be independent. Helen began to spend more time at the tiny fourth-floor studio she and Sonya Rudikoff had rented on East Twenty-first Street.

Helen was unusual among young artists in lower Manhattan, few of whom had much cash. The painter Grace Hartigan, whom Helen met later that year, lived downtown in 1950 with her boyfriend, the artist Alfred Leslie, in "steady, endless poverty," Hartigan recalled. A few years later, when she was a little better off, a street vendor selling penny tomatoes and a grim market selling meat at fifteen cents a pound reminded her of the cheap and foul food she and Leslie used to eat in those penurious days, back when Helen met them. They all became good friends, but Hartigan felt her early days showed her "what it means to be poor, really poor," something that "Helen will never know."

Helen, it is true, lived a comparatively posh life. She frequented the uptown beauty salon MacLevy's, where she would have her hair washed and sit under the dryer. She got her hair cut and styled at the tony salon Jean de Chant, or "Jean de Chump," as she called it when her hairdresser erred. She and Rodgers employed a maid to clean their apartment. Visiting her mother's place at Fifth Avenue and Seventy-fourth—Martha had moved there after 1946—she would switch on the marvelous new black-and-white television,

stepping out onto the balcony (Martha lived on the fourteenth floor) to look around as the mood took her. The disparity between her means and that of her artist friends could be awkward. Helen once thanked Leslie for giving her a ride to New England in his old truck by hastily flinging a handful of coins on the seat as she got out of the car at her destination—an embarrassing gratuity that Leslie found both charming and cheap: a pittance for gas money that reminded him of when Martha Frankenthaler paid him for three days' work on Helen's studio with a steak. Helen, like her mother, could be stingy. But she never apologized for her money. She knew she was serious, not a faker or a dilettante, and she expected others to see that seriousness, which they did.

One person saw it especially. In spring 1950, Helen was asked to curate a show of recent Bennington graduates' works at the Jacques Seligmann Gallery in midtown. Promoting the show beforehand, she brashly made calls, including one to Clement Greenberg, the most influential art critic in New York. "Oh, I love Bennington! I love Bennington girls," he told her on the phone. "But I'll come only if there are drinks."

Nearly twenty years her senior, Greenberg toured the show with Helen. He glanced at the pictures, most everyone's an imitation of Picasso. They came to Helen's contribution—a Picasso-inspired painting she had made earlier that year called *Woman on a Horse*. Bigger than anything she had attempted at Bennington, ripe with varnish, the painting was the state of Helen's art and she was proud

of it. But he was quick to see its derivativeness, its faults. "I don't like that one," he said, not knowing it was hers but finding out soon enough. "It's mine," Helen laughed. It was May 15, 1950, four days before the Astor ball.

This was a moment of truth. Next to the new possibility Greenberg represented, Helen's painting waned. The man beside her consorted with a whole different league of artists than the ones she had known. Born in 1909 in the Bronx, tough as nails with a nasty temper and a superb erudition, the Syracuse-educated Greenberg had emerged in the late 1930s as a critic of rare intelligence. First in the pages of the leftist cultural journal *Partisan Review*, then as a writer for *The Nation* and as editor for another leftist journal, *Commentary*, he wrote incisively about contemporary and historical art and literature. In 1943 he had spotted the talent of an unknown painter named Jackson Pollock, likening the fierce darkness of his paintings to the writing of Faulkner and Melville. He had emphatically praised other abstract artists, too—the sculptor David Smith, the painter Willem de Kooning, among others—pronouncing their art an expression of the "true reality" of the age—a reality of existential alienation. This was not criticism for the fainthearted. Greenberg announced which artists mattered, and which did not.

Talking at the gallery, the two were attracted to each other. Greenberg, forty-one, bald and brilliant, was reminiscent of Helen's father, and Helen, twenty-one, saw in her new friend's evident admiration an echo of her father's fondness. Greenberg, drawn to the party by the promise of Bennington girls, liked this pretty young woman with the big brown eyes, who used those eyes so expressively, to welcome and encourage and conspire with the person close

to her. It was not long before Greenberg telephoned Helen. There was a ballgame on the television and the announcer's voice sounded behind theirs. "We had a long phone call in which it was very clear that we shared a certain humor and interest," Helen remembered. "We made a date for drinks."

Martha Frankenthaler was not pleased. She took a dim view of her daughter dating a man so much older. But this, too, was a reason for Helen to admire Greenberg. Not only could he offer her a way into the New York art scene, he could also help her gain some independence from her mother. At the formal family dinners to which she would sometimes take her new boyfriend, Helen would also bring Alfred Leslie, strategically seating the intelligent young painter next to Martha with instructions that he spend the evening in conversation with her to prevent her from spending the evening criticizing her new relationship. The strategy worked like a charm.

Managing Martha Frankenthaler's disapproval was not difficult. Dealing with other artists as Clement Greenberg's girlfriend was another matter. On one of their early dates, just about the time that the photograph of Helen and Rodgers wearing mop wigs was appearing in the June 12 issue of *Life*, Greenberg urged Helen to attend Hans Hofmann's summer painting school in Provincetown, Massachusetts. Despite her preference to avoid art classes after Bennington, she agreed and spent three weeks that July away from her new beau working under Hofmann's direction. A photograph taken that month—so different from the *Life* picture, so different, too, from the one with her sisters—shows Helen in the new situation she had entered at Greenberg's recommendation. The sleeves of her white shirt rolled up in the Massachusetts heat, she cocks a cigarette

expertly in her right hand while holding a smeared paint rag in her left. Her eyes as big and rounded as her mouth, she looks steadily at the camera, proud and practical, every bit the working artist at her easel, perhaps with a greater sense of herself because of her new romance.

But Helen's confidence is also an act. She was surrounded in Provincetown by Greenberg's friends, mostly older people who treated the critic's young girlfriend as an object of curiosity and gossip. "I don't know these friends of Clem's," Rodgers consoled in a letter, "but if one has a healthy relationship in P'town, all the neurotics try to break it up because they are so damn jealous. It's this thing of . . . 'I am not happy so I don't want you to be happy, either.'" She gave Helen some advice: "I know you, Helen. You don't have enough confidence in yourself. Especially as far as men are concerned. You can hold your own always and I am sure that Clem is equally fond of you. So what if he doesn't write for a few days." Helen was already hanging on the new man's every word, fretting when he did not send a letter—her insecurities quickly emerging.

A new path was opening up for her, all the same. Soon she would stop painting cubist pictures of the kind on her easel in the Provincetown photograph. Even as she got better at this type of work, she was trying to unlearn her college proficiencies. She sensed that a truer and deeper way of painting was both already inside her and out there, somewhere in the world and within herself.

2

NOVEMBER 12, 1951

New York: Seeing the Dragon

A few hours before her first one-person show, Helen was a
nervous wreck. She had spent the previous day hanging
the eleven pictures, in company with a few others, includ-
ing Greenberg (whom she called Clem, as did others close to
him), Alfred Leslie, Grace Hartigan, and John Bernard Myers,
the director of the midtown gallery where the exhibition would
take place. So much of herself was on the line, but the pictures
would take care of themselves. She was worried about the opening,
what to say, how to be.

The seeds of the show had been planted the previous fall, back
in 1950, when she and Clem were dining at one of their favorite
restaurants, the San Remo, at the corner of MacDougal and Bleecker
in Greenwich Village. Over their bowls of al dente spaghetti with
white clam sauce, their slices of good bread, and their glasses
of Chianti, they were approached by Myers, another San Remo
habitué.

Standing at their table, he told them he was starting a gallery. It would be called Tibor de Nagy, after his cofounder, a Hungarian émigré who was Myers's lover. It would replace their previous enterprise, a traveling marionette theater that they had transported around Manhattan in a secondhand station wagon, getting gigs where they could. Myers told Helen and Clem that the gallery would feature a campy eclectic mix of works, but Greenberg convinced him there was a need to exhibit up-and-coming serious painters. Myers took Greenberg's advice and by spring 1951 the gallery was in operation on East Fifty-third Street, with Helen's friend Grace Hartigan already set for a solo show and Helen herself to be included in a group exhibition, *New Generation*, scheduled for later that spring.

By March Myers offered her a show of her own. It would take place in November, less than eight months away. For the most part, Helen was delighted. The Tibor de Nagy Gallery was a strange new venture—a "pretty odd" situation, she wrote to Sonya Rudikoff, who had meanwhile married a young sociologist, Robert Gutman (Helen had set them up), and moved to Hanover, New Hampshire, where Gutman had begun teaching at Dartmouth. If Rudikoff no longer would be a painter (she turned to writing instead), Helen confided her good fortune to her erstwhile studiomate without self-deprecation or false modesty. The gallery was "generally considered the new 'avant-garde' spot for new talent. . . . I'm pleased, surprised, scared, flattered about the whole business."

She braced herself for what the show would require. That spring she was already putting herself out there, showing a large painting in a group exhibition organized impromptu at an empty furniture

store on East Ninth Street. Her painting, a vast spread of cerulean blue, off-white, and tawny brown, punctuated by red and orange and locked into a scaffold of black lines reminiscent of monkey bars and switchboard wires, hardly shrank on the walls. At seven feet across, it was one of the bigger paintings in the exhibition, as bold as the painter was youthful: at twenty-two, Helen was the youngest painter in the show. But her own show was something different. The emotional pressure of creating a whole slew of exhibition-quality paintings in a relatively short amount of time, and with nowhere to hide when the Manhattan cognoscenti came to see it—that was new. Hartigan, thick in preparations for her own show that spring, understood the point exactly: "Easy for Helen to be the fairy princess," she wrote upon learning that her friend would get her own exhibition. "She hasn't seen the dragon yet."

But Helen was unfazed. In June 1951 she made a large square work on paper, somewhere between a drawing and a painting, called *The Sightseers*. A spread of thick sweeping black lines structures the picture, the artist keeping them loose and open. The lines move and vibrate, making a syncopated visual field, alive with scribbled crayon color, like a flashing neon sign caught in the pulsing moment when images and afterimages are the same. *The Sightseers* conveys the ecstasy of seeing the world, the joy of discovering that there is so much—too much—to see. Rather than trying to put the puzzle of modernity together—the splatter of sidewalks and the blast of movie marquees, the clamor of the crowd and the rush of life—the painting boisterously accepts the fragmentation. It throws the puzzle pieces into a shimmering and loose amalgam, a provisional assembly, as near to breaking apart as to

coalescing—the forever-forming, forever-unforming state of things being, truly, the sight to see. Although Helen downplayed her titles, assigning them usually after a work was finished, she had a canny ability to name her pictures rightly. Here the zany redundancy of vision—seers of sights—implies a world where vision is excessive: not only because there is so much to see but because, seeing it, we experience a delirium, an intoxication.

The paintings Helen worked on in 1951 start laying life out, accepting—loving—the excess of a day on earth. The homelier destinations of lower Manhattan were no less credible venues of extravagance than the most celebrated shrines. One of the paintings from that year, a fifteen-foot panorama she called *Ed Winston's Tropical Gardens*, naming it after a jukebox dance joint at 21 East Eighth Street, is a swath of yellow ground flowing with palm trees, huts, a river, a rainbow, maybe a parakeet. The palette and scenery recall those of the late-nineteenth-century painter Paul Gauguin in Tahiti—an island village, a society such as painters and anthropologists investigate—but unlike Gauguin, Helen did not travel halfway around the globe to find her sense of genuine life and its enactment in painting. It was right there at Ed Winston's, with its plastic palm trees and other dime-store exotica. Although Helen said she added the title as a "gag" after finishing the picture, it was a fitting name that spoke to the lusty ambitions of her art. This was not because she wished to celebrate jukeboxes and hula kitsch, to elevate the low and tawdry and popular at the expense of high culture. She agreed with Greenberg, who would end his essay on the poet T. S. Eliot in 1954 by contrasting the truth of high-minded "genuine culture" to the escapist mass culture blaring from "any

number of jukeboxes." But more so than Greenberg, Helen found that there was a jukebox already inside her. Irrepressibly, she adored the lurid and the garish, feeling at home amid the sticky splash of gin and tonics, the grass-skirt calendar girls, and the smoking toy volcano. Away with the pompous grandeur of uptown places, like the restaurant described by her acquaintance Chandler Brossard in *Who Walk in Darkness*, his novel of 1952—the dimly lit dining room, the heavy carpets and murmuring waiters, the Delmonico steaks on triangle-sliced toast. Helen knew such places from her youth, but tasteless banalities were also the stuff of daily life and its panoramic grandness. If a crummy three-pronged fan made the plastic fronds flutter, if it caused the cigarette smoke to move like miniature mists around the bar top, the stale spectacle was a hedonism as worthy as any ancient island rite. Life itself was miraculous in its ordinariness; life was the coin slapped on the bar.

More than any other artist, Jackson Pollock gave Helen this feeling—a sense of absolute freedom that she already possessed but needed to see exemplified in the work of another before she could realize it in her own terms. Pollock loomed large in Helen's first show—not as an artist to be imitated but as one who had given her permission to be as fearless and grand as possible.

Her allegiance to Pollock's art had started the previous November, when Clem took her to an exhibition of the artist's new drip paintings at Betty Parsons Gallery on East Fifty-seventh Street. He had told her about these paintings and about the artist, though Jackson Pollock was so new to her as a name then that she spelled

it with an "a"—"Pollack." She had met Pollock the night before attending the show, when she and Clem dined with him and his wife, the painter Lee Krasner. She found him "a very 'American' charming grump," a "prima donna but nice." Seeing the drip paintings was another matter. Nervous, ready, focused, she knew how much the occasion meant to Clem but was not sure how she should react. As the elevator doors opened to the second floor, revealing the gallery's large rooms before them, Clem invited Helen to look around on her own. "Walk in," she recalled him saying, "and see what it does to you."

What happened next was one of the most important experiences of Helen's life. "I was overwhelmed and puzzled," she remembered of that moment. "It was as if I suddenly went to Lisbon and knew no Portuguese but had read enough and had a passionate interest in Lisbon and was eager to live there; I mean I wanted to live in this land, and I had to live there but I just didn't know the language." The paintings "just thrilled me."

Three big pictures stood out in the show. One was *Autumn Rhythm*, a vast pulsation of black, white, and brown paint poured on a beige ground seventeen feet across. Filling up nearly an entire white wall of the gallery, the picture's swirling paint brought to mind barbed wire, forest thickets, and exploding galaxies without representing any of these things. Another painting of equal size was *One: Number 31, 1950*, also black, white, and brown, but very different from *Autumn Rhythm*, which hung next to it on an adjoining wall. Whereas *Autumn Rhythm* moved in razor whorls of black and elbow joints of brown, *One* was softer—a rain of dots, a vibrating optical field, with the paint thinned out so that the great spread of

drops seemed to syncopate like a thousand insects at dusk. The third painting, *Lavender Mist*, smaller than the other two but still the size of a department store window, was powdered like smashed pearls and came at the viewer in clouds, a driving and infinitely fine storm of paint.

Without realizing it, Helen had walked into one of the most important art exhibitions of the twentieth century. She found herself among the first—the first, it turned out, of millions—to be stunned by these strange and unprecedented pictures. Pollock had been making drip paintings since 1947 and had exhibited them at Betty Parsons on two prior occasions, in 1948 and 1949, but this third show included the large mural-sized paintings, his most ambitious and achieved efforts to date. No American artist before Pollock had quite so audaciously realized the aspiration *to make a world*—not to copy one, but to invent one. In place of trees and streets and people and painting's often-pale imitation of the real force of the world—its actors and environments—painting would itself be a reality, as vibrant as life itself. As Pollock is reputed to have said in 1950, "I don't paint nature; I *am* nature." Helen took this in.

She knew that she was looking at drip paintings, a technique that Pollock, sixteen years older than she, had arrived at only after nearly two decades painting with a brush—first representational works and then surrealist pictures. From Clem, she knew something of Pollock's actual procedure, which was simple, demanding, and infinite. Out at his Long Island studio, a converted barn a few feet from his house in East Hampton, he had made these pictures and others by using raw canvas rolled out on the floor, by moving

around the pictures and using a paint-laden stick or sometimes a turkey baster or a can of paint punctured with a can opener—all to let fall pours and swirls and dots of pigment in varied calligraphies simultaneously improvised and controlled.

Helen saw that it was a kind of magic. Nothing in her Bennington experience had prepared her for it. The repeated swirling forms marked the gestures of the artist's body as he approached the pictures from all sides—the vapor of his movements in space—even as they also established a permanent architecture for the finished painting, a structure as sound as beams and girders. The results she stared at were those rarest of things: paintings that seemed perpetually energized, always new, never freezing into static and fossilized forms. In the face of such perpetual newness, it was easy to rely on what one already knew—the *New York Times* critic Howard Devree had likened Pollock's traceries to aerial topographical maps. But Helen understood that the paintings' power was that they did not depict anything at all. Instead they were force fields, constantly exploding, constantly imploding, at various rates of speed—as fast as explosions, as slow as buds blooming in a verdant glade. Pollock put it best. "The painting has a life of its own. I try to let it come through."

His art gave Helen permission not to hold anything back. The fact that his work could not be duplicated was a liberation. The young painter could *only* turn elsewhere, transformed by what she had seen. The drip paintings "opened up what one's own inventiveness could take off from," she said, and now she saw her own boldness in a new light, as a quality still without a proper form, without a name, but existing definitively all the same. The master artist had

shown her, by virtue of his own extravagance, the boundless quali-
ties she also possessed.

Loving Pollock's art was a brazen choice, not an obvious one for
a young painter then. Despite or because of his growing fame, Pol-
lock was thought to be too gimmicky, a celebrity, just a fad. Willem
de Kooning, by contrast, was anointed a king of artistic integrity.
But Helen did not see it that way. "I was much more drawn to Pol-
lock's painting on the raw canvas than I was to de Kooning's easel
cuisine," she later said, using a cooking term she often employed to
convey something that was lightweight. "Aesthetically, socially, in
every way the de Kooning thing seemed to be much more produc-
tive, planned, admirable, at the time. But I didn't think so." Pol-
lock's art taught her "when to stop, when to labor, when to be
puzzled, when to be satisfied, when to recognize beautiful or strange
or ugly or clumsy, and to be free with what you are making that
comes out of you." She began to see how chance and improvisation
could emerge within the matrix of her own discerning intelligence.
The large and powerful works she began making in 1951 for her
Tibor de Nagy show, such as *The Sightseers*, emerged from this
realization.

They emerged, too, from solemn rites and vows. Helen spent
time with Clem in the Hamptons in summer 1951, staying with
Pollock and Krasner and visiting the sacred keep of Pollock's me-
ticulous barn studio. By then she and Greenberg had been socializ-
ing with the painter couple for some months, hosting them at Clem's
Greenwich Village apartment on Bank Street, where Pollock would
sit on the floor "totally silent, withdrawn, probably very depressed,"
Helen recalled, remembering him from other occasions that year

as "affable, pleasant, but non-communicative." The nearness of this artist, of whom *Life* magazine had asked in 1949, "Is he the greatest living painter in the United States?," could be daunting. So, too, was the presence of the Brooklyn-born Krasner, smart, suspicious, and loud, whose red-diaper-baby upbringing made her the spitting antithesis of genteel Helen, who described Krasner to Rudikoff as "a strong aggressive 40 yr. old Bennington type" who "makes me assert myself." But Helen's own gusto helped her withstand these imposing personalities and stay focused on Pollock's art, which, being a leap of faith, seemed to warrant Helen's own faith in it.

So it was that on the Hamptons dunes one summer day in 1951, she and the young painter Larry Rivers pledged an exuberant but serious oath to be true to Pollock. Rivers, who also showed at Tibor de Nagy, was out there on his own pilgrimage. "We were so moved and overcome by Jackson's work and genius and the pictures we'd seen," Helen recalled, "that we vowed and made a sort of mutual promise that we ourselves in homage to his urge would work and be true and produce and transcend." Although she remembered the oath as a stunt of youth—"the most schmaltzy, pathetic, embarrassing moment"—it was serious all the same, serious in the way that embarrassing youthfulness can be. From that oath, there was no going back.

In mid-January 1951, a month after the close of the Betty Parsons exhibition that stunned Helen, *Life* magazine ran a photograph of Pollock and seventeen other "advanced artists." The term was not misplaced. This was the big leagues of painters then in New

York, the group that Helen hoped—even expected—to join. Stern faced, the artists in the photo gather in accumulated weight, posed in protest. Their target was the Metropolitan Museum of Art, which after years of disdaining modern art had finally yielded to pressure and held a juried competition for its own show of recent American work. But the selections turned out to be conservative—just representational paintings with some calligraphic verve and occasionally a thematic freshness (a painting of a great fish kite, shown close up, by Yasuo Kuniyoshi). The work seemed new but really only upheld long-established painterly traditions. There was nothing abstract, nothing daring, altogether a lack of froth and slather, of limpid translucency, of, indeed, *any* of the new school's searching use of paint itself as a medium of emotion. So the artists gathered for *Life* photographer Nina Leen to protest the museum's milquetoast policies. Posed in attitudes of glum bellicosity—the photograph has come to be known as *The Irascibles*—they condemn a conservative art establishment they regarded as "notoriously hostile to advanced art."

Helen aligned herself with this group. It did not matter that she was a newcomer and an unknown; their battle was her battle. The previous October she had submitted one of her own paintings to the Metropolitan jury and been rejected, a dismissal that gave her some credibility. Her work must be as "advanced" as that of the established painters if it, too, had been found wanting in the eyes of the staid institution. Not surprised by the jury's decision, she predicted "some Renaissance revivalist" would win—a foresight that proved correct, based on the pictures that appeared in color in *Life*, which an artist of 1473 would not have regarded as wholly alien. Helen's alignment with the Irascibles was dauntless in

part because she was a woman. Of the fifteen artists in Leen's photograph, fourteen are men. Many considered themselves to be masters of the universe, with or without a photograph to suggest the fact. Pollock scowls at the center of it all, bald headed and holding a cigarette, diminished among the foreground figures but still radiating intensity and power—a prestige that the recent national attention in *Life* itself had attested. Directly in front of Pollock is the mustachioed Barnett Newman, dandy and muckraker, erstwhile candidate for mayor of New York in 1933, whose latterly named "zip" paintings, starting in 1948, presumed to rediscover the primal power of the first pictures made by mankind. To the right of Newman, wearing glasses and staring to the left, is Mark Rothko, who had just hit upon his grand manner—large glowing fields of color that seemed like depictions of the swirling energies left by the departure of God—and who thought highly enough of himself to imagine the priorities switched between him and one of the greatest painters who ever lived: instead of "Rembrandt, Rothko," he mused, it should be "Rothko, Rembrandt." Over Rothko's right shoulder, his right arm resting on a chair back, is Clyfford Still, who in his teaching days in San Francisco kept his studio perfectly ordered, with brushes and palette knives arranged precisely; who wore double-breasted suits to teach instead of the jeans and army fatigues his fellow instructors wore; and who displayed, in the trunk of his vintage Jaguar, a set of tools laid out on a bed of velvet. "Let no man under-value the implications of this work or its power for life or death, if it is misused," he is reputed to have said of his art. In the back row at far left is de Kooning, the handsome Dutchman who built up layered slashing depictions of female flesh, as in his

most recent major painting, *Excavation*, where a vast field of nude forms writhes in an orgiastic wall of angular limbs.

In the man's world of *The Irascibles* there is only the one woman. Hedda Sterne, a Romanian Jewish immigrant born Hedwig Lindenberg, stands above everyone else, clad in a dark winter coat with a stylish purse at her waist. When she posed for the picture, Sterne was already forty years old, a deeply experienced artist whose work grew out of her time in European avant-gardes in Bucharest and Paris before she came to New York in 1941. Her artist's statements from the time bespeak her hard-earned wisdom: "To serve your vision you have to master your technique. You cannot cheat matter. It shows. You must learn and respect its laws. You are required to use patience, courage and honesty." Helen, just turned twenty-two, did not flinch before such sagacity.

She could take some comfort in not being alone in her goal. Grace Hartigan, six years older, was at a similarly auspicious moment in her young career. Joan Mitchell, three years older, was painting accomplished soulful pictures in a blended manner of de Kooning and Arshile Gorky. Krasner, twenty years Helen's senior, had taken a back seat to her husband's budding career (her absence from *The Irascibles* is conspicuous), even as she fiercely kept painting. But Helen's personality was different from that of these other women. Hartigan, who came from a middle-class background in New Jersey, was soulful and introspective, in some respects a bundle of hurt; she could also be imperious and aggressive. A story about her punching a sniveling-nosed poet who failed to keep up

with her and her drinking buddies one night as they moved from one Greenwich Village bar to another says something of her toughness. Mitchell, like Helen, grew up in a family with plenty of money, but she behaved more like a brawler than a cosmopolite, peppering her speech with the word "fuck" and drinking hard with the men at the Cedar Bar, where she would exchange ribald stories and groggy hugs with the most ardent and reckless. Helen liked to go to the Cedar Bar, too, as did Hartigan, but her style was different, a mix of uptown and Greenwich Village bohemian, with no fists and no cursing. In that painters' milieu it was perhaps the least likely way for a woman to be taken seriously—this way Helen had of being elegant and pretty and smart—but likely she gave the matter no thought at all. She would be herself, even if she was not sure who exactly that was.

At the time she agreed to the show at Tibor de Nagy, Helen rented the studio of the sculptor David Hare on East Tenth Street, leasing it for a year while Hare was away. The thirty-three-year-old Hare was not one of the artists in Leen's photograph, but he was notable all the same. He had been one of ten sculptors to add their names to the painters' letter of complaint against the Metropolitan published in the *New York Times* on May 22, 1950. Moving into his studio was a major step up from the tiny railroad-flat place Helen had shared with Rudikoff. But there was no awe, no fawning. Helen wasted no time in repurposing the space to her specifications. With Hartigan and her boyfriend, Alfred Leslie, she built screens out of old surplus parachute cloth stapled onto frames to conceal

Hare's surrealist bronzes behind them. There would be no chance of his art getting in her eyes.

As she cleared ground for her own work, Helen felt liberated but also alone. "True artistic creation of any kind is a very lonely process," she later said, and in that necessary solitude, her relationship to her sisters began to change. There were no dramatic breaks, to be sure. In June, the same month that she painted *The Sightseers*, Helen visited Marjorie (Marge, as she called her) and her husband, Joseph Iseman, at their home in the Connecticut suburbs, where she laughed with the Isemans' two-year-old son, Peter, who told her his nipples were mosquito bites. But Helen was sensing that being an artist made her different from her sisters. Later she spoke of how uncomfortable people are around artists, that artists "house something out of the ordinary that often makes people uneasy." Although Helen and Marjorie were always friends, united by a kindred interest in creative endeavor (Marjorie was a talented writer and vividly aware of art), a chill grew between herself and Gloria—"I'm not at all close to her," Helen reported some years later—and it remained even when Gloria became an accomplished tapestry maker. As the 1950s went on, there were to be no more formal photographs such as Jerry Cooke's of the Frankenthaler sisters together. Instead, Helen starts appearing with her new "family"—artists, gallerists, and the like.

Her relationship with her mother was changing, too. The days of Martha Frankenthaler sucking up all the air in the room as she wished her youngest daughter bon voyage on that schoolgirl trip to Europe—though only three years earlier—were over. Martha was still powerful, but Helen had begun to push back—partly because

she had a growing life at her easel, partly because her mother had become less commanding. As of 1950 Martha was feeling ill. "Mother is really run down," Helen had written to Rudikoff in October 1950, lamenting that Marjorie was also hospitalized at the time (with mononucleosis). "This is getting to sound like a Yiddish play, but when you're near the situation it isn't too funny." On October 28 a surgeon removed Martha's reproductive organs and appendix. The next month, with her mother home from the hospital, Helen stayed with her at her uptown Fifth Avenue apartment for a few days until she could take no more. "Mother has one of the greatest wills for exploiting and taking advantage of those 'close' to her," she told Rudikoff. "It's exhausting and not fair, and while I'm willing to aid and comfort while she's sick, there's a point at which I must take hold." As it turned out, Martha Frankenthaler was suffering from the early stages of Parkinson's, though this was not clear at the time.

Helen retreated to her studio. She put her own experience first, silencing the distractions and staking all on the independence of art as a life-saving force. *The Sightseers* and *Ed Winston's Tropical Gardens*, both made as her mother continued feeling ill, are joyous and necessarily selfish acts of will and self-preservation. Her sisters would have to start reconciling themselves to Helen's absence from this or that crisis of the maternal bedside. For Helen perhaps there was a little guilt, or a lot, but each painting of 1951 savors as a simple statement, a fait accompli, a moment of self-invention—*This is who I am.*

Helen's relationship with Greenberg also began to change. He had been so attentive during the first three months. There he was,

having lunch with her on July 10, 1950, a few hours before taking the train that afternoon to Black Mountain College, in western North Carolina, where he went to teach for seven weeks. There he was at the end of August, fresh from Penn Station, having dinner with her again, hours after arriving back from North Carolina, a smitten lover none the worse for wear despite the twenty-eight-hour train trip. She had made the same trip to spend a week with him in the interim. In Manhattan the couple spent hours going to galleries, grading the works separately in their catalogues or announcements and then comparing notes. Across their different backgrounds, they found that they both loved to dance—Clem was very good at it, and so was Helen, who had learned as a little girl, like her sisters, at the Viola Wolff School for Ballroom Dancing not far from her Upper East Side childhood home. Their quiet time could be nice, too. At Greenberg's Bank Street apartment, Helen would cook dinner—shrimp creole was one of her recipes—and contentedly watch Clem writing at his desk. They could also be silly, emerging from the San Remo one night and posing for photographs taken by an Italian man with a box camera on a tripod and a pony. In one photograph Helen sits on the pony. In another she and Clem embrace in a "campy" hug.

But then there were the arguments and tears, the breakups and reconciliations, which started even before the end of 1950. "I'm just beginning to grasp the neurotic corners of Clem's personality," Helen wrote to Rudikoff on October 11, "which I might have recognized but not understood—as well—months ago." A man of many demons, Greenberg was often moody and angry. Rather than seek to understand and tame his monsters, he courted their favor, openly

enlisting his dark feelings to threaten and insult others as the situation demanded. It mattered a great deal to this brilliant man that no one cross him. Full of self-doubt and self-hatred—his diaries run amok in brutally honest instances of both—he would lash out at anyone, including Helen, who even momentarily made him feel less than superior. By December 1950, the month after Greenberg had published an essay "acknowledging the Jewish self-hatred in myself," Helen was going to her analyst every day for a month. The sources of conflict were numerous. One of Greenberg's former girlfriends—"a psychopathic liar," Helen said, "who accused me of all sorts of fantastic things"—persisted in calling him at 12:30 a.m. To make matters worse, Clem was still seeing this woman and shifting "in and out of strange moods." Helen's relationship was "complicated" and she found herself "vacillating," realizing too late "what a dreadful error it is to jump into anything prematurely." Soon after she first saw Pollock's paintings—when in genuine good faith Clem had opened this beautiful path for her—the couple was "breaking up, going back, fighting, loving, misunderstanding and understanding." Into 1951 they kept splitting and reuniting, with Helen feeling "unhappy, unsettled, and disturbed as hell." But she remained drawn to Clem, sticking to what she had told Rudikoff, that "despite his neurosis, he is a fine person."

Helen was witness to a gentler side of Greenberg that few others knew. In August 1951, on a vacation in Bennington, he arranged for them to meet with the fabled American illustrator Norman Rockwell, whose studio was just up the road in Arlington. Although Rockwell epitomized what Greenberg excoriated as "kitsch"—the ersatz of popular culture, the bad faith of art that did all the viewer's

thinking—he had a special reason to want to see and praise him. Rockwell had been his favorite painter when Greenberg was a boy, and he had never quite lost that admiration. Entering the studio, he and Helen saw on the easel a painting that would soon become one of Rockwell's most famous: *Saying Grace*, a picture of a grand-mother and little grandson humbly saying their prayers to the awe and amazement of two cigarette-smoking teenage punks who share the table with them in a crowded cafeteria in a dingy industrial town. The painting was slated for the cover of the Thanksgiving issue of the *Saturday Evening Post*, and since that was still several months away, the figures were all there that August day but the colors were not—it was all in gray tones. Greenberg and Helen en-thusiastically told Rockwell to keep it as it was. When the critic told Rockwell of his boyhood admiration, he occasioned a response of such humility that Greenberg never forgot its uniqueness in an art world driven by ego and power. I hope your taste has grown, Rock-well told him in all sincerity. The Greenberg of this visit was a man of disarming honesty and sensitivity.

But the tensions between the couple were growing, partly be-cause of Helen's autonomous energy and drive. The independence he encouraged her to pursue was becoming more and more a fact, putting him on edge as she began to assert it. It was true that he kept giving and she kept gratefully receiving. He had helped her "to develop a finer eye and detect the truth and magic in paintings," as Helen herself put it in a letter to Rudikoff in 1951. And he was teaching her how to be around artists, too—a lesson Helen very much needed to learn. At a dinner with him and Willem and Elaine de Kooning, the neophyte Helen wistfully complained that she

would rather be at her studio, implying with unconscious arrogance that she was more dedicated than anyone there. Advised Clem as they left the restaurant: "Don't say that again."

But in another sense, the doors that he opened inspired Helen's wish to explore life on her own. When he took her to cultured dinner parties where all the other guests were notable intellectuals Clem's age, she felt that it was "a grave mistake for me to be thrown into a world of feelings and experience which comes out of 20 years more living than I've had." There they were, the whole *Partisan Review* crowd, most of them Marxist Jewish thinkers shaped during the Depression: Philip Rahv, real name Fevel Greenberg, dapper and acerbic, a New Yorker by way of the Ukraine, Palestine, and Rhode Island, an aggressive, flamboyant, and dominating personality, yet also timorous and insecure beneath the bombast; William Phillips, whose family name was Litvinsky, who when it came to *Partisan Review* parties disputed Rahv's tendency to dismiss certain potential invitees as "nobodies"; Delmore Schwartz, frantic and manic, his voice stuttering, his limbs flailing, "probably the most tortured writer I have known," according to Phillips; Queens-born Lionel Trilling, the brilliant literary critic, courtly, gracious, the first Jew to get tenure in Columbia's English Department; Trilling's wife, Diana, constantly alert to the wrongdoing of other intellectuals, more so, it seemed, than to the beauty of creative art; the novelist Saul Bellow, proud and vain and vulnerable, ready with "quiet ferocity" to rebuke anyone who offered him even the mildest criticism. Then there was the novelist Mary McCarthy, Rahv's lover in the 1930s, who also "blew up when criticized the least bit" but who took genuine pleasure putting down friends and enemies alike, patiently

dismantling their work with "positive delight." In the 1940s, during her marriage to the novelist and critic Edmund Wilson, she had an affair with Greenberg.

At these dinner parties, Helen held her own. She listened as the writers talked of the anti-Stalinist Communist positions they had developed in the 1930s. She sensed or learned directly from Greenberg the back story of the group's debates, hostilities, and intrigues (perhaps including his affair with Mary McCarthy). And she shared the group's faith in complex art and literature as powerful forms of resistance to the dull rationalism of modern life. Throughout, she was not intimidated. Phillips thought her shy and "much less articulate" than the writers, but he liked her "sharp and cynical but good-natured wit, slightly Jewish in its irony and irreverence," and he praised her good looks and earthy charm. And even amid the heady conversations Helen was inwardly calculating her independence, realizing that "at every turn I'm being exposed to things through a short-cut" and that she needed to weigh experience on her own terms. Facing this nascent autonomy, this capacity to act and think for herself, Greenberg began to resent his young girlfriend's individuality of character, her difference from him, what he later called her "utter lack of delicacy." Privately, in his simmering way, he would find her "coarse."

Another factor was at work—one directly tied to Helen's growing artistic confidence and skill. Greenberg was not just a critic but a painter—and therefore Helen's rival. He liked to paint and draw landscapes *en plein air* and would spend summer hours away from New York patiently working on them. One of these, a Van Gogh–inspired picture of the dipping road leading down from the sculptor

David Smith's upstate New York studio and home at Bolton Land-ing, exemplifies his modest talent. There was no open hostility be-tween the two artists—they worked steadily side by side outdoors on the Bennington vacation in August 1951, assembling a sheaf of pictures that they joked would make a fine joint show. But it was becoming clear to both of them that Helen was far and away the better artist. As Helen's friend Barbara Rose put it, "Helen could paint the pictures that Clem couldn't. He would have wanted to paint the paintings she painted, but he couldn't. She was the artist he wanted to be."

This led to further reflections—hostile on Clem's part—concerning their respective upbringings. Greenberg, who came from a family of Polish Jews of Lithuanian descent, grew up in the Bronx in a household where his father and mother lit into him and his two brothers, Marty and Sol. The father, Joseph Greenberg—a shop-keeper, then a partner in a company that manufactured metal cas-ings for lipsticks, compacts, and cosmetic containers—regularly berated his sons for their ignorance. Not to be outdone, the boys' mother, Dora, used "morality and honesty as a club," Greenberg remembered, recalling also "her release of rage when finding some-body out in a lie or selfishness or pettiness." Young Clement liked to draw, but that was of no consequence. In his diary on May 16, 1951, Greenberg reflected bitterly on his childhood devotion to art and how his family had dismissed it: "Nothing preserved from my earlier years—not drawings, not paintings. Pa put no value on them."

Wealthy Alfred Frankenthaler, by contrast, doted on his youn-gest daughter so much that even her toilet training was a marvel. Long having outgrown the family's modest mercantile beginnings

44

in America, the Frankenthalers had ascended to the money, taste, and social prestige that Bronx-born Clement Greenberg craved. Although Helen's family was hardly without its own darkness and dysfunction, the love Alfred and Martha displayed for their three daughters created a calm and security that permitted rather than discouraged art.

On the August trip to Vermont, Helen found herself facing the unspoken element of artistic competition with Greenberg even as she also tried to manage another source of Greenberg's simmering feelings. Along for the trip was the critic's sixteen-year-old son, Danny, his child by a brief marriage back in 1935. Helen had met the boy the previous August in North Carolina, and she was not a fan, finding him "a real problem, neurotic, peevish, weighty." She later pointed to a small portrait of Danny she made that summer, saying that painting the picture was the only way she could make him sit still. On the Bennington vacation she cooked three meals a day for all three of them, standing to one side as Danny and Clem argued about the most trivial things, such as how much sausage the boy was allowed to eat (his father thought it contributed to Danny's acne). In such moments she found herself alternating between "sinking into deep but brief depressions" and simply trying to ignore the problems, the incompatibilities, not least the age difference and the instability of the artist-critic relationship. "All things take time," she wrote to Hartigan. They "work out eventually, somehow."

The day before the November opening at Tibor de Nagy, Helen and a few others hung the show. A photograph taken by Jerry

Cooke shows the young woman with one of her new art families. She talks with Myers, the gallery director; Greenberg stands beside her, next to thin Alfred Leslie, himself a Tibor de Nagy artist. *The Sightseers* leans on a wall behind them, near a small painting from summer 1950 called *Provincetown Bay*—which Greenberg loved and had asked Helen to give to him, which she gladly did. All eyes turn to Helen, her gesturing right arm a blur, her left arm cocked akimbo, her eyes looking down and across the way, evidently at a painting Myers points to at the base of an adjacent wall. Helen is not yet Hedda Sterne in a room full of men, far from it. But she is calling the shots, impressive for a person a month shy of her twenty-third birthday.

All the more so if we consider the feelings Helen suppressed to play her commanding part. Only a few days before, she had written to Rudikoff that her mother's health had taken a scary downturn and that there had been another breakup with Clem, developments that left her "very upset and unhappy" (though the couple had subsequently made up yet again). Even the ostensible escape—the role of serious artist—could seem overwhelming, as Hartigan noted in her journal on October 23: "I wonder if it has always been such agony to paint searchingly. Helen, Al, and I are all going through a crisis at the same time—Helen to such an extent that she wants to give up painting entirely." But Cooke's photograph portrays Helen summoning her strength, tamping the doubts. The young woman who had entered the Pollock exhibition almost one year before, staring at the huge paintings that practically vibrated on the walls, would now trust to her own pictures of life, even as she felt unsure

about continuing as a serious painter. For the moment, the glories and possibilities kept her on track.

She feared the opening, but Helen ended up enjoying the event. She felt like a celebrity at the gallery and back at her apartment, where sixty guests crammed into the small space and fifteen of them did not drunkenly depart until 5:00 a.m., Paul Feeley being among the last to leave, still with three hours to kill before the 8:10 bus back to Bennington. But being the star of your own opening was a temporary fix. Like Pollock, Helen was anxious for approval yet defiant about the opinion of others. There had to be another reason to keep going back to the studio.

It was a reason she found too personal to say out loud, at least back then. She sought to transform life, to bestow it with beauty and power and glory in such a way that the person looking at her art would sense that our experience of the world *is*, in fact, beautiful, powerful, glorious. Tibor de Nagy, who had lost his art collection in Budapest when his home was destroyed in World War Two, who lived out the remaining war years in Poland, and who, after the war, had been arrested by the Soviet secret police before immigrating to the United States in 1948, having seen, he later told Helen, "the worst of the human animal," might have been a good judge of Helen's affirmation of life. Imagine him looking at *The Sightseers* in 1951, seeing what he had seen. "A work is great when you are uplifted," Helen said, "when you gain a sense of order within the work and within yourself."

Soon she would make another such picture, her most challenging to date.

OCTOBER 26, 1952

New York: Desire Is the Theme of All Life

Helen came into the studio at two in the afternoon, moaning and groaning. She had just rented this working space on West Twenty-third Street, a few blocks down from her new London Terrace apartment where she now lived alone, she and Rodgers having decided to rent separate places. The studio was a quiet skylighted loft in the back of the building. From her old studio, the one she had rented from David Hare, she had carried the screens she helped make to cover Hare's work over to the new studio, where the screens now made a partition separating her work area from that of another painter. He was her new friend Friedel Dzubas, a thirty-seven-year-old German émigré whom she had met through Clem the previous year. Dzubas had the larger part of the space because he also lived there, his wife having kicked him out of their house. On her smaller side of the partition—she paid $25 in

monthly rent to Dzubas's $55—Helen began making a painting that afternoon as Pollock had done, with the canvas on the floor.

The canvas at her feet was unprimed. She had not bothered to apply the primer, a mix of Dutch Boy white lead paint and glue that like other artists she typically used as a ground to prevent the colors from bleeding directly into the porous canvas. Dzubas, recalling that day, said simply that Helen was "lazy." Helen somewhat agreed: "I might have been very impatient to paint, and a combination of impatience, laziness, and innovation decided why not put it on straight?" She thinned out her paints with turpentine, curious to see how they would soak and stain into the big empty canvas— seven by ten feet—beneath her.

Helen had first gotten the idea to paint this way the previous winter, back in late 1951, when she saw her second big show of Pollock's paintings at Betty Parsons. In those new pictures, on view simultaneously with her first exhibition at Tibor de Nagy, Pollock had applied black paint directly to the raw canvas, letting it soak in. Walking through the gallery back then, Helen was struck by how the bare canvas seemed to intensify the immediacy of the representations Pollock was now letting back into his pictures—eyes, faces, twisting Picasso-like bodies. She was drawn to the all-or-nothing spontaneity and fearless courtship of failure (with primer on, one could scrape off or paint over one's failures and start again, but a wrong or awkward pour on the canvas itself would ruin a picture). Her own wish to paint this way, she later said, "came from him no doubt."

So now on October 26, 1952, in the back of that building on West Twenty-third Street, Helen knelt before the big expanse of

canvas. Her first move was not to paint but to draw. She made a few charcoal lines clustering in the center of the big sheet. The lines suggested forms but only as an armature for what followed. Then she laid on the turpentine-thinned colors, blue and pink and salmon and red and sea-foam green, watching as they pooled and stained like her mother's nail polish had done in the bathroom sink many years earlier. On the big raw canvas the blue flared to the sides from a central fulcrum of pink and red, playing up and through and around the charcoal underdrawing, which it both respected and ignored. After three hours she stopped and called Dzubas over from his side of the loft so they could survey the painting.

Neither of them had seen anything like it before. The picture did not resemble Helen's paintings of the previous year. It did not look like Pollock's raw-canvas pictures either, since he almost exclusively used black paint. It showed the makings of order but stopped far short of what the world considered a "finished" painting. Angry detractors would say it looked like a rag for wiping brushes. There seemed to be no form, no order. But Helen felt each element was poised on a fragile edge of clarity, even of flaring neatness, like a wave risen to perfection at the moment before it spends its energy and falls apart. Moreover, she knew that the painting had been inside her for months—in her arms, she later said. She felt that on that October day it had emerged from the weeks of watercolors she had made that summer, when she and Greenberg had vacationed in Nova Scotia, home to the distinctive forms that now gave the painting its title, *Mountains and Sea*. Much to her satisfaction as she examined the picture, spontaneity and structure seemed to flow through each other without ever touching, as though

her long experience in studios in Bennington and New York had mixed with something buoyantly free and vulnerably honest.

She and Dzubas agreed that she should not make another mark on it. They could not quite say what the new painting was, however. "The point is, the point is," Dzubas said in his German accent, struggling to find the right words, "What do you make out of what you see? How can you accept, how can you accept, what you see?" Helen herself "was somewhat puzzled by it when I first saw it before me," she recalled, "but I also was aware I'd made something new and shouldn't fool with it one bit further." She signed the picture neatly in the lower right corner, dating it 10/26/52.

That month, Helen had again considered giving up being a full-time painter. The pressing demands of the everyday world—with its greater claims to importance and relevance—tempted even a driven person to abandon her passion. She was undertaking a half-serious job search, thinking she might like to work on a national magazine. Her sister Marjorie had worked as an assistant entertainment editor for *Life* right out of Vassar, and now Helen was thinking maybe she should find a similar position. "I've seen three people about a job on *Life* or *Time*," she wrote to Rudikoff on October 6, saying she would take a position at *Life* if offered one and relegate her painting to off hours. But she was not especially excited about it. The white-collar efficiency of the magazine was not to her liking. "The people that walk around the offices are almost frightening: brisk, alert, 'sophisticated,' Vassar and Yalish, thin, and groomed," she told Rudikoff. "Up and down the 36 floors of the

Time Inc. building they talk fast smart chatter. I don't know if I could stand it." The demanding work schedule also implied that she would be too exhausted to paint much. "Once you work for *Life* there's an unwritten contract for all your time and energy—in a way that doesn't apply to most routine hour jobs." Even so, Helen wondered if she should take one of these positions. The choice to share a studio with Dzubas was a part of her thinking. "This way, if and when I take a job, I won't feel that I have an independent operation to take care of besides an apt. and a job."

National events also made being an artist look less important just then. Helen painted *Mountains and Sea* nine days before the presidential election of 1952. Like Greenberg, she was a supporter of the Democratic candidate, Adlai Stevenson, in his campaign against the Republican Dwight Eisenhower. In early October, her preference known, she had been asked (she does not say by whom) to work on the Stevenson campaign's Professional and Business Women's Committee. Writing to Rudikoff on October 6, she told her much more politically minded friend, "I'm not sure I'll get into the whole thing," but she had strong feelings nonetheless, noting that Eisenhower's running mate, Richard Nixon, was "schmaltzy, low-class, and sickening."

After Eisenhower won the November 4 election in a near landslide, gaining 442 electoral votes to Stevenson's 89, Helen deplored how some liberals, including one of Clem's brothers, had voted for the Republican because they felt Stevenson was too soft on Communism. "I feel discouraged, to say the least," she wrote to Rudikoff, who was in England with her husband, who had taken a year-long position there. "Americans must be awfully frantic and

near-sighted to have voted this way." *Mountains and Sea*, its paint still wet, still felt serious but also incidental amid these momentous changes.

Events in the Frankenthaler family also exerted their pull. Both Helen's sisters were having babies in those weeks. Marge, six years older than Helen, had given birth to her second, Frederick, on September 7. Gloria, five years older, gave birth to her third, Clifford, on October 15. Helen was not envious. She pointed out to Rudikoff that Marge was too fat, that she was trying to lose weight, and that she felt the burden of managing a household that included a maid, nurse, and cleaning woman, not to mention her husband, Joe, who had fallen ill with a recurrence of a mysterious malaria-like sickness that in Helen's view required him to expend a lot of his weakened strength pretending that it did not worry him. Gloria, meanwhile, "is due to drop hers in a week or more," she wrote to Rudikoff in early October. "She looks well but annoys me terribly." Proudly apart from her sisters, not ready to start a married life, let alone one with children, Helen still felt beset by many pressures. When she saw Rudikoff and her husband off to England in late September, Helen burst into tears. "I felt that my own life had stopped as I stood on the deck and posed for the pictures and saw all the people going someplace."

Yet the despondency made her turn to her art with renewed focus. "Each crisis, if properly realized, can turn into production," she wrote on October 6. "I feel full of hope and resolution these days." *Mountains and Sea*, painted twenty days later, was a venture in speculative freedom, an independent journey of her own, away from known shores.

———

The painting recalled the freedom that Helen's sociology pro-
fessor Erich Fromm had espoused back at Bennington. "We
all know what a spontaneous act is and may have some vision of
what human life could be if these experiences were not such rare
and uncultivated occurrences," he had written. Fromm saw the
opposite of this freedom all around him in his adopted country.
Americans actually shrank from their liberty as from a terrifying
existential state. They filled their free time with drudge-like
activities—pointless drives on Sunday afternoons, heavy meals at
roadhouses, joyless trips to the movies—because they were un-
nerved by spontaneity, joy, and finally life itself. This was their
Escape from Freedom, the title of Fromm's 1941 book. *Mountains
and Sea* pursues the liberty Fromm envisioned. It suggests a search
for a freedom so pure that it scarcely knows its own destination but
trusts to the journey as a record, a monument, of unrestraint hap-
pening in real time. In a world of regimentation and planned plea-
sures, *Mountains and Sea* dares to show life in a startling present
tense—life on the wing.

There was a specifically inward feeling to this freedom, a recog-
nizably Jewish one as well. Greenberg, who loved the painting as
soon as he saw it and told Helen to keep making more like it, had
noted a few years earlier that the pursuit of *Innerlichkeit*, or inward-
ness, was "the real task for the individual Jew in the West." The Jew
needed to "emancipate himself from the world, to find [a] home in
his Innerlichkeit without display, without making his emotion ei-
ther a commodity or the motive of a Quixotic politics." It was a state

of being one could find among the *Partisan Review* writers—in, for instance, the voluble and clumsy Delmore Schwartz, who even in the midst of one of his rapid-fire, word-masticating diatribes had a way of "withdrawing into lonely thought," of conveying "the unmistakable look of the poet speaking from his own depths." In visual art, which by definition is meant for display, this *Innerlichkeit* was harder to find. Greenberg wrote in 1953 of the Russian Jewish modernist Marc Chagall, deploring his sentimental and pandering exploitation of Jewish folklore, his persona as the "lovable, fantastical Jewish genius from Vitebsk," his wish, seemingly, to be the O. Henry of the shtetl. As for "Quixotic politics," Greenberg detested the painterly forms of social-conscience art his fellow Jews in New York had been making for years—the war-torn playgrounds of Ben Shahn, the sinister atomic-age hieroglyphics of Adolph Gottlieb, the brooding and weary young women painted by brothers Raphael and Moses Soyer. *Mountains and Sea* was a liberation from all these false paths.

Remarkably, it did so without renouncing the extravagant personal revelation that was itself a hallmark of New York Jewish cultural life. In 1950, in an essay called "Plaint of a Gentile Intellectual," the writer Chandler Brossard noted that the gentile prefers "to withhold, to keep things to himself, not to make everything communal," but that among the Jewish writers, the "enjoyment of any experience, often one of extreme privacy, is talking about it, exploiting it verbally." *Mountains and Sea* is the painted equivalent of these intimate verbal disclosures. At seven by ten feet, it is a mixture of diary and declamation—disarmingly private shapes and stains on a canvas of the size previously reserved for grand public

statements, the coronation of kings, the storming of fortresses. It was as if one of the history painters of the nineteenth century had depicted, on a vast canvas, not the surrender of a city, not the decadence of the Romans, but a personal thought, a private emotion. What saved it, what made it an expression of *Innerlichkeit* and not a maudlin confession blasted from a loudspeaker, was that the language of the revelation was so delicate and untraceable that no one, not even the painter herself, could determine what it said.

Not that *Mountains and Sea* lacks recognizable subjects. Rocks, the ocean, what looks like a fish, compose an imagery that might have made it in other hands into a seaside mural. But the overwhelming effect of Helen's painting is of swaths of color dissolving as they come into being—of forms disdaining to become the hardened shapes of nameable things and remaining in a lyric world of daydream. Helen's question, pursued not as philosophy but as feeling, was how to be bare, how to be honest, how to be uninhibited, all in ways that announced an unknowable inwardness.

Precedents were there, to be sure. Wassily Kandinsky, the pioneer of early-twentieth-century European abstract painting who was one of Helen's art heroes, had praised a spiritualizing art that awakens "more subtle, undefined emotions," feelings that emerge from "complicated, subtle life." Extolling an art whose forms would be "as sensitive as a cloud of smoke," Kandinsky gave Helen her cue. His 1911 book, *On the Spiritual in Art*, appeared in an English translation published by the Guggenheim Foundation in 1946 that she likely read. Before radio station WNYC aired a prerecorded hour-long broadcast on October 27 called "16 Questions for the Avant-Garde Artist," she listened to her own interview and

laughed that "when I mention Kandinsky I sigh as if I were in bed with him."

But the Russian would hardly have recognized the artistic merit of the painting Helen made the day before her radio interview aired. Roughly twice as large as his abstractions, *Mountains and Sea* is also far more inchoate looking than Kandinsky's rigorously organized patterns of color and line. Helen had outpaced her sources, not only as a matter of basic competition (no serious painter would simply imitate an admired predecessor) but because something inside her demanded that she paint with this brazen yet gentle freedom, this sense of art as a *spilling out*, that more tightly controlled romantics such as Kandinsky would have seen as uncouth.

Resisting classification, *Mountains and Sea* is a study in lightness. Against the gravity of the era—heavy speeches, atomic threats, bitter political paranoia, not to mention the crushing weight of white-collar ambition and conformity—it is palpably a *lifting* painting. The shapes in it remain stable—a bouquet of pastel colors anchors it at the center, almost as if the picture were a massive floral still life—but they also rise and float. Too turpentine-soaked to be opaque, each color refuses to be dense. Lightness comes into being, so the painting implies, precisely in its precariousness. Lightness is fugitive—it is always falling away, as Helen's choice to suspend the whole floral array on the single blue line above a pink ball implies. Yet she holds this levity in place, catching it, not as the butterfly collector nets the specimen, the better to see it desiccate back in the collection, but miraculously to let the caught thing respire at the tip of her fingers.

Getting that lightness was no easy thing. As Helen painted the

picture, she sensed that the shapes had to gain strength and lyrical beauty from their own intrinsic pace and measure—from, too, their relation to the spreading ensemble of other designs emerging on the canvas. If this did not happen, the painting would lose touch with life and lightness simultaneously. It would become heavy, claggy, overworked. But if the flow of forms was there, if she could keep pace with the spilling appearance of the colored patterns, judging them in relation to those already visible, then the picture would lift into the ludic world of immediacy. It was at that point that Helen stepped back, asked Dzubas to come over to take a look, and knew that she should not touch it again. For it was just at that place of precarious balance, of lift, that another mark might begin to drag down. As she was to put it, "The light touch is often the strongest gesture of all."

Mountains and Sea would be the centerpiece of Helen's next show at Tibor de Nagy, set to open in late January 1953. She was close to the other artists who exhibited at the gallery—Hartigan, Leslie, and Harry Jackson among them. They banded together, these young painters in their twenties, most of them twenty years younger than the oldest New York avant-garde painters such as de Kooning and Mark Rothko and Barnett Newman, to form what is now called the "Second Generation" of abstract expressionist painters. They drank and doubted together. They also grew jealous of one another, succumbing to "pettinesses and bickerings," in Hartigan's words. Each became more lonely in their very comradeship. Into this milieu *Mountains and Sea* now entered.

The painting was a rival to a picture Hartigan had painted earlier in 1952 called *The Massacre*. The rivalry was not one of imitation—the pictures could not look more different from each other. *The Massacre* is a dense and energized mass of red, black, and grayish white, a thicket of bulbous and jostling forms emerging out of Pollock, de Kooning, and Picasso—whose own massacre painting, the huge *Guernica*, lurks as one of the sources that Hartigan transformed into her own vision. Helen took up the challenge of its epic size: not for nothing are the sizes of the two paintings nearly identical, *The Massacre* at 80 x 127 inches, *Mountains and Sea* at 86 x 117 inches. But in every other respect her painting is a riposte to her friend's. As she put it years later, back then "an artist could see another artist's work and say, 'I love what I just saw in your studio. You know it and I know it. I'm going back to mine now and I'm going to knock your eyes out.'"

The competition also had something to do with the artists' different economic backgrounds—and how those economics affected their self-conception as artists. Hartigan worked on *The Massacre* one winter in her cheap cold-water studio, returning to the easel again and again in coffee-driven cycles of despair and pride. No wonder the painting has the quality of being hard-won, of being an achievement—order wrested from chaos, in the manner of Michelangelo's *Dying Slave* and *Rebellious Slave*. Hartigan's forms, like Michelangelo's, writhe as if in combat with a brute material's continual wish to assert its inertness, its heavy dead stupidity and ineloquence. Hartigan's sentiment of 1951—"I wonder if it has always been such agony to paint searchingly"—fits *The Massacre* well.

Mountains and Sea disdains this fury. It is all apparent ease

and nonchalance. There is no turbulence, none of the struggle that other Tibor de Nagy painters equated with authenticity. "I'm not saying your days are not torturous. Or that doubt is never at you," Rivers wrote to Helen in February after seeing the show, conveying his honest criticism as a friend. "But all of that has no way of finding its way onto your canvas when you decided to paint." For him, this was a problem—"with no immediate demands you become a confusion of ideas"—but Helen saw it very differently. "I don't think struggle as you use the word, is part of the formula for good or strong painting," she responded in a letter she possibly never sent. "I think you feel that just because a painter . . . goes at and finishes a painting in say two hours, never erasing or smearing out or going over what he puts down,—that something is lacking." For Helen a "whisper" of a brushstroke could be more powerful than dense whorls of paint. Subtlety could be genuine; anguish was a cliché. But Rivers was not the only one of the Tibor de Nagy painters to find fault with Helen's lack of struggle. Hartigan took a dim view of the show, noting in her diary: "Helen's new work is terribly depressing, detached and uninvolved, the last gasps of Newman-Pollock-Kandinsky thing. . . . I believe her to be talented, but this show makes me wonder." She thought Helen's paintings looked like they were painted "between cocktails and dinner," as she put it many years later, a jibe alluding not only to Helen's apparently effortless art but to her wealthy upbringing. Although Hartigan apologized to Helen when the remark appeared in print—this was in 1975—the comment sounds similar to what she had written privately about her friend's work back in 1953.

Greenberg was a major factor in the tension between the two

artists. The critic had come to Hartigan's studio in mid-March 1952 to help her select pictures for the Tibor de Nagy show later that month, as was his wont and per the growing custom among ambitious painters in New York. His brusque candor and cussedness notwithstanding, Greenberg had picked out Pollock and named him as a great painter, which he was. There was no disputing he had an eye, probably the greatest in New York, and that next to his acid and eloquent reviews, the words of many other critics seemed like subjective mishmash. But his opinion was a storm to be braved, and on this occasion he made Hartigan fret that he seemed to value the painting of Dzubas, whom she regarded as a lightweight, much more than her work (though he liked *The Massacre*). Soon she would vow not to rely on his opinion any longer, a fateful and upsetting move, not least because it meant frosting her relationship with Helen—the two would soon be keeping their distance for several years.

But Greenberg saved the worst for the opening of Hartigan's show. There he loudly pronounced that another of the Tibor de Nagy painters, Hartigan's ex-husband Harry Jackson, a traumatized World War Two veteran who had been wounded at Tarawa and Saipan, was the greatest American artist since Pollock. A talented artist, Jackson was also unpredictably mean and fervently sentimental, a "mess," according to Hartigan, who scorned his "pseudo-masculinity, pseudo-directness, pseudo-seriousness," the "phoniness that he wears like a cloud around him." There was indeed a falsity about Jackson: despite his cowboy mannerisms and phrases, he was a working-class kid from Chicago's South Side whose real name was Harry Shapiro. Greenberg loved him almost

for this reason, confiding to his journal how pleased he was to see Jackson painting in "such a forthright & therefore un-Jewish way"—in big bold slashing strokes of color and swelling forms, as in the painting *Condor*. Here was art that avoided what Greenberg privately abhorred in a dark journal passage: the "awful, awful Jewish intellectuality" he saw all around him, "all brightness, all cleverness, energy expended in [a] vacuum, for the celebration & enhancement of the zero at the center of oneself." Even as Greenberg praised Jackson for his gentile cowboy persona, however, he too wondered at the phoniness that made the man's painterly freedom possible, his "change of name, change of voice, cadence, pronunciation, gestures, manner," the ways that Jackson "worked so hard at not being a Jew." Granted, there were other Jews around like him—Brossard, writing his piece in the leftist Jewish journal *Commentary*, noted an unnamed Jewish writer of his acquaintance who looked like an "avuncular academician from Minsk" but wrote like Ring Lardner. But Harry Jackson was a special case. Like Greenberg, Helen thought he was a fine painter, but in a photograph of her and Jackson standing side by side with Greenberg in front of one of his large paintings at his first Tibor de Nagy show in 1952, she looks impatient, her arms folded, anything but pleased. Meanwhile Greenberg smiles. His grandiose praise of Jackson sent shivers of uneasiness among the gallery's young painters, not least Jackson himself, whom Hartigan pronounced "the most cowardly of us all."

This is the community in which Helen found herself. It was not all bad. The fact that no one was selling anything helped create a "dialogue and healthy competition," she recalled, a "relatively

trusting and beautiful period" among them all. But the lack of sales also promoted jealousies. Without the rewards of lucre to create the most immediate animosity, the artists were left to stew upon their actual talent and drive, their inspiration and gift, as God and Greenberg had anointed them. The result was a grinding war of attrition in which stances shifted and no one knew where they stood. "Your best friend would put a knife between your shoulder blades," Hartigan recalled, "but we needed each other."

S tarting around New Year's 1953, Helen became depressed. She was paying sick calls to her mother, who was increasingly ill. An old friend of her father's, the restaurateur Dinty Moore, had died on Christmas Day—bringing up memories, now of a freshened sadness, of all the times that Alfred Frankenthaler had taken the family to the restaurant on West Forty-sixth Street. In early February, the reception of her just-opened show added to Helen's blues. Over at Tibor de Nagy, her pictures were for sale and no one was buying them—not a surprise but still painful. A *New York Times* critic gave faint praise to her heart-and-soul efforts, including her favorite, the vast *Mountains and Sea*. The works were "fresh, pale, and pleasant," "sweet and unambitious." Helen had created a "confection of agreeable harmonies," but—like an erratic interior decorator—she refused "to push things to sensible conclusions." Sinking into a lethargy, Helen found herself thinking that in her whole life "nothing mattered very much." Even her psychoanalytic sessions, on which she usually placed great store, struck her as boring. She was "not taking myself or life or plans too seriously—not

caring enough," she wrote to Rudikoff. She found herself taking afternoon naps: "The sleep is wonderful but the habit bothers me."

Helen was depressed because she felt her life was at a standstill. Back in September, just before she sailed for Europe, Rudikoff had spoken to her friend about "forcing oneself to take action." Helen needed to make choices about her career, about her up-and-down relationship with Greenberg. Now, four months later, she ruefully confided to Rudikoff that she still had not acted on anything. She was "powerless" and despised it, consuming her thoughts with "a terrible sense of wasting time." She was "in a curiously child-like state," a way of being that the outside world, fooled by her "constant adult poise," would never guess. "I am closer now to making some profound decisions than I have ever been. But make them! It's become a matter of sinking and swimming, and my depression has to do with the sinking feeling."

The depression was more than situational, however. It owed to Helen's very nature, to some primal sadness bound up in her. "Helen really battled depression," says her nephew Clifford Ross, the youngest son of Helen's sister Gloria (and the one born eleven days before she painted *Mountains and Sea*). Ross mentions William Styron's depression memoir, *Darkness Visible*, published in 1990, as the book that most comes to mind when he recalls his aunt. Yes, Helen could be joyous and fun loving, like the time in the 1970s when she and Ross went to a Baskin-Robbins in Stamford, Connecticut, where Helen then lived, and she ordered all thirty-one flavors for them to taste. And there were the times in the 1980s and '90s when they would go dancing at the Rainbow Room in New York City, on the sixty-fifth floor of Rockefeller Plaza, each with a

partner, and "there was no darkness; it was just fluidity, it was heaven. She could be ebullient, without referencing the darkness; but when she was in the darkness, there was no light."

This darkness was inseparable from Helen's choice to be an artist. Back in 1950, Helen's then roommate Gaby Rodgers had put it well. From Abingdon, Virginia, where she was embarked on a grueling apprenticeship to become an actress, Rodgers wrote to "Frankie," then in Provincetown, about their mutual blues: "I guess both of us have keen alert minds that will never make us terribly happy in the usual sense . . . that is, calmly so." She closed the thought more hopefully: "But at least we're living and we are productive and we have a future . . . I tell myself." Myers, the director at Tibor de Nagy, recalled a conversation with Helen in the early 1950s over a beer in Greenwich Village. They talked of "the subjective difficulties that faced many artists, in particular the nuisance of melancholia." Helen told him she had a strong premonition that she would not live past thirty-five. She already had "a sad view of life," said Myers, noting also her wicked sense of humor, a saving grace he felt many depressive artists shared. One evening in February 1953, hibernating in her London Terrace apartment, Helen re-read Henry James's *Daisy Miller*, the tale of a pretty young woman who dies young. She found it "such a beautiful and moving story."

A film Helen saw in early February was a fable of her artist's malaise. The movie was *Limelight*, Charlie Chaplin's latest, which she likely saw at her neighborhood movie palace, the RKO 23rd Street Theatre on the northwest corner of Eighth Avenue. Thirty blocks away *Mountains and Sea* hung with its sister paintings at Tibor de Nagy, but here in a completely different world, a vast

movie theater seating 1,900 patrons, Helen found a sentimental echo of her depressive doubts and fears. She called Chaplin's film "schmaltzy, pathetic, revealing (tho' certainly touching in spots)." And she singled out for praise the performance of Claire Bloom, a beautiful twenty-one-year-old English actress, then virtually unknown.

It is not hard to see why Helen liked Bloom. The beautiful young woman with long dark hair was a kind of alter ego. In the movie she plays Thereza, a ballerina so talented that she could rise to the top of her profession if only she could overcome her neurotic guilt and sadness. As the film opens, Thereza lies unconscious in bed, dying by suicide after having left the gas on in her apartment. Rescued by her upstairs neighbor—Calvero, an aging ex-clown, played by Chaplin—Thereza recovers but only to lie again in bed, torpid, speaking despondently of "the utter futility of everything." Barely able to lift a finger, she tells Calvero, "I see it in flowers, hear it in music, all life aimless, without meaning." Ashamed of her talent, in guilt-ridden combat against her own gift, the bedridden Thereza is literally paralyzed, having convinced herself that she has lost the use of her legs until Calvero helps her overcome the psychosomatic affliction. Even once she becomes famous on stage, she frets morbidly—unable to escape her fated sadness and hysteria.

The maxims of the glowing screen were too pat, but it was possible for the fantasy to be terribly persuasive, a chamber of death and dreams, bereavement and ecstasy, lucidities and glories mixed with despair. Says the fatherly Calvero to Thereza early in the film, coaxing her out of bed in words Helen might have recognized: "Desire is the theme of all life." This is what eventually brought Helen

out of her lethargy, too. It always would, in her ongoing combats with despair. There was some joyous force in her, perhaps nearly synonymous with her gift, that compelled her to the studio and out into the world at large. *Mountains and Sea* is a paean to that genuine feeling.

It would always be that way. John Blee, who as a young abstract painter met Helen in 1969 and became friends with her for nearly a decade, wrote her a postcard on the twentieth "birthday" of the painting in 1972, occasioning Helen's appreciative reply. Still marveling at *Mountains and Sea* many years later, Blee says that the painting is about Helen overcoming her native sadness, the grief and insecurity of her girlhood that never truly left her, about her capacity to lift into some clear and laughing air. The spontaneity of that joyous freedom was her greatest gift, he says, calling it a power to "*defeat the darkness*" in her work. "It's what she called 'beauty.' But it was something even more."

Now *Mountains and Sea* hangs in the National Gallery of Art. But even there the painting is so delicate and free that it resists its very enshrinement. Deceptively casual, it wants nothing of fixities and labels. The forms dance as if forever suspended in some pause of time. And back of that pause is some nameless feeling of the artist's own, her drive to cede darkness to day.

4

JULY 27, 1953

Madrid: The Draw of the Past

Helen sat on the steps of the Prado, smoking a cigarette in the blazing heat of midafternoon while the museum was closed for siesta. By then she had been in the darkened galleries for five hours, having arrived when the doors opened at nine, and she would go back in when the doors reopened and stay until closing time at seven thirty. This was Helen's routine every day during her time in Madrid, part of a two-month tour she took alone that summer through Spain and southern France.

That spring, Helen had been thinking of escaping Manhattan for part of the summer. The city was too grimy and noisy. Her analyst was taking the month of July off. Her sister Gloria was in Europe with her husband, ticking off boxes on the list of popular sites—"everything was wonderful, beautiful, divine, delicious"— and the banality of her sibling's tourism was an inspiration: Helen knew she would never waste a European trip like that. Meanwhile

her mother's condition was worsening—"She is really a very sick, helpless, hopeless woman in so many ways, and the whole situation is depressing and difficult to manage"—and the relationship with Greenberg was never easy. On July 8, she was one of a thousand passengers on board the S.S. *Constitution*, an air-conditioned luxury ocean liner more than two football fields long, departing New York for the six-day voyage to Gibraltar.

Spain was both a sensible and a daring place for her to visit in 1953. Dictator Francisco Franco, in power since 1939, had recently started promoting American tourism to his country. Recognizing the economic benefit of American travelers and wishing to encourage political relations between the two countries, Franco and his ministers began advertising and diplomatic campaigns to counter the idea that authoritarian Spain was an unfriendly place for Americans to vacation. Franco saw an opportunity to ally his country with America's fervent anti-Communism, the two nations' mutual hatred of the Soviet Union forging a truce between dictator and democracy. In 1951 Franco changed the rule whereby Americans required a visa to enter Spain, and the following year the country established a tourist bureau on Fifth Avenue in New York. Helen booked her trip soon after.

Helen was not a political person, not in the way that many of her friends and acquaintances were. To Rudikoff she noted Madrid's "unreal, showplace character, which is very different from true conditions in Spain," but she did not specify these true conditions, leaving it to her correspondent to imagine the details of not just Madrid, but Málaga, Granada, and Seville, the first stops on her tour. Her very politically minded friend soon wrote, asking for

specifics: "What sense do you have, if any, of the political life in Spain? How much do you notice the gov't, etc.?" But Helen never did write that account.

She had more important things on her mind. Politics was never her passion, whether in Franco's Spain or back home in New York. That winter, praising *Limelight*, Helen had not mentioned that the American Legion was boycotting Chaplin and his film, which soon would be banned from some theaters because of the actor's ties to Communism. Even the headlines she took note of, such as the espionage trial of Julius and Ethel Rosenberg and their execution in June 1953, did not really absorb her. Try as she might, she could not be as interested as Rudikoff in what the death of Joseph Stalin in March 1953 portended for global politics. In Fascist Spain that summer she was unlike leftist American visitors, such as the novelist Saul Bellow, whom she had met through Greenberg. "The police come first to your notice in Spain, taking precedence over the people, the streets, and the landscape," Bellow wrote in 1948. He noted the rifle slung over the back of each gray-uniformed lawman, the tommy gun that each Guardia Civil soldier carried in the crook of his arm, the peddlers moving among the restaurant tables of central Madrid, selling counterfeit Lucky Strike cigarettes packed with dung and crumbled straw. Far from Bellow's tone poem of the uneasy alliance between American capitalism and Spanish dictatorship, Helen went overseas in 1953 for a completely different reason. She was there to look at art.

This was no escape from reality; it was her reality. She would look at paintings with as much attention as Bellow did at the world outside. Her visits to the Prado were a pilgrimage to stand before

actual works, to bask in their aura. She did not care for a "museum without walls," a phrase coined by French writer André Malraux in his book *The Voices of Silence*, published later in 1953, which extolled the fact that "an art student can examine color reproductions of most of the world's great paintings" without ever leaving home. Helen was no longer an art student. Her Bennington days critiquing postcards on bulletin boards were over. She was a real painter now, with far more blood and toil and ego invested in the pursuit. She would look at the Old Masters to double down on her own art, to draw direct inspiration from the greatest artists who ever lived, to fashion an imaginary alliance with these men from the past who would inspire—by some internal standard of her own—the measure and seriousness of her art.

Her days inside the museum might still seem odd. What could a young abstract painter wish to find in the varnished pomp of centuries-old paintings hung one after another in gloomy marble halls? The very term "Old Masters" conjures dusty paintings in heavy ornate frames. It invites us to imagine beclouded figures acting obscure allegorical dramas; somber bishops leading processionals of a purpose now lost; martyrs laying their heads down on chopping blocks or subjected to gruesome instruments that whir their intestines right out of their bodies. What does this have to do with the painter of *Mountains and Sea*?

But Helen loved these old paintings. Back in New York she enjoyed going to the Old Master gallery run by Saemy Rosenberg, the father of her friend and former roommate Gaby Rodgers (who had

changed her last name as she pursued her acting career). The fancy gallery's contrast with the simple white walls at Tibor de Nagy, or the residual smell of hay at the avant-garde Stable Gallery, so named because it had once been a horse stable, was striking. At Rosenberg & Stiebel, on East Fifty-seventh Street, you had to ring a bell to get in the office. Servants attended, and wine-velvet drapes parted to expose the paintings. But Helen loved the atmosphere and the experience viewing the gorgeous old paintings, like the two Tiepolos and a Rembrandt, "really fine examples," she had seen earlier in 1953.

The Prado then and now is a remarkable place for such reveries. Built on the private collections of Spanish monarchs such as Philip II and Charles IV, the museum holds room after room of glorious paintings, including Diego Velázquez's famous *Las Meninas*, of 1656, with its extraordinary illusion of a court entourage, including the painter himself, gradually becoming aware of the presence of the king and queen. This painting and others by Velázquez there, such as the one of tapestry making known as *The Spinners*, are almost uncanny, as if they were not painted at all but simply *were* life. "It seems as if the hand doesn't take part in the execution," a stunned eighteenth-century painter commented on *The Spinners*. "It is painted only with the will." Velázquez made his paintings, this awestruck admirer concluded, "with disdainful ease."

There were others, each its own glory: Francisco de Zurbarán's life-sized St. Peter Nolasco confronting the blazing apparition of his namesake, St. Peter, crucified upside down in an inferno of pillowy clouds; Jusepe de Ribera's huge *Martyrdom of Philip the Apostle*, with naked Philip hoisted onto a ship's mast, his sagging muscular

body crisp and sharp against impartial blue skies. There were rooms full of El Greco, the Greek-born painter of wriggling saints' ecstasies, all hands thrown to heaven, twisting pelvises, and pregnant clouds, who never knew a contour he could not shake in seismic vibrations. There was picture after picture by the sixteenth-century Venetian trio—Titian, with his long-limbed Jesus gently lowered into the tomb, the skies singing in electric distress; Veronese, with his Adonis slumped in courtly red upon the stout thigh of Venus; Tintoretto, with his enormous painting of Christ washing the feet of the apostles, the whole space extending in a perspectival grid so elaborate that rationality itself seems warped.

It all required a deep breath, taking in paintings of this kind, none more so than those of Peter Paul Rubens, an artist Helen loved whose work anticipates her own protean creative energy. Master of bombast and vulgarity, Rubens was probably the *wettest* painter who ever lived, the artist who most reveled in oil paint's shimmer and viscosity, the one who put a person in mind not of a palette but of a bubbling cauldron as the source into which he dipped his brush. In picture after picture he set about his subjects—martyrs, mythologies, coronations—with a zeal that portrayed skin, water, sky, robes, fishes' gills, decapitated heads, marble statues of maenads squirting fountain water from their breasts, muscles flexing on broad backs, the foliage of trees, *anything at all*, as if these lustrous facsimiles were nothing more than the products of a regular day at work, just another morning in the studio. Helen thought Rubens was "the greatest painter of all."

Two years before her trip to Spain, she explained to Rudikoff the *charge* she got from looking at such paintings. The word was

notably anti-intellectual; the more bookish Rudikoff did not like it. "Do you really get a 'charge' out of a painting?" she wrote back. Helen's response was, "Of course I do! I believe that's the only way to really look at a painting." Sure, works of art offered more: "I do think that the first second of seeing a great painting is only a charge; and then you can look at the whys of it; its history or tradition, technique, etc." But for Helen that first moment was paramount; a picture succeeded or failed exactly then, not by some academic scrutiny that came afterward. She was adamant that "no painting is good 'intellectually.'" And she credited one person with helping her make that realization. Paul Feeley had taught her how to paint, Meyer Schapiro had taught her what paintings mean, but Greenberg had "really helped me to see or feel paintings; to develop a finer eye and detect the truth and magic in paintings." She had gone with him to Philadelphia in late March 1952 to see a touring show of Old Master paintings from Vienna and had come away with a "thrilling feeling." Now, at the Prado, without Clem, Helen was finding this magic for herself, and she was thinking that she, too, must make knock-out paintings—works that would stun the viewer with an unforgettable first impression, a sensation that endured, a "charge."

At stake was the greatest thing a painter could do—convey the sense of being alive at a certain time, just as the Old Masters had done in their eras. In New York Helen looked around and felt that few painters were doing that. "I feel that contemporary painting simply isn't great painting," she lamented in 1951. The art crowding the walls of modern art galleries "isn't good enough for us, now." It missed the feeling of life that Helen found at Ed Winston's Tropical

Bar and other such places: the texture of experience, the life on the street, the elusive and intoxicating sensations that Ralph Waldo Emerson back in the nineteenth century had extolled as the greatest subject for American poets and painters: "the meal in the firkin; the milk in the pan; the ballad in the street; the news of the boat; the glance of the eye; the form and gait of the body." The Old Masters had found these sensations in their respective eras, portraying biblical and mythological events with a lustrous presentism: a peasant couple in their coarse rags welcoming disguised Jupiter and Mercury to their hut; callous soldiers in their leather jerkins and silvery black armor, rolling dice and swilling ale, one of them fitting Jesus with his crown of thorns. As she thought of painting in her own time in comparison, Helen went into a "real depression." She had gone first to a contemporary art show at the Kootz Gallery in New York, then to a masterpieces show at a Manhattan Old Master gallery, then back to Kootz, where the new paintings that had looked fresh and exciting before now looked meager, unimportant, trivial. She made an analogy: "Shakespeare is greater than most (all) things going on now poetry-wise, but this is not his era."

Who would be the Shakespeare of the 1950s? Who would be the Rubens? Pollock was on their level. So was Arshile Gorky, the morose Armenian hedonist whose surrealist-inspired paintings of lush Venus flytrap pleasure gardens, aglow in spike edges and orifices, had grown in fame since his suicide in 1948 at the age of forty-four. But Helen felt that they were "the only ones of a particular school that give me a real charge that might compare— somewhat—to the excitement I get from seeing a really great Old Master."

The old-time painters, to be fair, had it so much easier. They proceeded from recognized standards of representation and a certain de facto claim to cultural relevance. Their subjects came to them abundant and preordained: saints spitted on barbecues, mercenary generals astride their chargers, queens in their diadems. There were looming palaces and halls with walls ready to fill, commissions for the best artists to undertake. But by the early 1950s—when representational art had become the stuff mostly of magazines and posters, with artists such as Rockwell skillfully adapting the formulae of the Old Masters to commercial usage—the modernist painter faced a daunting task. The "inner need" from which the best abstract pictures came—to use the phrase of Helen's early twentieth-century hero Wassily Kandinsky—was indistinguishable for many viewers from whimsy, caprice, and, worse, a lack of talent.

Jane Freilicher, one of Helen's fellow Tibor de Nagy painters, put it well: "The artist is a free agent, but without any fixed position." Titian and Velázquez had painted for kings, but Helen and Freilicher painted for no one exactly, and not for any explicable purpose beyond their inner compulsion to do so. In an era when painting had lost its cultural prestige—its sense of being an inevitable force in the world—all that was left was the artist alone before her picture. The freedom of the experience could be joyous but also terrifying. "Because I create the painting as I go along without having any preconception," said Freilicher, describing a way of working that was Helen's as well, "at each moment it's like a decision, and it's sort of exhausting, because you're really going on nerve . . . you have nothing to guide you." Freilicher was a representational painter (of a Matisse-like kind), and Helen took a dim view of her art. But

like Helen she worked on instinct and savvy, always near the edge of failure, and without a sure sense that anyone beyond a few friends would care.

The previous December, the critic Harold Rosenberg had published an essay called "The American Action Painters" that described this feeling of painting without a safety net. For Rosenberg, it was useless pretending to any relation between Rembrandt (for example) and an artist of the present. The present-day painter must make a work out of nothing but their own existence at the moment they paint it. The picture would be an existential record of the painter's actions. The canvas was "an arena in which to act," the picture "an event," and it was "pointless to argue that Rembrandt or Michelangelo worked in the same way." Helen knew and liked the garrulous and bearlike Rosenberg, Greenberg's contemporary and rival critic in New York art circles, but she did not believe she was an "action painter." She did not think her paintings came out of nowhere, or that she was an existential hero making pictures that recorded nothing but her subjective experience at the moment she painted them. If that were the case, there was no difference between making a painting and chewing gum, between finding a color or a form and driving a car or walking down the street. Plainly for her—echoing Greenberg—art required a careful technique and self-awareness to go along with the spontaneity. She felt her individual talent *did* relate to tradition. But what did that relation look like in her art?

The question was urgent in 1953 because her acquaintances were wondering the same thing about their work. In spring that year Hartigan was busy studying Old Master paintings at

Helen (*right*) with her
friend Gaby Rodgers at an
artists' costume ball at the
Hotel Astor, May 19, 1950.
The life of the party, both
fresh out of college, they
both were dead serious
about making their mark,
Gaby as an actress,
Helen as a painter.

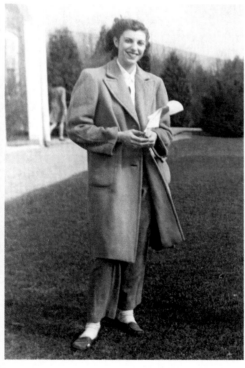

Helen at Bennington, ca. 1948.
Her studies—in literature,
philosophy, and sociology as
well as art—taught her about
the ethical power of freedom,
of knowing, in the words of
one of her professors, "what a
spontaneous act is," of what
"human life could be if these
experiences were not such rare
and uncultivated occurrences."

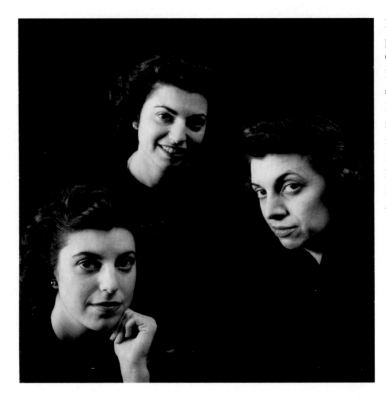

Helen (*lower left*) poses with older sisters Gloria (*top*) and Marjorie (*right*) in a studio portrait, ca. 1950. Both her sisters were married and had started families at that point. Helen was already beginning on the independent path of the artist.

Helen and her mother, Martha Frankenthaler, with a "bon voyage" cake prior to Helen's trip to Europe, summer 1948, just before her senior year at Bennington. Tall, beautiful, and impetuous, Martha commanded Helen's attention.

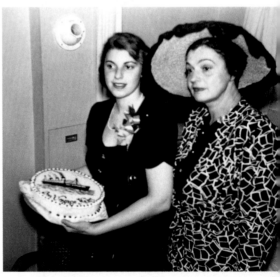

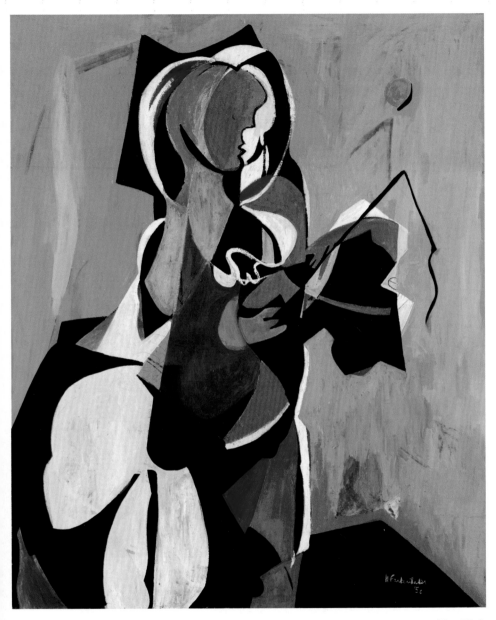

Woman on a Horse (1950). Helen made this painting in New York
the year after she graduated from Bennington. The critic Clement Greenberg
saw it the night he met her. He said he didn't like it.

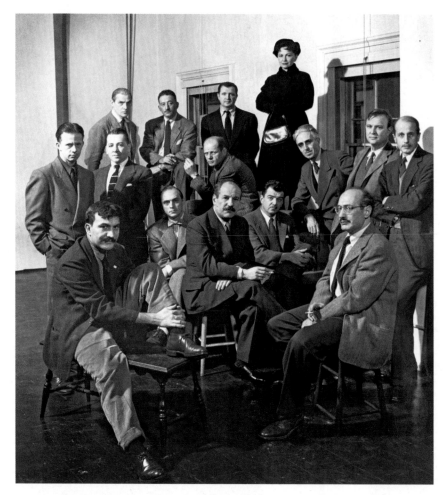

The Irascibles, Nina Leen's photograph that helped make the Abstract Expressionist painters famous when it appeared in *Life* magazine in early 1951. In a nearly all-male art world (the European émigré Hedda Sterne stands out as the one woman in the photograph), the youthful Helen believed she could compete, and she did.

The painter Harry Jackson (*right*) at an opening of his show at Tibor de Nagy Gallery in 1953, together with Helen and Greenberg. A traumatized veteran of Tarawa and Saipan, Jackson drew Greenberg's praise as a promising artist for works such as *The Condor*, at left.

Helen at a table at Eddie Condon's nightclub in 1951, together with Lee Krasner (*left*), Greenberg, and Jackson Pollock (*right*). Pollock's drip paintings, which Helen first saw in 1950, opened the way for her own art. She was "so moved and overcome by Jackson's work and genius."

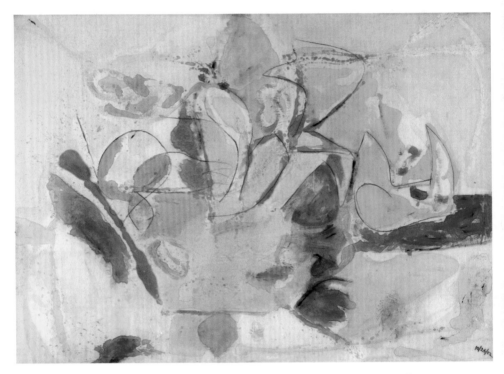

Mountains and Sea (1952). A venture in speculative freedom, quickly and daringly executed, the painting struck critics and even sympathetic artists as lacking gravity, seriousness, finish. But for Helen the light touch was "often the strongest gesture of all."

Mrs. Gertrude Eastman Cuevas (Judith Anderson, *top*) and her daughter Molly (Elizabeth Ross) in Jane Bowles's *In the Summer House*. Helen saw the play in early 1954, calling it "the best bit of contemporary play-writing I've come across in years."

Charlie Chaplin and Claire Bloom in *Limelight* (1952). When Helen saw Chaplin's film, she admired the beautiful twenty-one-year-old Bloom, whose character, the brilliant ballerina Thereza, must overcome neurotic guilt and sadness to succeed.

David Smith's *Australia*, installed at Bolton Landing, New York, ca. 1950s. Helen regarded Smith as a great friend, a fellow romantic, and the most serious of artists. Like her paintings, his welded sculptures could be free, lyrical, and ferocious.

the Metropolitan, imagining her own abstract equivalents for seventeenth-century works such as Rubens's massive and typically outrageous *Wolf and Fox Hunt*, with its slavering furry animal biting the spear that stabbed it, such that the reflections of its bloody tongue show resplendent on the silver spade. "I have an idea I want to contrast some tense, knotty areas against some broad, open ones—this is the answer for 'detail' in the old masters," Hartigan wrote in her journal. Looking at the Rubens hunt scene, she was asking herself how to translate the savage wolves and blaring huntsmen into an expression of her feelings. "The thing for me now is to know from the start of a painting what each thing 'is'—i.e. a wolf, hunter, horse, dog, etc." Then she could begin to render those motifs abstractly and dig into her own emotions: "From there I can go deeper and deeper into myself."

By 1954, Hartigan would abandon these subtleties and begin making open homages to the art of the past, notably *Grand Street Brides*, a large painting of gown-bedecked mannequins inspired equally by Lower East Side bridal shop displays and reproductions of *Las Meninas*. In one swoop, she had linked herself to Velázquez and the wedding industry of post–World War Two America. Meanwhile Helen's friend Larry Rivers had abandoned his allegiance to abstraction and painted a campy version of Emanuele Leutze's *Washington Crossing the Delaware*, the famous nineteenth-century painting ensconced at the Metropolitan Museum of Art.

But Helen scorned such open imitations, deriding Hartigan, Rivers, and others as "subject-matter avant-gardists." Writing in spring 1953, she was unmistakable in her contempt. "Painters like [Robert] De Niro, Rivers, Hartigan, Freilicher" were making

representational paintings "and feeling that it's all new and good just because it's been churned out of 'abstract expressionism.'" Their works "really amount to very little, either in terms of the past or the future, and usually are not even beautiful statements in themselves." She wondered what it all meant: "Is it that more abstract painting is impossible, that it's all been said or done, or that the next step would only end 'painting' and turn it into decorated walls?" She felt let down by her peers.

Her alternative looked radically different. In *Open Wall*, a painting of that year, there is assuredly no direct correspondence with any Old Master. At more than ten feet across, painted on the floor, with raw blue, salmon, and ocher saturating the bare canvas, *Open Wall* is utterly remote from the paintings at the Prado. Comparing it to, say, Tintoretto's vast *Christ Washing the Feet of the Disciples*, one of the pictures that Helen may have seen there, we can only recur to Greenberg's common-sense distinction between the old and the new art: paintings such as Tintoretto's show "a world whose depth, resonance, and plenitude are the product of illusion," whereas a modernist work "thrusts a sheet of pigment at you with an immediate force proper only to the realm of material sensations." But those sensations had a way of being more than arbitrary—of being, indeed, a record of Helen's experience, much as Joyce's *Ulysses* had been the raw document of a day. Just as Joyce had been—in Greenberg's estimation—"interested in the texture, feel, of experience, not in its content or meaning," Helen pursued an art of immediate impressions. And like Joyce she drew on precedents—in Joyce's case, Homer's *Odyssey*—to transform illusion and "meaning" into an art of sensation.

There is no record of the rough sequence in which Helen painted *Open Wall*, but a subjective tour through the picture suggests her way of combining chance, intuition, and a deep sense of past art. Suppose she started at left center, with the two sinuous vertical columns of pink. Perhaps then she moved on to the left, where the rectangular slab of blue gradually asserted itself under her eyes, staging the need for a matching form on the right, which became the wild field of bronze. Bigger and more varicolored and reckless than its blue counterpart, the bronze also extends a dark stalk toward the picture's center. Then perhaps, stepping back, she reexamined the pink columns. With their lively, fretted contours, elastic and bending, the long shapes call to mind an abstract form of "nude," a bending Daphne or Venus, at any rate something sensuous and energetic, a pulse on the eye. These sister shapes might then have invited further designs—the four blue forms to the right that crane upward as pale and rich repetitions of their ascent, or the punctual blotch of red between them, which in Helen's art suggests Camille Corot, the nineteenth-century French landscape painter whose eye-catching dashes of red she adored. In *Open Wall* those four blue forms are small enough to invite us to think they are in a "background," as if they grew from a body of water surmounted by a pale sky, something like the stalk-headed bathers, central pool, wooded arch, and light blue heavens of Paul Cézanne's *Large Bathers*, which Helen had seen the previous year with Greenberg on their visit to the Philadelphia Museum of Art. Splitting the difference between improvisation and memory, Helen let her picture take shape as a fresh experience rooted in the art of the past.

The title *Open Wall* is apt—a poignant nod to the modern

artist's liberating but also terrifying lack of self-evident social purpose and context. Once upon a time the Christian framework had given Tintoretto and the others their basis, providing a set of terms they shared with their beholders. Their art could develop into new experiments, new freedoms, all founded on this bedrock of faith. The modern artist, by contrast, worked without incense and candles, lacking the old chapter and verse. Her open walls were, if anything, too open—expanses of blankness in search of a faith. But the beauty of Helen's art, as she began to conceive it, is that she, too, by looking deeply into the art of the past with an eye to her own moment, might still be a seeker, a religious figure; that she, too, could quest for a kindred feeling of ecstatic revelation, speaking a language of lovely and devastating sensation that was the parlance of her own times. *On the Spiritual in Art*, Kandinsky had called it.

Open Wall is one dream of a new revelation. Other painters of Helen's acquaintance were seeking that just then, albeit in far different terms that emphasize her unique sensibility, her chutzpah. Foremost among them was Barnett Newman, an Irascible who had become friendly enough with Helen to see her off at the pier, in company with his wife, Annalee, when the young painter set sail for her European trip. Helen, for her part, was grateful to the Newmans for "helping me to feel at home and comfortable in the art world." Accordingly, Newman's customary panoramic format can be felt in *Open Wall*. In the early 1950s he was painting vast horizontal pictures aiming for a holy aura, an experience of miracles and visions, transposed to a realm of pure abstraction. Vast pictures such as *Cathedra*, measuring more than seventeen feet across, sought to

encompass the viewer in an overwhelming sensuous experience akin to a believer's at a holy place. The pulsating blue field was like the empyrean home of saints, an ecstatic emptiness, affording a religious experience after the death of God. The white line just to the left of center, as well as its paler counterpart to the right, are like slivers of light on the first day of creation, crackling like God's finger in Michelangelo's *Creation of Adam*. A secular New York Jew like Helen, Newman was stepping into the void, heralding a new form of belief—momentary, sensuous, without doctrine, yet as miraculous as Moses striking the rock.

But there was a difference between Helen and this painter twenty-three years her senior. Unlike the proud, pompous, and erudite Newman, she did not preach. Her paintings did not have the effect of a prophet coming down from the mount. The many vertical forms in *Open Wall*, not to mention the painting's mural-like horizontality, allude to Newman, but only in order to depart from him. On the right of *Open Wall*, scaling the bronze field, there is even an apparently direct reference to pictures such as *Cathedra*: a ghostly vertical line, an echo of what came to be called Newman's "zips" and perhaps made by the same means: by applying masking tape to the canvas. But Helen painted over this zip, and all her prominent verticals sway so organically, like windblown sails and grasses, that it is difficult to miss her disagreement with the rabbinical Irascible. Newman made pictures that follow Greenberg's principle of "one-shot" painting—a viewer could behold them at once, suddenly, whole, complete. But Helen made her paintings according to "a richer, slower sense of how you perceive a picture, how

you read a picture," says her nephew Clifford Ross. Her charge was meant to stay and stay, to unfold itself over repeated viewings and gradual contemplation. The Old Masters had done the same and outlived themselves. Helen still had everything to prove, but maybe with luck she would live on, too.

FEBRUARY 13–14, 1954

Bennington and Bolton Landing: The Gift

C lad in winter coats, Helen and Clem started the drive north to Bennington from Manhattan, Clem at the wheel. It was a Saturday morning in February, and the two were on the road by eight o'clock, aiming to make it to Vermont for lunch. They were headed to the home of Paul Feeley, Helen's college teacher, who lived on campus with his wife and two daughters. The next day, Helen and Clem planned to accompany the Feeleys to visit the sculptor David Smith's studio at Bolton Landing on Lake George.

For Helen, the trip north was a welcome change. Distracted by the search for a new apartment and studio, she had not painted in weeks and was anxious to get back to work, but she needed a catalyst. She sensed that being around Feeley and Smith would stir her creative powers.

She and Clem had a lot to talk about in the car that Saturday morning. Three nights before, they had seen a Broadway play, Jane

Bowles's *In the Summer House*—"the best bit of contemporary play-writing I've come across in years," opined twenty-five-year-old Helen, never at a loss for resounding aesthetic judgments. The play concerns a destructive relationship between a domineering widow and her teenage daughter. The mother, Mrs. Gertrude Eastman Cuevas, played by Judith Anderson (best known for her role as the sinister housekeeper Mrs. Danvers in Alfred Hitchcock's *Rebecca*), resents her daughter Molly's lonely wish for independence. "Sometimes I have the strangest feeling about you," Mrs. Eastman Cuevas says to Molly in agitated paranoid tones. "It frightens me . . . I feel that you are plotting something." Molly, played by Elizabeth Ross, escapes her mother as much as she can, retreating to the tiny and secluded summer house on the family's property. By the end, with Molly having met a young man and moved away, Mrs. Eastman Cuevas pleads for her daughter to return: "I'll make it all up to you, darling. You'll have everything you want. . . . I'm the only one in the world who knows you." But Molly escapes and foils her mother's wish to break her will.

Martha Frankenthaler was no exact match for Mrs. Eastman Cuevas, no more than Molly was the image of Helen. But it is not difficult to appreciate why Helen was so moved by Bowles's play. Only two or three months previously, Martha had been admitted to Mount Sinai for treatments of her Parkinson's. Although the care was good and the regime so strict that even imperious Martha had been pleased to be put under close supervision and subject to routine, it had done her little good. Visiting her the day before she saw *In the Summer House*, Helen found her doing "better." Still, the whole experience was depressing, and Bowles's play—"full of really

<u>felt</u> drama and meaning," she said—spoke powerfully to Helen at a moment when her relationship with her failing mother was at the top of her mind. At the same time, the play's reception was also a grim statement about the fate of serious art. Helen and Clem saw *In the Summer House* only four nights before it closed after only fifty-five performances. Perhaps she felt the play failed because it was so direct and forceful and true to life. It spoke so truly, so honestly, that there was no taste for it, no market. The world demanded what it already knew, or so it seemed.

And even original talents who succeeded ultimately lost their inspiration. In early February Helen and Clem had seen *Coriolanus*, the play Shakespeare had written after the extraordinary fourteen-month period in which he had created *King Lear*, *Macbeth*, and *Antony and Cleopatra*, three masterly portrayals of human depth. *Coriolanus* was no such thing, just a play about a one-dimensional man whose every action is predictable. Helen found it "boring," "<u>terrible</u>!" The fault lay not only with the lead actor—the handsome forty-five-year-old film star Robert Ryan, whom she called a "Hollywood jerk"—but in the production and the playwriting. For any artist, even Shakespeare, it was hard to keep the weightless ball balancing at the tip of the fountain's jet. In those years Greenberg was grimly noting that Pollock had a great run from about 1942 to 1952 but that he had "lost his stuff." If Shakespeare and Pollock could lose their stuff, how precarious for the rest of us, whose gift descends into the fingertips for *a while*, maybe just a few months or a year, maybe just once, before just as mysteriously vanishing.

A macabre recent event intensified this sense of fragility.

The Greenwich Village poet Maxwell Bodenheim, a star of the bo-
hemian literary world back in the 1920s and 1930s, had been mur-
dered on February 7. Bodenheim, sixty-one, had been found shot
in the chest, lying on his back on the floor of his shabby fifth-floor
furnished room on the edges of the Bowery, a copy of Rachel Car-
son's new book, *The Sea Around Us*, open on his chest. Nearby lay
the corpse of Bodenheim's wife, thirty-five-year-old Ruth Fagan,
stabbed in the back. Elsewhere in the room was the battered leather
briefcase out of which Bodenheim peddled the manuscripts of his
once-praised poems for fifty cents or a dollar, and a painted sign
reading I AM BLIND that he used when begging on the streets. On
February 11, a twenty-six-year-old itinerant dishwasher named Har-
old Weinberg was charged with the crimes.

Helen had followed the accounts of the murder in the papers.
She and Clem likely knew Bodenheim from the San Remo, where
the starved poet was a regular and where his wake was held. In one
sense, it was easy to disassociate themselves from this bohemian
lothario, from his sexually daring novels of the 1920s and '30s (*Na-
ked on Roller Skates*, *Replenishing Jessica*), and from the scandals
that followed him in his handsome youth (an eighteen-year-old ad-
mirer had attempted suicide the day after he dismissed her writing
as trash). Perhaps it was easy to look down on the quaint Greenwich
Village avant-garde of Bodenheim's prime, "a gin-sodden commu-
nity of weak-talented poets, artists and writers," as a *Times* writer
had put it.

But if that bohemia was gone, leaving "only dusty odds and
ends" by the time of Bodenheim's death, then what guaranteed that
the bright abstractions of 1954—so modern, so hip—would not

themselves follow suit? Helen and Clem both knew that before long most of the work on view in Manhattan's modern art galleries would be as forgotten as Bodenheim's poetry. Helen thought a show of abstract paintings at the Stable Gallery that February was "really dreadful." She saw that within a few short years of Pollock taking the world by storm, now *everyone* was making abstract paintings, and most of these pictures were depressingly bad. The Stable show gives "the impression that finally everyone has learned the skills of modern art," she said. "The general level is so low." Compounding matters, critics and the public alike were so clueless that they could not discern the difference between a work of merit and urgency, such as her own contribution to the show, called *Granada*, and other pictures that were simply thrown together, slapdash. A case in point was Pollock's current exhibition at the Sidney Janis Gallery on East Fifty-seventh Street, a well-received display that Helen selectively admired but thought "his least good show that I've seen." It was bad enough that so few people knew how to judge the new abstract art; what made it worse was that they tended to like the weaker paintings most. "I see it over and over again," Helen wrote on February 12, "that when something becomes mediocre, people generally go for it." The corrective seemed simple: make great work, make infinite work, if one could. But achieving lasting recognition and fame was not easy. When art was challenging, when it was different, when it was urgent (like Bowles's play), then it was even more likely to be misunderstood and forgotten, Pollock's startling success notwithstanding.

Talk of great art, of past and future accomplishments, gave Helen a superstitious dread, a feeling that she might not live long

enough to make her greatest work. Only a few days before she and Clem drove to Vermont, she had finally summoned the nerve to visit a doctor—her first visit in years. She had been too afraid to go. "After years and years of hypochondria, and never going for a check-up, I finally went, fearing the worst, and in a terrible panic," she wrote to Rudikoff on February 12. The results were comforting: "Outside of bad sinus, and a few little swollen lymph glands, my health is perfect, and I'm so relieved." The real problem, Helen recognized, was not her mild winter illness but her catastrophizing dread, a problem since her adolescence. "This all sounds so nutty," she confided, but it also made sense "as a symptom of many other problems." The previous spring, after the fifty-three-year-old abstract painter Bradley Walker Tomlin died suddenly of a heart attack, Grace Hartigan described her "fears of being stopped before I reach any real expression." Perhaps these were Helen's fears, too. "Work, work, for the night cometh when no man work," Hartigan wrote, quoting the hymn of Anna Louisa Walker. The same directive seems to hang over Helen's paintings from that time, too, no matter how bright and joyous her art appeared. The quick-coming night was a fantasy, it was a superstition, and for the moment it had been routed, dispelled by the reassuring checkup. But she kept fearing she would die before she made her best work.

Around 1:00 p.m. the couple pulled onto the Bennington campus, driving past the familiar buildings en route to Feeley's home. The old carriage barn where she and other students had gathered on the night of the 1948 presidential election, where they had

come in from the November bonfire and cheered on Truman, looked its usual self.

So did Feeley's red wooden house, where he lived with his wife, Helen, and their two daughters, Gillian, fourteen, and Jennifer, eleven. Situated on a part of the campus called the Orchard because of its apple trees, the house was modest but inviting—a reliable northern getaway for the Manhattan couple, who had counted on Feeley's hospitality on previous occasions as well.

Despite the development of her career, Helen still felt sentimental about Bennington and about Feeley's vital role in her education. Feeley was a force unto himself, not a figure easily reconciled under the tame rubric of the word "teacher." A man of contradictions, he was a brilliant conversationalist who kept great silences; a witty person whose wit expressed and concealed deep melancholy; a stoic who complained bitterly at the world's injustice; a good friend who let his friends down; a wise man who committed "many follies." A few years before her visit, perhaps in spring 1951, when Feeley had just returned from a seven-month sabbatical in his native California, Helen gave him a splendid gift. It was a piece of Rajasthani mirror-work embroidery called a *shisha* (or *shisheh*)—a brightly colored Indian fabric set off with pieces of glinting glass. A photograph taken in the Feeley home in August 1951 reveals the *shisha* hanging in Feeley's studio, a small room adjoining the main house; likely it was still in the studio in February 1954, a sign not only of Helen's thanks to her teacher but of her ongoing bright presence in his life. Gillian, who went on to a career as a distinguished anthropologist, feels the *shisha* was symbolically loaded in the manner of all gifts. "I'd always assumed it carried something of the giver with

it, and, once given, was an embodiment of their relations," she wrote in 2017. "I'd always identified it with Helen, like herself so skillful, gorgeous, and glittering."

On that day in February 1954, Helen was an ever more important person for Feeley. With Greenberg right there beside her, she was a conduit between her little-known professor and the possibilities of New York. The previous month Feeley had been among eleven artists featured in *Emerging Talent*, an exhibition that Greenberg had selected. Going from Bennington to a gallery at the corner of Madison Avenue and Fifty-seventh was no small thing for this artistic veteran eighteen years older than his star student. Soon he would have a one-person show at Tibor de Nagy, Helen's own gallery. Yet she kept a certain arch distance from her teacher. His paintings at Greenberg's show, she told Rudikoff, "weren't too hot." And she used him. Another Bennington faculty wife observed that Helen and Greenberg relied on Feeley's good nature and his hopes of success to get things for themselves, such as a nice place to stay in the countryside, a convenient escape from the city whenever they needed it.

On Valentine's Day, the day after their arrival in Bennington, Helen and Clem and the Feeleys set off in their two separate cars for the home and studio of David Smith, some two hours north on Lake George.

Helen had first visited Smith's place in 1951, traveling there with Greenberg. Smith was one of Greenberg's discoveries, and

the critic liked to show off the man and his art. A bluff, handsome Indiana native then in his forties, Smith had first made welded sculptures of steel while working at a Brooklyn foundry in the Depression. During the Second World War he forged distinctive totems that spoke to the menace and grace of the times. *Jurassic Bird*, a steel predator based on an ichthyosaurus skeleton Smith had seen at the American Museum of Natural History, casts the atomic bombs of Hiroshima and Nagasaki as the latest episodes in the world's primeval rapacity. Other sculptures are more pastoral—the *Agricola* works of 1952, made from fire pokers and tractor parts, stand out as boldly as a farmer's plow in a poem by Robert Frost.

Smith made these and many other works at Bolton Landing, where he had moved in 1940 to escape the distractions of Manhattan, christening his upstate studio Terminal Iron Works after the Brooklyn foundry where he had once worked. His smaller pieces could be seen in Manhattan shows—there had just been an exhibition of them that January at Willard Gallery on East Fifty-seventh Street—but Bolton Landing was by far the best place to see his work. There he installed the pieces in the open air, in a lower and upper field on his property, creating his self-proclaimed "sculpture farm." Helen and Clem had visited Bolton Landing the previous September, but the winter was also an extraordinary time to be there.

Getting out of their cars at 4:00 p.m., the visitors were greeted by Smith and his young wife, Jean Freas Smith, then seven months pregnant with the couple's first child. After posing for photographs, everyone set off for the fields in the fading Valentine's Day light, their feet crunching in the snow. Among the rows of totems was

Australia—a great aboriginal bird made of painted steel that cut a calligraphic profile sixteen feet wide against the sky. With feathers, face, and talons written in metal, it was the equivalent of Pollock's cursive way with paint, his swirls of pigment except now thrown and hung against the clouds. Another was *The Hero*, a painted-steel form about six feet tall, with an eye-shaped head set upon a slim body with a transparent box-shaped rib cage: the human figure reduced to an elemental form, mortal and strong. The works were like lightning rods bidding defiance to higher powers, fingering the gray February scud, splitting the clouds. They expressed no faith but that of the artist, no creed but his own—the mix of lyric sensibility, industrial know-how, and disciplined labor that led him to create them with a trip-hammer and acetylene torch in the studio he had built himself. The Feeley daughters were mesmerized; so were the adults. The sight of Smith's sculptures—so free and lyrical, so ferociously and delicately created—would make any artist, even the most assured, take a deep breath. Helen adored Smith, twenty-two years her senior, regarding him as a great friend, a fellow romantic, and the most serious of artists. She already owned one of his small sculptures and within a decade would acquire two more. His art, like hers, gathered life into forms meant to awaken a sense of life's possibility in a person bold enough to encounter it in an honest and open spirit.

What brought Helen and Smith together was a united belief that an artist's solitude was ultimately generous—that it was social, ethical, of deep cultural importance. It only looked like the opposite, a narcissistic escape. Helen put it this way: "True artistic creation of any kind is a very lonely process, a totally selfish act" that is

also "a totally necessary one that can become a gift to others." The artist needed to rely on personal experience to make the work—to draw on some inmost life, a set of feelings and attitudes—but the aim of all great work was to free itself of the artist's personality. Then and only then would the work become an offering to others, a kind of truth for them to live their lives by. Yet men like Smith had a far easier path to this generous status than did the women. *Australia*, for instance—who in their right mind would take that great aboriginal bird as a sign of Smith's personal life? The men were assumed to be universalists, and they relished the assumption. Newman had called his vast painting of 1950–51 *Vir Heroicus Sublimis*—man, heroic and sublime. But the art of the women among the abstractionists tended to be seen as only a personal statement—Helen's *Granada*, for instance, the painting on display that February day in the group show at the Stable Gallery. With its orange design resembling a flower or rays of sunlight dappled on a courtyard wall of gray and baby blue, the painting features an ovule of black suspended as a point of weightless depth at the flower's center. How easy the temptation for a critic then or now to stereotype the painting in feminine terms, to see it as pretty or carnal in the way that Georgia O'Keeffe's irises and lilies can seem.

But *Granada* strives for an objective luster reducible to no personality, least of all the artist's. With its mixture of petals and sooty hole, its lyric lightness and anatomical curiosity, it spares as little of life as a love sonnet that dwells with equal ardor on body and soul. In *Granada*, as in all of Helen's work, the route of personal feeling is only a way for the artist to find what is *not* herself, the otherness that is sometimes called the *world*, or *life*, or *actuality*—and

that makes the artist, finally, only a humble ambassador for the objective experience she makes available to the person who views her work. The propensity to regard a painting biographically will always be there, partly because it is so much simpler to engage in that game than entering a genuinely foreign pictorial world set apart from many known coordinates, among them ever-ready formulae concerning the personality of the artist. The art historian will always have to answer questions about Picasso's mistresses, Leonardo's childhood, Caravaggio's murder of a man. And in important ways such questions are always conceivably relevant. Who Helen was, where she came from, what she thought on a day-to-day basis, are inextricably bound up with her gifts to us. But her work is not her life, even though only she could have made this work.

"You can't decide to take your rage or happiness or gloom or fear and direct it onto the canvas," she later explained. "That would be affected, dramatic, and false." But you might be aware of a mood, a feeling, as you set about your work. *Granada* might have begun like this, from some original impulse—some humor, some temper— that generated first one form, then another, one decision, then another decision. Then the painting itself would take over. Absorbed, Helen would work on one part of the picture, then another, judging, stepping back, moving in, closing not only with the physical surface of the canvas but with a certain feeling that might, just at that moment, seem synonymous with a color, shape, or drag of the brush. What finally emerged was a picture that took her personal experience, rhymed with the spontaneous decisions of the studio, and transformed it into a separate thing in the world, a soaked and stained canvas there on the studio floor, as complete unto itself as

an autonomous kingdom with its own language and laws. The artist at that point was as profoundly outside the picture as its most sensitive viewers would be. The result was a gift to the person who encountered the painting in the right way, who could recognize in it a release from the world's constant expectation that life be remorselessly divided into categories, definitions, and meanings, not least those of the "artist's biography," and be confronted instead with a sensuous experience, as punctual and clarified as the sound of a symphony compared to the noise of the street, yet ever-wild in its ordered and melodic array.

A few weeks after the couple returned to New York, Helen moved uptown into a new apartment, a fifteenth-floor place at 697 West End Avenue with north light and space enough for her studio, and beautiful views of the Hudson. In that space over the next several years, she would make some of her best paintings. But any immediate inspiration she took from her trip to Bennington and Bolton Landing was interrupted in the most disturbing way.

At eight thirty in the morning on April 23, 1954, clothed in a nightgown, Martha Frankenthaler jumped from her fourteenth-floor apartment at Fifth Avenue and Seventy-fourth Street. A maid had seen her on the apartment's terrace a short time before, but when she went to tell her that breakfast was ready, Mrs. Frankenthaler was not there. The building superintendent, summoned to the apartment, saw her body below, in a space adjoining the building and the neighboring French consulate. An ambulance arrived from Roosevelt Hospital, police came from the East Sixty-seventh

Street station, but there was not much for anyone to do. "Justice's Widow Killed," ran the headline on page 7 of the *Times*—"Mrs. Frankenthaler Plunges from 14th-Floor Window." The time at Mount Sinai had not worked, neither did a subsequent stay at a Westchester County sanitarium; nothing had. Martha was fifty-nine.

Among the Frankenthaler sisters, a newfound tension developed after their mother's death. Grief and the depressing task of dealing with her belongings exacted a cost. Marjorie, the eldest, took it hard. Gloria, who had seemed to ignore that their mother was ill, was "broken," says Clifford Ross, one of her sons. According to him, the tie between the sisters was never the same after the suicide. Both Marjorie and Gloria thought that Helen's behavior was outrageously selfish in the aftermath of their mother's death. "Helen focused on her work, and her life, as separate from the family and its trauma," Ross says, acknowledging that he owes his views partly to his mother, "not a reliable reporter, and very negative about Helen" (as Helen was about her). Marjorie, with whom Helen maintained a warm relationship throughout most, but not all, of their lives, was nonetheless so deeply angered by Helen's nonresponse to the suicide that nearly fifty years later she brought the matter up out of the blue to a friend, railing "in a very angry tone," as if she were reliving it, "how she had to spend an enormous amount of time chasing Helen down to deal with their mother's suicide." It was true—already in May Helen was telling Rudikoff she was tired of talking about her mother's death. Says Ross, "When her mother died, she did not engage. She did not deal with the issue; she just

wanted to keep working; she wanted to get up and out from the family darkness."

Yet her mother's death remained deeply inside her. "She could bury things," says Ross. "I have no doubt that she buried it." In the 1970s John Blee was struck by how Helen referred often and affectionately to her father but almost never to her mother. The one time Helen mentioned her mother in his presence, says Blee, was when he innocently commented on a small watercolor he saw hanging in Helen's kitchen and found out that Martha had painted it. He was surprised when Helen curtly dismissed the picture as of no importance.

The watercolor is one of several surviving pictures of Martha's that descended to her daughters. They are all small, about five by five inches in size, with titles such as *Pleasant Dream*, *Weird Fantasy*, *Autumn Fire*, *French River*, *Far Away*, and *Birth*. One of them, in the possession of Marjorie's daughter Ellen Iseman, is dated winter 1954, not long before she died. Somewhat strangely, these watercolors look a bit—just a bit—like her youngest daughter's work. Ross half jokingly calls them "mini–Helen Frankenthalers." Maybe the dim resemblance accounts for Helen's dismissal of the one she owned in her retort to Blee. Ross also remembers that Helen was contemptuous of her mother's little pictures. He thinks that Helen was defensive about them because she thought their abstract color patterns might lead a person to think that her own art came out of her mother's amateur pictures—rather than the history of modernism—to him, an absurdly insecure reaction for a painter of Helen's gifts.

Over time Helen came to describe her mother in idealized terms. In a 1968 interview with the art historian Barbara Rose, she eulogized Martha as she was not long after Alfred died: "My mother was beautiful, in her early 40s, with three young girls, and widowed, and had never had another man, no other man would ever do and never did. And she was patrician and really beautiful, she was lively, youthful, earthy but with class. You know, in a way very vulgar and in another way had great taste. A splendid, large woman." Photographs from Marjorie's wedding in 1947 show Martha majestic in a floor-length black gown with intricate lace sleeves, posing with a family friend, dancing with another friend, kissing her eldest daughter deeply on the cheek. In one photograph she smiles at the camera, her eyes sparkling, her lips parted to reveal perfect teeth—a gorgeous woman who could have been mistaken for an aging movie star.

But in early summer 1954 Helen felt glad to be free. She found working in her new West End Avenue studio easy and rewarding, excited by the paintings she was making there. In late July she and Greenberg went to Europe for an extended trip, visiting the Amalfi Coast, Florence, Venice, Milan, Paris, and London, among other places. A photograph taken on September 19 shows them with Peggy Guggenheim at Sirmione, on Lake Garda, in Italy—the three posing in Guggenheim's snappy duo-tone convertible roadster. The couple also spent time with the eighty-nine-year-old connoisseur Bernard Berenson at his villa outside Florence, and in London they shopped at Harrods and attended a play starring Ralph Richardson and John Gielgud. The demanding neediness of her mother, the

years of her illness, and then her suicide—Helen ignored, repressed, and fled from it all.

She and Clem did not set foot back in New York until October 11. No sooner was she back in the city than it was time for her to choose and prepare works for her next solo show at Tibor de Nagy that November. Finally in December she spent most of one week working to sell, give away, and divide up her mother's furniture and other effects, which had been in storage. Now it was concluded. "It was a horrible job, and all done now, thank god," Helen wrote that month. It was two days after her twenty-sixth birthday.

"Go," says Mrs. Eastman Cuevas to her daughter Molly at the end of Bowles's *In the Summer House*. She has been holding on but now she releases her grip on the young woman. "Molly's flight is sudden," say the stage directions, which give a sense of what Helen saw that night back in February at the theater: "She is visible in the blue light beyond the oyster-shell door only for a second."

6

AUGUST 2, 1955

East Hampton: Alone

The heat in Manhattan during the summer of 1955 was oppressive, but Helen had other reasons for wanting to get out of the city. She had broken up with Greenberg in April—or at least begun the breakup, the real thing, instead of the off-again, on-again tumult of the previous five years. As it turned out, the split was not so easy: for the rest of the year, Greenberg was insistent, demanding, pleading, hoping. Helen found it difficult to avoid him, even as she stuck to her words back in April: "I have changed my life."

True to her uncertainty, she planned to get away from Manhattan that August by going to the Hamptons—not the best way to gain her independence. The place was second only to Manhattan itself as an epicenter of the New York art world. A number of important artists lived there: Jackson Pollock and Lee Krasner had their home in Springs, in East Hampton, on Fireplace Road. The abstract painter Alfonso Ossorio lived nearby, on Georgica Pond.

The artist Ibram Lassaw had just bought some property in Springs. Then there were David Hare, the gallerist Julien Levy, and others. The place's art-world feel grew every weekend in the summer, when on Friday evenings the 4:19 p.m. train from Penn Station delivered an assortment of painters and writers from the big city, Greenberg often among them.

But Helen still found some detachment in the Hamptons. At the recommendation of Pollock and Krasner, she rented the house of their neighbors on Fireplace Road, the painter Conrad Marca-Relli and his wife, Anita, who were away in August. Newly redesigned by the couple, the place was small and beautiful with a white and austere light-filled interior. French doors with venetian blinds opened to a little brick-paved patio and vine-wrapped trellis, with a simple table and chairs set in the shade. Marca-Relli's studio was in a converted barn about fifty feet away. Now on August 2 Helen was just settling in for her month rental, enjoying her independence: walking down the driveway to the road to get the mail from the mailbox, feeding the couple's cats, swatting flies, fixing screens, driving a station wagon to a nearby chain supermarket, Bohack, to stock up on groceries. "The first night I spent here alone I sat up until 2:30 a.m. worrying about highway robbers," she wrote to Rudikoff. Fireplace Road was only a few feet away and the sound of passing cars mingled strangely with the place's solitude. But she quickly grew to like being alone.

The breakup with Greenberg that April was Helen's decision and "a real one," she said. Her reasons were clear enough. Greenberg's relentless self-absorption and unresolved pain and anger—a story unto itself, from his childhood—made him unpredictably

hostile and sad. He needed to be in control, to feel dominant, and Helen, suffering under this cruelty, complained, attacked, and upbraided him in return. She had also simply outgrown the relationship, which had begun less than a year after her college graduation. Now, five years later, with growing awareness and confidence, she realized she had no obligation to live constantly under Greenberg's irritable and volatile moods, his anger and lacerating self-hatred. She did not need to suffer while he brooded on the many things that he had done or that had been done to him—his power and powerlessness, all made vivid to him by his photographic memory and true delight in holding grudges. She still cared for him and thought that in many respects he was a good person. He could be a father, a friend, a guide, and he had been all of these things. But their romance was over.

Or so she felt back in early April, when she broke the news to him. The two kept seeing each other periodically, however, with Helen unable to conceal that her feelings had changed and Greenberg assuming, as he had done previously, that the relationship was not truly finished. But a crisis was coming. In May they drove to Bennington to see an exhibition of Hans Hofmann's paintings and Greenberg was hurt by Helen's remoteness. Back in New York, he grew suspicious and wondered why he got the busy signal so often when he telephoned her. Who was she talking to? There was an episode on May 23 when the two could not find parking on West Eleventh Street and Helen summarily demanded to be taken home—Greenberg was stung. The next night, sensing the situation had grown desperate, he made what he later thought was a big mistake. He told her how much he cared for her.

In reality it was no mistake—Helen had simply moved on. Around that time she had met Howard Sackler, a twenty-five-year-old playwright and graduate of Brooklyn College. A hunter and outdoorsman, handsome and virile, Sackler was an aspiring creative person like her. He had recently written the script for a film called *Fear and Desire*, the work of a neophyte director named Stanley Kubrick, a friend from his days at William Howard Taft High School in the Bronx, and in 1955 their second collaboration premiered, a boxing noir called *Killer's Kiss*. Sackler was Greenberg's nightmare—a confident and sexy man Helen's own age. "Didn't notice Helen's bloom under sex until 23 May," he wrote in his diary. He felt sick.

On June 2 Helen and Howard met with Greenberg, confronting him with the reality of the new situation. Their aim was to help him move on. They told him they respected his "toughness" and "honesty" and said that they would need him to be especially tough now. This did not sit well. Greenberg went home, drank a few martinis, and called Helen at ten thirty that night. He commented spitefully about her body and told her that he had never really enjoyed sex with her. A few days later he felt dreadful. He missed Helen terribly. The day after, he wandered around Greenwich Village, disoriented. The day after that he had lunch with Helen at Longchamps, an upscale Manhattan chain restaurant, where he found her aggressive and angry and their conversation turned into a "power struggle"— perhaps what their relationship had been all along. Greenberg, devastated, began slipping into the most severe nervous breakdown of his life, one that would last almost all of 1955, an extensive dark night of the soul. He began seeing an analyst, examining the sources

of his anger with remorseless analytical precision, but his anger and sorrow, his "infinite sadness," ran unchecked.

His lover's fury and wounded ego that summer provide an unusually intimate depiction of Helen's body. Sparing no details, Greenberg wrote in his diary how he disliked the rounded tips of her ears, the two or three coarse hairs on her cheeks, the bunions on her feet, the way her feet were set into her ankles. He did not like the softness of her flesh. He was indifferent to her nakedness, an indifference that he felt she was deluded enough never to realize. Switching to the way they spent time together, he thought bitterly of Helen's insistence on their "marriage-like" intimacy—cozy dinners and evenings together, a quiet coupledom of the woman reading, the man writing at his desk. He reflected on how he had resisted this fantasy of reassuring domestic comfort but that now he believed it more than Helen. He hated her for having foisted this life on him that she herself had abandoned. "It's what she put over on me."

His critical examination likewise ranged over every facet of their relationship. He thought of demanding, hysterical Martha Frankenthaler: "What always got me about Helen: how she could come unmarred, unscathed, and untainted from such a mother as hers. But she didn't. Not at all." He felt that Martha Frankenthaler was "the clue perhaps to everything unformed yet coarse in Helen," to her "utter lack of delicacy." Turning on himself, he dwelled on his own motivations in pursuing Helen—his wish for a trophy girlfriend. The "beautiful, rich, cultured, etc., daughter of [a] somewhat famous father" was "someone the world outside admired me for possessing. That's why I put up with her lack of real

attractiveness for me." He reflected on why pretty women such as Helen liked to be seen with ugly men such as himself. It was a "declaration, an announcement, to the world of their own enhancement by male weakness. . . . Maleness, weakened, degraded, defeated, is, by such women, thought to glamorize themselves." And he thought back to the night he met Helen in May 1950—how he should have trusted his first impression. "My first look at Helen in Seligmann Gallery: my type neither physically nor temperamentally. Too forward, stiff, hard-edged somehow."

Helen, sitting at the typewriter in the heat of August 2, had felt the force of this all summer, even as she stayed away from Greenberg. The breakup had been "a confused and painful and hysterical time for each of us." But she was glad that it appeared over at last and looked forward to a visit from Howard that weekend.

But on that August day Helen's independence was in for a test. In Greenberg's mind the relationship was far from over, and he was coming to the Hamptons that weekend to stay with Friedel Dzubas, who had a place there. Supposedly he was doing better, but Helen intended to keep her distance all the same. He was a hard person to evade, however, and perhaps Helen still held out some hope—despite her better judgment—that she could reason with him and explain her rationale for moving on. Besides, even as her new relationship was starting up, she felt a kind of isolation: "I felt lonelier because I was lonelier," she later said of that year. She and Clem ended up having drinks on August 6, the night he arrived, and the following evening, a Saturday, there was Clem at the

Marca-Rellis' door, one of the guests at Helen's dinner party. How-
ard presumably was there, too: Greenberg later confided to his jour-
nal of his "terror at seeing Howard *en menáge* w. Helen in Springs."
What distressed him most was not only the sight of the two young
people together but the fact that Helen did not seem to be getting
back at him. She did not kiss Howard to make a statement; she
simply had a new man. "You think I have contempt for you, don't
you?" she asked him that weekend. But she did not; she told him
how much she respected him. He hunkered down in irrational rage:
"Beware of those whose first names begin with H or J but H espe-
cially: Helen, Howard . . ."

As the year went on, Greenberg kept after Helen, his mis-
guided pursuit revealing how unhinged he had become. In early
October at a party on West Fourth Street he slapped her. Above the
conversation and jazz music, guests heard a woman's cries coming
from the apartment's small bedroom. Running in, they found Helen
huddled on a chair, sobbing and surrounded by friends. Greenberg
was on the other side of the bed. The person who recalled the event
in detail, Janice Van Horne, a Bennington graduate five years
younger than Helen, was stunned to see this woman whom she did
not yet know—a woman whom she had glimpsed earlier in the eve-
ning and immediately sized up as the party's "shining center," "a
tall beautiful magnet of a girl"—was the same one now weeping in
the bedroom. Van Horne was doubly discomfited to see that the
intelligent charismatic man she had met earlier that evening—she
had had no idea who he was either when he had sat next to her on
the couch—was the one who had slapped Helen. Awkward, inse-
cure, taking her leave, Van Horne nonetheless summoned the

courage to ask Greenberg if he would like her phone number. He jotted it down in a leather address book he took from his breast pocket. She and Greenberg began dating. The next year, they got married.

Greenberg's diary allows us to piece together Helen's state of mind in the days after the slap. When he called her the next morning to apologize, she picked up the phone but did not say a word. Eventually, he emitted "two suffering hellos." She was angry and he felt it: begging for forgiveness from Helen was like "baiting the bull, dancing in front of [a] locomotive, daring the sea." Her power reminded him of the times when as a teenager he would stand amid the crashing waves at the beach to see if he could withstand the punishment. But he himself raged as much as she did, and his anger beat down upon them both in waves of its own. One night he blew off his fury by making violent expressions in the bathroom mirror—trying to abate the wrath that had started earlier that evening at the White Horse Tavern, where he had told one of his drinking buddies that he would like "to slap H. soundly right-left and kick her in [the] behind." Part of the anger was that he had proposed marriage—contritely, soon after the slap—and she had refused. "My bottommost desire," he wrote in his diary, "to strangle Helen. . . . I can see my hands clutching her unattractive throat and throttling the magnificent and baneful vitality out of her." The only time he felt calm was when he elicited Helen's own open rage—"the howl of pain released by her Demon"—because then he received her anger directly, in revealing blasts of uncontrolled malice, rather than in the "plain aggression or furtive sadism" she often used against him.

———

What had kept Helen with this man for five years when even as early as fall 1950, in the opening months of their relationship, she had seen the "neurotic corners" of his personality? Was it just a matter of getting ahead, a relationship of convenience, as cynics contended? Anyone close to Helen disputes that idea, saying that it does not begin to capture the subtleties and complexities of her bond with Greenberg. She knew the disarming moments of kindness and modesty that others never would have guessed about the fearsome critic—the time in August 1951 when they had visited Norman Rockwell's Arlington studio, for instance. Then there were the real affinities between Helen and Clem—perhaps affinities of friendship more than anything else—that would make it not strange at all that, into the 1980s, we could find him visiting Helen at her home, the two in earnest and friendly conversation.

But back in 1955 Helen's departure from Greenberg for Sackler was a moment of growth for her. She was moving past the obvious destructiveness of the time with a man of such demons. Yet the two relationships had things in common. She put herself in a vulnerable position with Sackler also, perhaps failing to realize that he was not necessarily ready to settle down. Even back in high school, Sackler was thought to be a ladies' man; his awed and curious classmates suspected he was a gigolo. Now with him Helen again found herself in a situation where the man was in control and she was often miserable. This vulnerability was born of a neediness that manifested as a premature wish for comfort, for security of a cozy domestic sort, even before she and her partner knew each other very

well—what Greenberg, resentful but acute, disparaged as Helen's insistence upon a "sacramentalized" relationship. Helen's insecurity around men—the trait that Gaby Rodgers had noted back in 1950—was always there in some form. How could it be, her friend the art critic Karen Wilkin wondered when she got to know Helen in the 1980s, that a person so fearless in the studio could be so afraid outside of it? Why when they went out together would Helen keep reapplying her makeup, why did she always need to appear attractive for another person out there, a man? Helen was plenty attractive and even seemed to know it a good deal of the time, but her compulsion and doubt were there all the same.

In late 1955, Helen attended an opening with Sackler, looking decidedly morose and glum. Greenberg, hearing of her appearance from Dzubas, agreed with his informant that it must mean that "Howard is on top." Soon after her birthday on December 12 the couple broke up, "sad and painful and complicated for both of us," Helen told Rudikoff. A few days later they were back together, but the next year they broke up for good. A gift Helen had given Sackler when they were a couple wound up as a strange and prolonged addendum to their relationship—one that put Helen's need to corral a man on unflattering display. She had lent him a cherished item of her dead father's furniture—the chaise longue on which he used to take naps in his office during his long days at the New York State Supreme Court. The loan of this very personal item was generous, overly so, in a relationship in its early—and, as it turns out, only—stages. It is reasonable to imagine that it also carried implications, even demands—that it was a way of binding Sackler to her, before he was ready to make such a commitment, before even Helen herself

was ready for the same. The need to possess—to control—is what comes across. So does this: several years after the relationship, Helen became obsessed with getting the chaise longue back. She hired a lawyer. She threatened to sue. But Sackler refused, telling his own lawyer, "She gave it to me. I'm not budging on this. I'd sooner give her my arm." Frustrated, Helen eventually instructed her lawyer to offer a large cash settlement, $2,000, for this remarkable family heirloom that she had loaned away to a man she had not known very long. Sackler again refused.

In the studio, Helen was another person altogether. She disliked being called a "woman painter"—just plain "painter" was the correct term. Aristocratically, she assumed that it was her perfect right to claim a place among the formidable thicket of accomplished male artists. Talent was the thing: she had it, they had it, and that made them equals, as a matter of fact. She did not need to awaken to her independence, to her gifts.

She read Simone de Beauvoir's *The Second Sex* shortly after its publication in an English translation in 1953. She found it perceptive but also only a confirmation of what she already knew. There was "a lot of French crap in it . . . also a lot of real insight—though nothing <u>really</u> new in a large sense." De Beauvoir's revelation—that "women are not simply 'women,' but are, like men, in the fullest sense human beings"—was second nature to Helen. So was the idea that "feminine character" was not innate but largely a theatrical role devised mostly by and for men. She knew all that from as far back as her Bennington days, when she and her fellow students

were perfectly capable of seeing themselves as freethinking women calling their own shots. She knew it even in her childhood, when she brimmed with pride in her uniqueness—a confidence instilled not only by her parents, for whom she had been the darling talented littlest, but by her native chutzpah, which had the quality of appearing out of nowhere, a force as joyous as the gumption that propelled her down playground slides in 1930s Manhattan.

At the same time, Helen felt her art drew specifically on a woman's experience and that it could be great for that reason. In *Partisan Review*, Elizabeth Hardwick had praised *The Second Sex* but faulted de Beauvoir for failing to notice the simple fact—socially determined as it was—that "women have much less experience of life than a man, as everyone knows." Going on, in an essay Helen "didn't much care for," Hardwick cited *Ulysses*: Joyce's novel is "not just a work of genius, it is Dublin pubs, gross depravity, obscenity, brawls." She went on: "Stendhal as a soldier in Napoleon's army, Tolstoy on his Cossack campaigns, Dostoevsky before the firing squad, Proust's obviously first-hand knowledge of vice, Conrad and Melville as sailors, Michelangelo's tortures on the scaffolding of the Sistine chapel. . . . It is in the matter of experience that women's disadvantage is catastrophic." Apparently immutable social laws, combined with the fact that, for Hardwick, women are not as physically strong as men and would consequently always lack the sheer "vigor" required to create works of genius, suggested that women artists and writers would always be at a disadvantage.

Helen was having none of this. She disliked Hardwick's way of "sacrificing with ambiguities," her way of making the gender split too neat. Why could not her art, too, portray what it was to be alive,

richly, fully, strangely? She did not accept that her range of experience was more limited than a man's. It was conceivably far richer—even literally so, thanks in part to her money and education—than that of many men. Back in 1953, she had ranged alone from Gibraltar to Nice. Up the coast at Antibes she had visited the villa where, only five years before, Picasso had spent time creating paintings for that one spot on earth. She was right there, in the place where he was, her experience not a matter of secondhand tourism but of deep assessment made possible by her money and venturesome spirit.

But another aspect of Hardwick's critique irked Helen more. What Hardwick termed a limitation—the way women were more accustomed to sheltered lives—was in fact an opportunity, a deep artistic source unto itself, in which the feeling of life existed as fully as on the sweep of Napoleonic battlefields or in the scrum of intrigue among worldly cardinals beneath Michelangelo's frescoes.

For Helen, a woman's worldly experience might come from the very sequestration Hardwick accepted as a natural limit. Why were battlefields and bars the only places to find out what the world was really like? Emily Dickinson, writing her poetry in her room, "never saw the Sea . . . but knew what a Billow be." Intimate private experience could itself be a kind of cosmos, a freedom of outer limits. Getting at this, in the 1990s the art historian Lisa Saltzman wrote of Helen's stain technique as an allusion to menstruation—an interpretation Helen was right to dispute as a totalizing explanation of her work but that contains some truth. It rhymes with the feeling in Helen's paintings of a resolutely private experience made public in an unapologetic and fearless way. It is as though each painting were a grand variation on a first physical blotch—a humble first

note, a first stain of color on the canvas—out of which a whole sym-phony would emerge. The painting that left the studio, the painting that hung on the gallery wall, offered such a range of experiences and emotions that it might disguise how it had all started with a gesture connoting such a private and bodily function. Indeed the disguise is more complete than that, since in fact at *every* point, not just at the origin, each of Helen's stain paintings is intensely private, intensely bodily, in a specifically feminine way. Even if her goal was to make a picture, a world—to be thought of as a painter, not a woman painter—a woman's experience is there throughout, unmistakably, all the more present for having been transmuted into these other things, these other sensations, these "worlds," these "universals."

The thing for her to avoid as a woman, Helen knew, was what she called "the gimmick." The writer Mary McCarthy had pub-lished a story the year before in *Partisan Review* called "Dottie Makes an Honest Woman of Herself" that Helen condemned with this term. Set in the 1930s, the story describes the sexual experi-ence of Dottie Renfrew, a twenty-four-year-old recent Vassar grad-uate whose gruff lover, Dick Brown, tells her curtly to get a "pessary," a diaphragm, for future assignations. The story ends with Dottie having gone to a gynecologist and now seated on a park bench, squirming and unhappy. The diaphragm was for Helen the story's "gimmick," the plot device round which the vulgar story revolves, yes, but also an all-too-personal invitation to the viewer to speculate on the autobiographical experience, McCarthy's own or another's, the story comes from. As Helen said of McCarthy's story, which she detested, "<u>Everyone</u> was asking <u>everyone</u> else about it."

This "who is it really about" name game was precisely what she wanted to avoid in making her paintings, even as she drew ineluctably and powerfully from her personal experience to make them. The stain, whatever it was, was not a gimmick.

Instead it portended a depth, a hidden world welling up. Helen described the paintings she made in 1955, such as *Blue Territory*, as "inner amorphous worlds or depths exploding on the surface and in perspective." The metaphor implies an emergence from below, a school of fish suddenly rising to the ocean's surface. The canvas that Helen laid on the floor before her in her West End Avenue studio became a body of water down into which she would stare as the different forms burst on the picture plane. As "inner amorphous worlds," the forms were personal, making Helen in her studio a Narcissus at the pool, staring at her own reflection—yet with the decisive difference that what she saw there, what emerged so privately, *was drawn from her own depths but did not depict her own life.* There is no painting showing the split with Greenberg, no painting that reacts to the death of her mother, even as the paintings she did make could not exist except by the hand of a person who had experienced such things. As Helen was to put it much later, "I don't think anything anybody does is apart from life. . . . Every fact of one's reality is in one's work." But her art portrayed bigger things than herself.

A key to the painting's impersonality is what it looks like on the wall, away from the studio floor on which it was painted. The transit from one state to the other tracks the passage from private to

public in Helen's art, though "passage" is a poor word to describe what was, in fact, at every stage of the process, Helen's vacillation between private intimacy and public extravagance. Like her other works, the emerging painting was *always* a play between the sensuous directness of the artist's encounter with the canvas—a reflective pool in which only she could exist—and the gallery wall for which she knew the work was destined. Every mark on the surface was correspondingly deeply personal and vastly public at the same time.

This unstable relation was never predictable; it was always on the edge. In *Blue Territory*, a painting nearly ten feet tall, a great upward burst of forms extends like the stalks and petals of trees and plants. Hand-like fronds rise above what looks like a cartoon heart. The graffiti of a schoolgirl's private confession takes on the aura of saintly ecstasies, a conventional sign of forlorn adolescence martialed almost against its will into a bold strapping air of titanic achievement. It was a measure of the unwieldiness of the combination, and of Helen's genius for exploiting that unwieldiness, that we can never say where the personal leaves off and the impersonal begins. That is why the painting's address is always arrestingly intimate *and* grandly declarative, and why we ourselves might come to feel, looking at it, that our own private emotions are not such trivial things.

Helen's solitude was now on display. De Beauvoir had said that even a woman born with "the generous inclination for transcendence" could not realize this power except vicariously, in the transcendent subjectivity of the man she loves. He would be her "value

and supreme reality," the "absolute" that an unjust society refused to grant her as an essential part of her own being. But Helen felt differently. Greenberg had inspired her, but only to find a value that was already within herself. And now that she was on her own, it was funny how the world kept opening up.

PART TWO

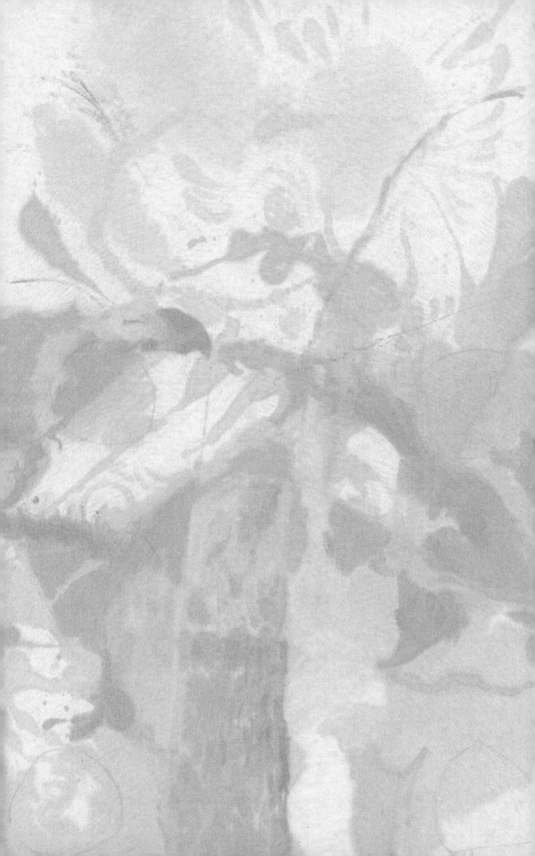

AUGUST 12, 1956

Paris, Hotel du Quai Voltaire:
An Undying Art

On August 11, 1956, Jackson Pollock was killed on a bad bend of road three miles north of East Hampton. He was drunk, speeding, and took the turn too fast. The crash took place not far from Pollock's home, near the house of Conrad Marca-Relli, where Helen had lived the previous August. Now she was in Paris, part of a European journey that summer, staying at the Hotel du Quai Voltaire and frequenting the café Les Deux Magots, home to French and expatriate writers and artists alike. As it happened, Lee Krasner accompanied her on some of her travels, having separately gone to France to seek a respite from her husband's raging alcoholism and womanizing. On August 12 both Helen and Krasner were in Paris, Helen at the hotel, Krasner at the home of the painter Paul Jenkins and his wife, Esther. When the phone rang at the Jenkins home—it was Greenberg on the line with the sad news—Jenkins did his best to console Krasner and then

telephoned American friends in town to see if they could help. Helen came over immediately. She and Jenkins walked with Krasner through the streets of Paris and bought her cognacs at cafés to pass the time until her flight back to Idlewild.

Back in New York, Pollock's death shook the art world. He became more famous than he had ever been in life, beginning his ascent to myth and legend. Meanwhile, the void he left was an opportunity. Established and aspiring artists alike adjusted to the vacuum left by his demise. An homage to him at the Club, an artists' establishment on Eighth Street, turned into a free-for-all. "De Kooning turned on B. Newman, Clem on Kiesler, Newman on Clem, and so on," wrote the painter Herman Cherry. "All the bitterness against each other came out. Pollock was merely the catalyst. God the art world is bitter. The groups keep shifting. One group won't talk to another and so on. Most of it has to do with position."

Helen's reaction to the artist's death was different, not a matter of acrimony toward other artists. From the first she had a direct and personal relation to Pollock's art. She never forgot the permission his great paintings had given her back in 1950, how he had "opened up what one's own inventiveness could take off from," and in 1956 that gift was still her art's foundation. But the affable man she had met in 1950 had become "drunken, wild, angry, demonstrative, wanton" since then, she said. "I mean he really was two different people." Likely she shared the view of her friend B. H. Friedman, who wrote to her two days after Pollock's death to say that he wished it could have been avoided but that the painter's violent end was "inevitable."

Whatever personal feelings it occasioned, Pollock's death was also a release. That fall Helen's paintings became freer, more improvisational, more brazenly indifferent to protocols of "finish." Some new joy came with the master's demise; some liberation, inseparable from the pall, fueled her work. And maybe for the first time that fall Helen could actually take a deep breath and view her career in historical perspective, as an affair of beginnings, endings, and phases, a new one now under way. Her romance with Greenberg was over, and now the artist Greenberg touted was dead. Helen's world was becoming bigger—the freedom that Pollock's work had granted her now ironically doubled because of the liberator's death.

In this respect Helen had one notable companion, at once logical and unlikely. Frank O'Hara was a poet and critic who had lived in New York since 1950, when he arrived fresh from his undergraduate years at Harvard. In the same years Helen was finding her way in the New York art world, O'Hara was doing the same. Getting a job working at the front desk of the Museum of Modern Art, he so much impressed the staff with his knowledge, insight, and sheer intelligence—he admired Pollock's art above all—that he soon became an indispensable part of the museum and eventually a curator. With his ready wit, his irresistible personal and physical charm, he became a fixture among artists and writers around Manhattan.

Pollock's death profoundly affected him. Five days after the artist was killed, and one day after the funeral, O'Hara wrote "A Step Away from Them," which his longtime roommate Joe LeSueur later described as the first great poem his friend wrote in his most famous idiom: the "I do this, I do that" mode. "A Step Away"

describes O'Hara's experiences as he walks through Manhattan on his lunch break. He notes the construction workers in their yellow helmets, the storefronts with their bargains in wristwatches, a lady putting a poodle in a cab. The impressions of the bright afternoon create a wry and pensive mood, an alert reverie, that turns to a meditation on death—not just Pollock's, but those of the lyricist John Latouche, who had died of a heart attack at age forty-one four days before Pollock, and the poet Bunny Lang, O'Hara's great friend from Cambridge who also died in 1956, of cancer, at age thirty-two. O'Hara asks, "But is the / earth as full as life was full, of them?"

O'Hara, like Helen, learned to keep his distance from Pollock the person—but for different reasons. "Did Pollock call Frank and Larry [Rivers] faggots one night at the Cedar, either to their faces or behind their backs?" LeSueur asks, trying to remember. No matter—O'Hara did not like Pollock as a human being, though he preferred to keep silent rather than voice his distaste. But Pollock's paintings were another matter. O'Hara admired them "extravagantly," says LeSueur, and in 1959 he would publish the first monograph on the artist. "A Step Away from Them" inaugurates this intense response, and its mode—"I do this, I do that"—might be O'Hara's most successful transposition of abstract expressionist painterly spontaneity into words. In "A Step Away" each seemingly random experience crisscrosses and loops with the others, creating an inevitable logic, a lucid delicate force, the whole hanging together. First one gesture, then another, an animacy of lines.

———

Helen met O'Hara in the early 1950s in the circle of Tibor de Nagy artists. At first she did not care for his way of thinking. On April 28, 1952, she had gone to a salon featuring O'Hara and several other poets, and she told Rudikoff she "thought it was awful." That could have been the night when the brash O'Hara railed against the "'deadening and obscuring and precious effect' of T. S. Eliot" on contemporary American poetry, an opinion likely to have outraged Helen, since Greenberg regarded Eliot as the most important poet of the age and since Greenberg likely sat next to her as she heard O'Hara opine. Two years later O'Hara favorably reviewed Helen's most recent Tibor de Nagy show, but her reaction was arch: "There was a fairly nice, though somewhat pansy-ish review of it in this month's <u>ArtNews</u>." Nevertheless, O'Hara got her work like few others did. The force of her paintings—"the power of their impact"—"is that of natural violence evoked in a lofty and immaculate tone." He lauded the works' "disdain of appearances," their "private unpleasantness of tenor which is made beautiful by its unimpeded self-assertion." He felt that the realities of emotional life, even the ugly feelings, came through objectively in her art, so that "the artist disappears and we have a fact of experience."

The affinities were there. Helen and O'Hara both dealt in impressions, sensations, fused into lovely and unlikely rhythms that give a feeling of the world as it appears, freshly, vibrantly, to a longing intelligence. "You just go on your nerve," O'Hara said of his methods. "You have to take your chances and try to avoid being

logical." Helen told Hartigan, "Thank god for my nerve, that's gotten me out of and through things since I was born!" The staining of color at close range, the fast arc of a soft line, the velvet pulsation on the eye of a shade of purple, another of brown—these are her painterly equivalents to O'Hara's guiding dictum: "I am mainly preoccupied with the world as I experience it."

It was not a surprise when in 1957 O'Hara wrote a poem called "Blue Territory," inspired by Helen's panting of the same title. "Now please if you don't like it or if the association bothers you in the slightest . . . please tell me and I can change it," he wrote to her in tones that show they had evidently grown much closer since the early 1950s (indeed they would have lunch later that week). O'Hara was kind and generous with many people—and he was much closer to Grace Hartigan and Jane Freilicher—but he and Helen had their own lasting connection. She would choose O'Hara to write the catalogue essay for her first one-person museum retrospective in 1960. And they kept close after that, sometimes literally side by side. At a party likely at Helen's in early 1966 O'Hara would scribble on the back of an envelope: "Dear Helen—I loved your party," before crossing out the word "party," the "d" in "loved," and the "r" in "your" to leave the sentiment: "Dear Helen—I love you," to which Helen responded on the same envelope: "& I love you because you're my first syllabil [sic]." The union of Frankenthaler and Frank stayed secure—long after Hartigan had decamped to Baltimore and ended her friendship with O'Hara, long after Freilicher had gotten married and grown more distant from him as well. When O'Hara was struck by a vehicle in 1966 on Fire Island, Helen was one of the people who reached him on the phone at the hospital before he

died. In the days that followed, her sorrow left a strong impression on the art critic Peter Schjeldahl, who interviewed O'Hara's many friends for a piece in the *Village Voice* that appeared shortly after his death: "Your remarks about Frank were very beautiful and left me very moved," he wrote to her. "I wish I could render on paper, more than your words, the tone of your voice. It would be the finest tribute." Even in the next decade, Helen suddenly broke into tears when she happened to see O'Hara's photograph.

Back in fall 1956, she reacted differently to another death—Pollock's. Her artistic freedom in the months after his car crash was a painterly equivalent to O'Hara's in "A Step Away from Them." Her paintings from that fall are airier, with lots of bare canvas, something like *Mountains and Sea* except with a zany ferocity that was new. One of them was *Eden*, a large eight-by-ten-foot picture painted on unprimed canvas, per Pollock's example, but a curious and remarkable departure from all the master had done. It shows a radiant child's sun at upper left, paired with a red hand to the right that seems to say "stop." Between sun and stop a pendulous teardrop shape, perhaps an apple, sports an incongruous pair of 100s, while to either side of the teardrop-apple, snakes and vines extend, a lush catalogue of glories and prohibitions. A feeling of madcap hedonism obtains: blue forms above the teardrop arise like spirits from a genie's bottle; spattery meteor-showers rain in from the right, propelled by cartoon speed lines of the kind that had stayed with Helen since childhood.

Helen's word of praise for it was "clumsy." She did not trust paintings, including her own, that were too neat and pretty, too accomplished and sure of themselves. She learned to look for

moments of discomfort and awkwardness as she worked; she wanted to feel "*clumsy* or *puzzled*," as she later put it. "If you always stick to style, manners, and what will work, and you're never caught off guard, then some beautiful experiences never happen." What she sought in her work was an honest exploitation of accident, chance, surprise: ugly lines, weird unkempt impulses, their blotchy painterly equivalents. Pollock exploited accidents, too, but in his greatest pictures he rhymed the blots back into order, coherence, a feeling of unity. Helen let the clumsiness stand, believing it opened out into richer worlds, more magical ones, than absolute control could ever portray.

Those worlds relate to the artist's own environs, her own body. *Eden* is a landscape of sorts, but foremost it depicts an intimate space. A red line runs horizontally across most of the lower part of the picture, making the rectangular blank at the bottom look like a floor. Another red line, a vertical one rising to one side of the sun, suggests the corner of a room, where one wall meets another. Rudikoff, who published now in *Partisan Review* and *Commentary*, her career as a fiction writer and cultural critic growing in parallel with Helen's as an artist, contributed an essay to a book on young artists edited by B. H. Friedman in which she noted this intimacy— the feeling of *nearness*—implied in her friend's paintings. "Despite their immense size, they project a specifically human space, responsive to emotion, tangibly perceived," she wrote. "I don't think her pictures ever suggest scenes viewed by an airplane or a telescope: the visual cues are closer, more individual and more specific." Presenting "a space of human scale, imaginatively, sensuously, visually," they are a "continuous and vital response to existence": not to

a person's place in the universe but to what it feels like to be in a room.

Unsurprisingly given their friendship, Rudikoff was spot-on about paintings such as *Eden*. "I was very involved in the emotional, as well as the physical, environment of a space," Helen recalled of those years. Like any artist, she was sensitive to her studios, to the way each one felt, its subtle characteristics of light and darkness, its smell and surfaces, its changeable atmosphere. "I have worked in windowless rooms, and I have worked in rooms flooded with light with a landscape immediately beyond the window. I have worked going from one to the other. I have worked in railroad flats, on boats, in hotel rooms," she later said. In the 1950s her sensitivity to rooms was most literally present in her work, starting at the decade's outset. *Woman on a Horse* clearly shows the demarcation of floor and wall in the lower right corner; *21st Street Studio*, another picture of 1950, follows in the grand tradition of artists portraying their working spaces. Soon after, she began painting *on* her immediate environment as well as in it, making two abstract works on window shades that she took down for the purpose—*Window Shade No. 1* and *Window Shade No. 2*. Then while in Paris in summer 1956, at the Hotel du Quai Voltaire, she made a painting on the brown drawer paper of her hotel-room dresser, employing her lipstick and nail polish as part of her palette. Although that picture suggests a view outside—we see what appears to be a window—the artist's materials bring the distance inside the room, near to her, as private as her own room key.

O'Hara also took his immediate surroundings and turned them into art. "A Raspberry Sweater," a poem he wrote in the same weeks

that Helen painted *Eden*, turns away from the wide world to con-
centrate only on a sweater the poet wears. Huge political events
transpired in those weeks—the Soviets were subduing the Hungar-
ian revolution, the Israeli military had crossed into Egypt in the
direction of the Suez Canal, and the 1956 presidential election be-
tween Eisenhower and Stevenson was two weeks away, with Steven-
son given little chance to unseat the incumbent. But O'Hara focused
only on the sweater he wears: "It is next to my flesh," he opens the
poem, by way of justification. "That's why. I do what I want." Helen
did likewise. On October 30 she wrote that "everyone I've talked to
has been terribly excited and frightened. . . . There's a real minute-
to-minute crisis atmosphere and that's all anyone's talking or read-
ing about." But she, too, portrayed only what was close—the
mysterious self-invented swirl of a physical and emotional space, the
feeling of a direct sensation. *Eden* is her raspberry sweater.

Pollock was the unlikely underwriter of these immediacies. To
many critics his drip paintings represented vast and remote
distances—"a distance beyond the stars—a non-human distance,"
in the words of the critic Parker Tyler, referring to works such as
Galaxy, *Comet*, and *Reflection of the Big Dipper*—but O'Hara
thought just the opposite. "In the past, an artist by means of scale
could create a vast panorama on a few feet of canvas," he wrote. But
in Pollock's art—because of the lack of identifiable subjects—"the
scale of the painting became that of the painter's body, not the im-
age of a body." Pollock's abstraction made each mark a record of his
physical encounter with the picture surface, not an illusionistic de-
piction of something else. "It is the physical reality of the artist and
his activity of expressing it, united to the spiritual reality of the

artist in a oneness which has no need for the mediation of metaphor or symbol." Although it portrays recognizable subjects, *Eden* always makes us feel Helen's relation to the picture surface, the different motifs scaled to her body, her action, until they do not seem to be a *result* of that action so much as a living extension of the person who painted it.

Sometime in early 1957 the photographer Burt Glinn took pictures of Helen in her West End Avenue studio, giving us a sense of her physical relation to her art. In one of Glinn's photographs, she stands on a chair, wearing a pencil skirt, tattered slippers, and a smock-like white blouse, the sleeves rolled up. Her hair falls in her eyes as she swirls paint in a Savarin coffee tin while judging an evolving painting on the floor. In another photograph, she sits in that same chair, her legs crossed, studying the work on the floor as we see behind her a smaller and larger work, together with a large portfolio. In another, she moves across her painting, her slippers not scuffing the picture, contemplating her next painterly move. Even the photographer's conspicuous presence does not disturb her dancer's poise, the practiced grace of her simultaneous tasks— mixing the paint, studying the painting, pushing off her right leg. The movements of eye and foot, the pendulum balance of delicate weights—right arm across the body, left arm holding the tin—work in perfect coordination, even as her aim was to watch for and exploit moments of awkwardness.

No form in Helen's painting emerged without mirroring the mobile intimacy of her relation to it. Tyler, the critic who had noted Pollock's cosmic abysses, saw how Helen's "emergent forms . . . seem to correspond closely to kinesthetic responses." Her body was

first at one spot, then at another. Each time it left a vestige of her presence, a kind of ghost form, without creating a forlorn sense that the artist is missing. Helen is always present, her body nearby, though never explicitly there.

A great example of this intimacy, again from late 1956, is Helen's *Venus and the Mirror*. Based on a Rubens painting Helen had seen that summer in Munich, the picture not surprisingly depicts a room. A horizontal line runs across it, establishing the join of floor and wall. Rough forms denote the woman and the glass from the Rubens original, here treated as the merest templates. This made it seem "diffuse and sketchy," as the *New York Times* critic Dore Ashton wrote in 1957, referring to *Venus and the Mirror* and *Eden* among other pictures. But it was this diffuseness that designated an intimate space in flux, a living environment rather than a frozen shell, and it required "immense delicacy," in Rudikoff's words, to get this feeling of forms and space flowing through each other in some unaccountably emotional way. With its upper tier largely painted in black pours and splotches on the bare canvas ground, *Venus and the Mirror* recalls Pollock's daring pictures of 1951, when he had allowed Picasso-style figures to return to his art, black and bare on an unprimed canvas ground. But Helen transforms Pollock's heroic and self-destructive totems—his guardian animals and staring fetishes—into a disarmingly private space.

The goddess's boudoir lacks metaphysical pomp. But it does something more daring. Helen's sensitivity allowed her to grant ordinary experience—faltering, incomplete, apparently meaningless—the large solemnity of art. No more promising a feeling than the primping vanity of beauty—an epitome of private life in its

self-absorptions—becomes the unlikely stuff of an ongoing dream: a work that, goddess-like, does not grow old because it is, though complete, never *finished*. Helen knew how to take a picture right up to the edge of legibility, to leave it just on the verge of literalism and then how to draw it back, letting the emblems retreat into their groves, away from meaning, away from philosophy, away from all explanation, until we have a subtle feeling of experience, hers and— ultimately—ours as we encounter this never-ending openness. "Life as it is lived," Rudikoff called it. O'Hara himself, with his yellow hats, his windows full of wristwatches, his ladies and poodles and cabs, his strict availability to perception, strove for the same. Not without sorrow, he and Helen both caught the quick scintillation of days.

In early fall 1956, Helen fell for another man. Herbert Gold, a thirty-two-year-old novelist, had moved to New York from Detroit at the end of the summer. Not long after, Harold Rosenberg and his wife, May, introduced him to Helen. She was ready to meet someone new. Her relationship with Howard Sackler had ended, and she adored Gold right away. He was handsome, with thick dark hair, full lips, a shapely jaw, and a brooding intelligent aspect. From a working-class Russian Jewish family in Cleveland, he had gone to Columbia, spoke Russian and French, and had written several novels by the time he met Helen. She could not wait to introduce Rudikoff to him, writing in schoolgirl tones that he had brightened her days, but she misjudged the depth of his interest in her. Fresh off a divorce from a deeply unstable woman, Gold arrived in Manhattan

"like a kid in a candy store," agog at all the women he was now free to date. Helen just happened to be the first one he met, and though they were sexual partners, that was about it. She was "not my type," he recalls. "Our souls did not meet."

Helen missed another cue—this one bearing on her art. As a novelist, Gold was a storyteller. As a storyteller, he could not make sense of Helen's paintings—one reason he turned her down when she offered to give him one. "I saw her on the floor," he recalls of watching her paint at her West End Avenue studio. "I could see the colors as charming and interesting, and I could see the accidents that would happen from the things that would be washed around by her hands. But I didn't find her painting that exciting. I knew they were serious; I credited them with exploring something that meant something to her," Gold says, but he also "wondered if it was all a shuck"—just the work of an "ambitious Bennington girl who met a significant art critic who was willing to promote her." Gold preferred art that told stories, that conceived itself as a window onto the world, like his writing. In his road novel of 1954, *The Man Who Was Not With It*, he lovingly described the big tawdry American world—the actuality that he felt Helen's paintings ignored: "the chicken-and-steak shacks shut in the suburbs of Cleveland . . . [the] open winter farmland, brown and quiet beneath its snow . . . those board houses and barns . . . a country fairgrounds."

But Helen's paintings were not windows. From her apartment she could gaze on the Hudson River, but her studio was less a platform to observe the world than a staging ground for the world to enter it—to funnel into her immediate space, where it would take shape as hers. The landscape elements in Helen's canvases always

came inside, as it were, so that forests and mountains and cumulus became intimate affairs of her body, of her process, of her absorption in just the experience of making *this* picture *then*, in a way she could literally touch. Not that she ever minded being around literary men who engaged with broader social and political issues. Gold was good friends with Saul Bellow, author of *The Adventures of Augie March*, and Bellow was friends with Ralph Ellison, author of *Invisible Man*, and they all attended Helen's dinner parties in fall 1956. It was a lively atmosphere—Helen was in her element—but literature of this rarefied kind was foreign to her art. Soon after *Augie March* came out in 1953, she noted how Clem and Rudikoff both felt that Bellow had "tried to jam in all his knowledge and prove something and that it was tortured"—a verdict reminiscent of Helen's point that no painting (no creative effort of any kind, one might say) is good "intellectually." Gold said that Helen's affection for him did not extend to reading his books.

O'Hara's mode was much more her own. She increasingly courted the "disdain of appearances" the poet had praised. In *Giralda*, another painting from 1956, a large phallic shape alludes to the bell tower of Seville Cathedral, the Giralda, which Helen had seen with Greenberg on their trip to Europe in 1954. But the tower is no distant object of recollection, no object beheld through a window. It is as near to Helen as the picture was to her body as she painted it. All is close, the record of an immediate physical encounter, a million happenstance impressions and feelings transmuted to an indelible nearness. Of the painting the artist herself might have said unapologetically, "It is next to my flesh." The intimacy of the sensation, moreover, has the courage not to be pretty. *Giralda*'s

atmosphere is heavy, churning, bacchic. With its turbid crescents of dirty white, its blooms of exploding green, its long contour of fretted purple-gray that swoops up along the left edge, *Giralda* is a far cry from the lyrical peacefulness of *Mountains and Sea*. No critic could possibly see it as "pale and pleasant." It gives the feeling of passion before it is edited, tamed, turned into romance. In its rapturous ugliness, the painting has the feeling of a heavy frolic, flesh and sex in some sylvan setting. The genius of Rubens—whom that very year Helen had anointed as "the greatest of them all"—lurks in these frenetic and somber zones of lust. As O'Hara had put it two years earlier, "She does not hesitate to deal with her subject with a frankness approaching sordidness."

Helen's paintings and O'Hara's poetry alike suggested a release, an exhalation. Critics likened the work of each to wind. *Eden, Giralda*, and the other works in her 1957 Tibor de Nagy show "carry with them evocations as of gentle winds, waves, sprays of light, and even fragrances wafted in on the horizontal flow of paint," Dore Ashton wrote that year. "The shapes," said another reviewer, "are as unsubstantial as colored gas let out of a bottle and diffusing through the atmosphere." O'Hara's poetry "always makes me feel like a cloud the wind detaches (at last) from a mountain," wrote the poet's friend James Schuyler in 1956, "so I can finally go sailing over all those valleys with their crazy farms and towns." Schuyler, himself a poet, was also an art reviewer and in 1957 he praised the way the paint in Helen's *Planetarium* "drifts like wind." In a decade famous for its button-down conformism—the movie version of Sloan Wilson's novel *The Man in the Gray Flannel Suit* was

released in 1956—Helen's paintings and O'Hara's poetry were like fresh air blowing through a stuffy house.

At the same time, reviewers such as Schuyler misjudged Helen's paintings. Her pictures are not exactly breezy or gentle. The critic Barbara Rose was closer to the truth when she wrote later of the "billowing, flooding, churning, or flowing" energies of her art. In Helen's own words of 1957: "I think of my pictures as explosive landscapes, worlds and distances held on a flat surface." And again that year: "I am involved in making pictures 'hold' an explosive gesture." *Giralda* and *Eden* are explosions—great whirs of energy that burst toward the viewer with the ferocity "held," suspended, on the picture plane. Think of a detonation in which debris flies toward a camera that clicks: at that moment, the image portrays the volatile spread of disparate materials let loose in the blast. This is the effect Helen sought to attain: the meteor shapes flying in from the right, trailed by their cartoon speed lines, in *Eden*; the phallic burst of forms in *Giralda*. In each painting Helen catches these energies, holding them on the surface of her pictures as surely as the red hand in *Eden* marks the sign of stop. Helen's critics in 1956 and 1957 softened the strength of her maelstroms, turning her tornadoes to zephyrs, even as their metaphors of "colored gas" and "sprays of light" did name some delicacy her storms encompass in their very strength.

In her paintings, as in O'Hara's poems, no single sentiment ruled the day. No picture was so clear that it could be sorted into an expression of one emotion. Delicate mixtures of melancholy and joy, rapture and pain, all get their quantum of weight and air. O'Hara's

poem "My Heart," from 1955, might as well be a manifesto for Helen's own emotional method:

> I'm not going to cry all the time
> nor shall I laugh all the time,
> I don't prefer one "strain" to another.

The mixed feelings, moreover, required no explanation. It was not the poet's or the painter's fault if the work failed to make ready sense. As O'Hara was to put it in 1959, "Who cares if there is a point to be gotten, a message to be sent? How can you really care if anybody gets it, or gets what it means, or if it improves them. . . . Too many poets act like a middle-aged mother trying to get her kids to eat too much cooked meat, and potatoes with drippings (tears). I don't give a damn whether they eat or not." Helen was the same way. "You want clues?" she asked a reporter who inquired about the meaning of her art. "There are no clues."

Back of it all for both was Pollock, great because he was elusive, even and especially in death. At the artist's grave, a little girl tells O'Hara in "Ode on Causality" that the man is not actually buried beneath the stone. "He isn't under there," the little girl tells him, "he's out in the woods." The poet watches the little girl run off and wishes that he, too, may always be a child, "distant and imaginative," and that his poetry's "ambiguity of light and sound" will grant him a posthumous glory, away from the grave, out in the woods somewhere, where he, too, like the painter whose art he adored, will nobly live outside the calculations of those who add and divide the strict meanings of life. Helen felt the same way.

But in one important respect about their undying art they differed. O'Hara trusted that his poems were great and that his reputation would take care of itself without any undue effort on his part. Helen, however, wanted to make sure she became well-known, even famous, certainly in her lifetime, and she did not regard it as a degradation of her ambiguous art if she sharply oversaw the making of her fame.

MAY 13, 1957

New York: Buying

G ordon Parks arrived in Mobile, Alabama, ready to find what pained him. The most famous black photographer in the United States was there on assignment for *Life* magazine, his task to make color photographs for a feature on the segregated South. Among the pictures he took that summer of 1956 is one of a black father helping his daughter to drink from the "colored only" drinking fountain outside an ice cream shop, while three other black girls patiently wait their turn, as the adjacent "white only" drinking fountain stands unused; another of a little black girl staring avidly at white child mannequins in a department store window; a third of six black children staring through a chain-link fence at a carnival from which they were excluded.

The sorrowful trip—on which a group of white thugs tried to steal Parks's camera on the train to Nashville—prompted only one type of picture he made that year. He also took gorgeous photographs of white fashion models in Manhattan and environs.

One shows four paramours in top hat and tails flirting with a lady wrapped in a fur cocoon cape at dawn before the Flatiron Building; another depicts a woman in a flowing red gown stepping onto a Park Avenue curb attended by her beau, also at dawn. A third features three pert women in fashionable everyday wear—sweaters and pants—posed in the afternoon light filtering through a Hoboken warehouse. With his skill and cosmopolitan awareness, Parks was adept at getting viewers to buy into his visions, whether of injustice or haute couture. He was a natural choice to take the photographs for an article on young women artists that would appear in *Life*; his photographs would help establish abstract art as a privileged new fashion.

When Parks came to her West End Avenue studio, Helen did not shrink from the occasion. In the images Parks took that day, she poses not only with her paintings but on one of them—*Blue Territory*. Her gaze variously pouty, confident, and serene, Helen gathers her legs up behind her, her blouse and skirt harmonizing with the pastel colors of her paintings. Having already appeared in *Life* back in 1950, and knowing something of the magazine's house style from her job interview there in 1952 (as well as her sister Marjorie's stint there in the late forties), she likely understood nearly as well as Parks how to craft an image exactly for the magazine's massive target audience. She would be the demure but bold independent woman, the creator of her own world—a relatable novelty to the millions of housewives and their husbands who read the magazine.

The article, called "Woman Artists in Ascendance," appeared in the May 13, 1957, issue. It focuses on Hartigan, Joan Mitchell, Nell Blaine, and Jane Wilson, but Helen gets pride of place in a

full-page photograph leading off the piece. Her simpering lips a beautiful shade of red, her dark hair a lustrous black, she looks up at the camera, *Mountains and Sea* over her right shoulder, her direct gaze suggesting a pride and power of ownership, a sense that she is the resident mermaid of this aqua-exotica, the maker of all the wall-to-wall shades of blue that translate so well to the magazine's bright pages. No one else gets quite this star treatment. Appearing on the next page below the headline, Hartigan's picture is smaller than Helen's, and Mitchell's, on the page after that, is smaller still. Wilson, a model as well as a painter, gets the bombshell treatment, reclining on a divan before a chalice of grapes, one of her Rubensian nudes behind her. But even this housewife voluptuary pales before Helen's more evident dignity of being in her studio, with her work, her beauty bound more readily than Wilson's to the making of her art, not the simple display of it and herself.

Of course, these photographs were pieces of marketing. An accompanying text notes that the featured young women's paintings are "being sought by leading museums, galleries and collectors." It could be hard to tell, in fact, where the magazine's editorial content ended and the advertisements began. For each issue, *Life*'s editors carefully arranged the jigsaw puzzle of stories and ads, attending to the crossover between editorial and sales content, and for the May 13, 1957, issue they aligned the photograph of Helen with a color advertisement for Jantzen "sunclothes" showing sporty young women and their summer sportswear. One of the women, dark haired, happens to look a lot like Helen. With or without the echoing ad, *Life*'s adoration was clear enough: Helen is young, attractive,

going places, and in the business of selling—not the clothes she wears but the art she makes.

Appearing in the pages of a magazine with a massive circulation promised her a big boost. Since her first exhibition at Tibor de Nagy back in 1951, few people had bought Helen's paintings. When the gallery's director, John Myers, called her on a November day in 1952 to say that a customer had purchased one of her drawings for $30, she was delighted—even a small purchase was worth celebrating. But she also faulted Myers for not doing enough to promote her work. "I've gotten several raw deals and feel quite furious and frustrated," she wrote in 1953, excoriating him at the time *Mountains and Sea* was on display. Myers, for his part, said he simply found her challenging work difficult to sell. He recalled how at Helen's first Tibor de Nagy show, back in 1951, he had been puzzled when an elderly gentleman bought a small painting of hers. The man did not look like the type. It made sense only when he mumbled "something about his great friend Judge Frankenthaler." By the latter part of the decade, with the market for abstract art picking up, Helen was thinking about how she, too, could reap the rewards.

The sale of a painting was validation of the kind she needed. Even if she did not need the money itself, she was keen to keep up with her peers and elders, whose work by mid-decade was becoming unexpectedly marketable. She saw that her friend B. H. Friedman and his wife, Abby, owned a modestly sized Pollock drip painting, *Number 11, 1949*, which they displayed proudly at their large apartment on Sutton Place at Fifty-seventh Street. Friedman was a real estate executive for the Uris Buildings Corporation, an exciting and lucrative profession in an era when the office boom was just

beginning in Manhattan. He had money, he was sensitive (at Cornell he was already an aspiring writer and he eventually published many books, including one on Pollock), but he had no particular art background. He and Abby just came to love modern art, first that of the Europeans, then, gradually, the Americans. This was no dalliance. Friedman thought of Pollock as "synonymous with the expression of freedom" and likened his art to the poetry of Dylan Thomas.

Friedman's friend Ben Heller was on a different plane of collecting. A Manhattan businessman, Heller had begun buying modern art with his wife, Judy, and by mid-decade their ambition, taste, and checkbook suggested unheard-of possibilities. Back in August 1955, when she was staying at the Marca-Relli house in the Hamptons, Helen noted approvingly how Pollock had just sold one of his paintings for the astronomical sum of $8,000, by far the largest amount the artist had ever received for a single picture. The painting was Pollock's great mural-sized picture *One: Number 31, 1950*, and the buyer was Heller. A photograph of Heller studying his new purchase just after it was delivered to his Central Park West apartment shows *One* on the floor, newly divested of its plastic wrap, while in the background two Rothkos already hang on the walls and a second Pollock, *Echo*, which the artist had thrown in gratis after Heller's munificent purchase, awaits its own installation. Heller was changing everything not only because of his wealth and willingness to spend it, but because he had taste, erudition, and attitude, a combination of feelings that made Pollock and other artists feel that their art was genuinely appreciated. "Buying *One* was an act of faith," Heller recalled, noting how he and Judy needed to get used to "the day-to-day living with a creation of such dominance," how

they would have "to live up to the work." The journey *One* took them on was transformative: "From it we learned how penetrating, changing, enlarging and vital an experience living with such a painting is." This was the kind of collector Helen dreamed of.

By 1957 many of the established abstract artists were eager to pay court to Heller, whose enthusiasm for the new art suggested that others of his coat-and-tie ilk might soon follow his lead, even if initially his friends scratched their heads before Pollock's drips. The artists sensed the ripeness of the moment and accustomed themselves to pitches, even as they grimly sought to maintain the fierce independence of the days when few admired their work. In early 1957 Rothko and Newman attended a party at the Heller place, where they admired their works in his collection and hobnobbed with the nouveau riche while condescending to fellow artists of a lesser rank as a "peasant class." The hierarchy intensified the following spring, when Rothko reached an agreement with Phyllis Lambert, the daughter of Seagram's president Samuel Bronfman, to provide "500 to 600 square feet of paintings" for the Four Seasons Restaurant in the new Seagram Building in midtown, for the unheard-of fee of $35,000. Even if Rothko eventually reneged on the agreement, repulsed by the elitism of the space he had agreed to decorate, it was apparent that the abstract artists were entering a lucrative new era. The collector was becoming more important than the old camaraderie that everyone's lack of sales had made possible. It was "topsy-turvy shit," the painter Herman Cherry told David Smith. "What pretentiousness to say, 'It is risky business to send a painting into the world.' Not if it's bought at a good price it isn't."

Helen's pose for *Life* took place in this brave new world. The

fact that she was in the magazine at all, her youthful debut in the Hotel Astor photograph aside, spoke to a change in the times and in herself. It showed her distance from Greenberg, who scoffed at *Time* and *Life* magazines, reviling their smooth reportage as false, fake, a full-on mission to "discredit reality." This was the "psycho-pathology" of these magazines, as another intellectual of Green-berg's circles, Marshall McLuhan, had described it: the "rapid-fire prose" encouraging a "sub-rational response" to stories and ads alike; the careful courtship of different demographics, with middle-class readers encouraged to envy the "exotic fooleries" of their taste-making economic superiors while given subtle permission to regard these same achievements as "unbelievably moronic." By 1957 the cultural critics themselves were becoming part of American insti-tutions, gaining professorships and generally recognizing that, in Philip Rahv's words, American postwar prosperity had made the "intellectual bohemian or proletarian" a thing of the past. Even so, there was a difference between this conformity and appearing in full color in the pages of *Life*. Helen had made her peace with what the old *Partisan Review* crowd still detested.

Her pose suggests something of the new era. Helen's air is proprietary—she comes across as the owner and the seller of her art—and the sense of ownership marks a subtle but important change from only a few years earlier. Back in 1953, at Greenberg's invitation, the painters Morris Louis and Kenneth Noland had come up to New York from Washington, D.C., to visit Helen's stu-dio, hoping to take inspiration from her art, and she had not minded in the least. When Louis and Noland soon started borrowing freely from Helen's technique of staining on raw canvas, acknowledging

that *Mountains and Sea* had shown them a path between Pollock and their own art, she welcomed the appropriation. "When they saw *Mountains and Sea*, they really admired it, admired me, wondered at it, and were going to lick it. Join it and lick it both. And I liked that," she recalled. Those were the years when artists took each other on, largely freed from the jealousies that money brought, the days when *Mountains and Sea* grew as a response—"I'm going to knock your eyes out"—to Hartigan's *Massacre.*

By the time of the *Life* photo shoot the terms of artistic exchange were shockingly different. "Oh my God, can you believe this?" Noland said to Michael Hecht, his accountant, after someone bought one of his paintings for $750 later in the decade. But Helen took the new prosperity in stride. It was her right and expectation to profit from her art, and of course her paintings should fetch a good price. Hecht, a fresh-faced graduate of Baruch College when he became Helen's accountant in 1959, remembers how she had "a little more self-confidence" than the other painter-clients his firm was attracting. "I think Helen always thought a little more of herself than her artist pals. She was strong and she was convinced, and it was very important to her to have the sales, the recognition." Her strength and conviction are already there in the *Life* photograph.

In 1957 a new uptown venue signaled the growing market Helen hoped to exploit. Leo Castelli, a cultured Hungarian émigré who had curated the Ninth Street show in spring 1951, finally opened the gallery he had long aspired to. Located on the third floor of a town house on East Seventy-seventh Street, the Leo Castelli Gallery had its first show in February 1957. Castelli himself implied, in his manner and appearance, the refinement of the market forces now gathering power.

He was "enthusiastic, optimistic, apparently totally self-assured, comfortable and graceful in most situations, at home in five or six languages (including Rumanian)," wrote the art critic Alan Solomon. He "seems invulnerable, absolutely secure, in command. If your own security is at stake, he is one of those people who can be very threatening. He is too smart, too quick. Beneath all that charm there must be a cagy operator." Helen was not among the threatened ones. By the end of the year one of her paintings would be included in a group show at the new gallery. By the end of the decade, Heller owned a small and beautiful painting of hers, *First Blizzard*.

With the art market growing stronger, Helen was not content to watch and wait. She wanted to make things happen in her favor. She may have had something to do with the *Life* feature, planting the idea for it behind the scenes. She may also have campaigned for another story that ran in July of that year, an article in *Esquire* about the New York art scene—specifically the wealthy patrons and the hip artists they admired, including Helen and Hartigan. In photographs taken by Burt Glinn, the article shows moneyed intelligentsia at urbane cocktail parties and late-night jazz clubs, where they talk intensely with poets and painters at crowded tables over highballs amid the plucking of cello strings. Three of Glinn's photographs of Helen in her studio also appear. The pretty young painter absorbed in her work, her hair over her eyes, perfectly flatters an *Esquire* reader about his "Upper Bohemian" tastes. So does another photograph of gallery-goers at Helen's most recent Tibor de Nagy show, with *Venus and the Mirror* in the

background. She did not mind becoming a token in a tug-of-war then developing between *Esquire* and *Playboy*, its neophyte competitor, as the older magazine sought to match the upstart publication's celebration of the cultured bachelor as a ne plus ultra of modern life. The cover of the July 1957 *Esquire* shows the trophy wall of a man-about-town: two tickets to the theater, a *carte de visite* of Shakespeare, tubes of paint, a paintbrush, a glass of white wine, a cutout color photograph of a woman's shapely legs, a trumpet, a woman's ponytail hung like a scalp, and the announcement for Helen's Tibor de Nagy show. She had hit a kind of big time: the cover of a national magazine, her art a symbol of a bachelor's swinging lifestyle. When the issue came out, Hartigan wrote to Helen with the air of someone who had a say in its creation: "I am looking at the *Esquire* cover with Frank [O'Hara] . . . I think the article is good, and amusing to see everyone."

Gaining this recognition inspired jealousy. "Helen's all over the place in *Esquire*. And wherever Helen isn't, Grace is," Joan Mitchell groused to O'Hara, who promptly told Hartigan, who relayed the news to Helen. The dispute was of a small order—it was already clear that Mitchell despised Helen, whose stain technique she dismissed as the work of "that Kotex painter"—but the envy signaled that Helen needed to be especially tough in the emerging era of publicity and sales. Thank goodness that she shared a genuine bond with Hartigan—a "little provincial sorority of the spirit," as Friedman critically described it, observing the two of them gossiping together in February 1957. The alliance helped amid the jealousies of fame and money.

But there were other battles, other resentments, that required

greater fortitude to rebuke. Barnett Newman, the dapper grandee of the New York art world, was litigious and unpredictable, and when he saw *Esquire*'s layout in galleys back in February and discovered a photograph of himself in it, he was furious. "Barney, the paranoiac" was "ready to sue *Esquire*, Tibor de Nagy, Helen F., etc. because his photograph was taken for some 'Upper Bohemia' article that *Esquire*'s going to do," wrote Friedman in his diary. Newman's threat was more than verbal bluster. He sent Helen a chilling letter damning her art and implying that she had a role in creating the *Esquire* story:

> *Dear Helen:*
>
> *Art is cunning, so say the dictionaries, but it is time that you learned that cunning is not yet art, even when the hand that moves under the faded brushwork so limply in its attempt to make art, is so deft at the artful.*
>
> *Now that I have found you out, I urge you to make certain that your friends, Felker [*Esquire *features editor Clay Felker] and Glinn, follow the advice that I have already given them and which my attorneys are also giving them, to make no use whatever of any photos taken of me or of anything I may have said.*
>
> *Very truly yours,*
> *Barnett Newman*

Newman felt Helen had encouraged the article, that she was "cunning," a conniver and publicity hound. He worked hard to craft

the letter's insulting tone, writing several drafts before settling on the final language, and when it arrived Helen found it hard to take. "I've been generally tearing all day," she wrote to Rudikoff, saying she found the letter "very upsetting" but also "strangely flattering." But she was not intimidated. She thought Newman was crazy, "mad," in her word. She was hardly dissuaded from publicizing her work and that of her friends, or from continuing to make the kind of work that Newman damned. She could even take a kind of pride in what had occurred. In a few short years, she had gone from a relative nobody to inspiring the wrath of an Irascible—moreover, one with an "Old Testament sense of Justice," as Friedman put it—and she did not back down.

What saved her was her indifference to upsetting others. Intent on getting her way—in this case, promoting herself—she did not mind how she came across. Naturally, she rubbed people the wrong way. The *Esquire* dispute bothered her friend Friedman, who deplored what he, too, called Newman's "madness" but admired what the older artist's contempt stood for: "the avoidance of the chic, the fashionable, the opening, the event which can't be missed." For him, his friend Helen stood for all these things. He lamented her "compulsive attraction" to fame, foretelling a rift between them that would last nearly thirty years after he drafted a piece on her for *ARTnews* in 1965 and became so dismayed at her irritable rewrites (she required him to send it to her) that he threw up his hands. "I was too hurt by what I perceived to be your choosing careerism over friendship," he would write to her in 1992, finally relenting to her overtures of peace twenty-seven years after the much-revised essay was published. "I haven't forgotten how fond I was of you

pre-<u>ArtNews</u>." Ever since her relationship with Greenberg, which had struck observers as a power grab on her part, Helen had turned others off in this way. In fall 1956 Herb Gold recoiled when she hosted a party for the prominent San Francisco art critic Alfred Frankenstein. "I felt like she was sucking up to him. Her house was open to anyone who could help her career," he says. It was a "single-minded pursuit," and part of the reason he ended their brief relationship. Alice Baber, Gold's new girlfriend, was an equally serious artist but much more humble than Helen: living in a tiny place on a mews on Commerce Street downtown, she "wanted to make it as a painter but didn't have the drive and intensity about it or the money, like Helen." Indeed Alice Baber—though a fine painter—is little known now.

Something saved Helen, however. Her paintings stood apart from her quest for recognition and sales. No matter what rough-and-tumble world her pictures might enter, they had a quality of remaining apart, of being secure in their separate realm of exalted sensations. A good example is one of her greatest paintings of 1957, *Jacob's Ladder*, purchased, soon after it was painted, by the Manhattan labor lawyer and businessman Hyman Nathan Glickstein. A 1926 graduate of Columbia Law School and a ubiquitous figure in Manhattan courts, Glickstein vigorously represented unions in strikes. He had defended rock-throwing shipyard workers after a melee with police in Brooklyn in 1937, and the Compressed Air Workers in a twelve-day strike during the construction of the Brooklyn–Battery Tunnel in 1948. In the 1950s, Glickstein turned

to business and in 1956 became the head of a New York syndicate
that built the El Commandante horse race track in San Juan, Puerto
Rico, a venture that promised a monopoly on horse racing in that
territory and that opponents deemed suspicious and "highly irreg-
ular" but that opened in 1957. That same year, or very soon after,
Glickstein purchased *Jacob's Ladder* from the Tibor de Nagy
Gallery (a success for John Myers, despite Helen's criticisms). His
purchase tells of the rapidly expanding clientele for abstract pic-
tures in those years—a toughened lawyer used to staring down
judges being a different kind of patron from the connoisseur busi-
nessman Heller.

But *Jacob's Ladder*, in itself, suggests nothing of the new sales
atmosphere. Not that it necessarily should. Helen certainly did not
paint it for Glickstein, or for anyone in particular. But one could
make a case that in a time of growing market interest—when it in-
creasingly entered a painter's imagination that now *anyone* with
money, whether a lawyer, businessman, doctor, or politician, could
step into a gallery and buy a picture—the art would bear some trace
of that expectation of patronage. It would pander, it would seduce;
it would "come on" to the well-to-do clients the artist knew were out
there. Hartigan's large painting *Billboard*, of 1957, with its bright
patterns of blue and orange and smiling faces, based on a collage
she had made of *Life* magazine advertisements for toothpaste and
liquor and Jell-O, made an uneasy truce with the beckoning new
class of clients—people who wanted art to be pretty, welcoming, as
happy as the people in the advertisements themselves—while striv-
ing to protect Hartigan's apartness from, as she put it, "that which
is vulgar and vital in American life." Yet *Jacob's Ladder*, like

Helen's other paintings of 1957, remains not only apart from that popular milieu; it seems oblivious of it, as if all the hullabaloo that she herself was helping stir up became silent, nonexistent, when she was in the studio, alone with the fantasies she made. "When the artist reveals his concern for the audience," she said later, "there is something wrong, something cynical, and the creative process is no longer pure."

Jacob's Ladder is certainly a large and public painting—like all of Helen's work, it hardly minds attracting notice. At nearly ten feet tall, with its fluttering pink wing shapes at the top rising from a central stalk, it demands to be seen. But some quality in these aggrandized bursts implies a melting and vulnerable softness as of feelings so delicate they can be stated only in whispers. The paint soaks into the canvas, retiring in the very act of appearing. The emotions it implies are so idiosyncratic that, as in *Mountains and Sea*, they amount to something like an excruciatingly private sentiment laid bare, revealed vastly in public, as in a diary left open whose words yet cannot be read. Only a cynic could see the melting lyricism of this painting as one with the loud and brash world of Nathan Glickstein and other members of the new art-buying class. Even the reasonable assumption that these new businessmen-connoisseurs sought the tamp and softness of a painting that was "just" color, that did not mean anything at all, and that was a relief from the hurly-burly of means and ends, hard decisions and final rulings—and that, moreover, they might value this association with valuable meaningless things because they needed to keep up with the moneyed elite of New York such as Heller who were going in for that sort of thing just then—even this assumption does not mean

that their concern for social dominance really ever touched the inwardness of her art. It is true that Helen eventually owned a small picture of a crucifix of dollar bills, painted by the artist and frame maker Robert Kulicke, which she hung in her kitchen as a reminder of the sacrifices she made for sales, but that was later, in the 1970s, when, according to John Blee, she became too cozy with the businessmen who bought her paintings and accordingly lost something of her gift. But back in the 1950s, she could cordon off the metaphysics of *Jacob's Ladder* from the aspirations that, outside the studio, the same painting would help fulfill.

"Dream" is a word for that inscrutable privacy. In the story from Genesis that the title alludes to, Jacob lays his head on a stone pillow, falls asleep, and envisions steps coming down from heaven. Helen rarely recorded her dreams, unlike others in her circle (Friedman and Greenberg, for example), but she was a veteran of psychoanalysis and like other Manhattan secular Jews regarded the analyst's office as a temple, therapy as a religion. *Jacob's Ladder*, with its unaccountable forms, suggests a kinship between the inscrutable inwardness of dreaming and the process of painting: a kind of automatism (the imagery forming itself, associatively, before the painter's eyes) punctuated by periods of "waking"—of alert, distanced judgment. Like *Western Dream*, another painting she made that year, like indeed so many of her paintings, *Jacob's Ladder* shows an assortment of pictorial episodes—disparate patterns and incidents—something like the breathtaking scene changes in the dreams her acquaintances recorded in their diaries. As in those dreams, where the dreamer is transported from one

phenomenon to another one completely different, Helen's paintings abruptly shift motifs: *Western Dream* suggests a sunrise, flowers, buzzing insects, and a whirling blue tornado-like blob. Paintings so effectively dreamed—as irreducible to "meaning" as the dreams of her friends—strongly resisted becoming mere merchandise and status symbols in the hands of a buyer. Owned by MoMA after Glickstein gave it to the museum in 1960, *Jacob's Ladder* is bold on the wall but strangely unconscious of the public eye.

Her art was inward, but Helen resented that viewers and owners did not more readily get it. On February 10 Friedman, an owner of one of her paintings, wrote in his diary that Helen is "so defensive (manifested in being aggressive). I ask 'How's your clot?' [A minor blood clot she was then suffering from.] She feels put down: 'It's an embolism.' I try again, pointing to [a] painting by her over the mantel [the picture of hers that he owned]: 'Is that typical of the work in your show?' . . . Her defense mechanisms mesh: 'No,' she almost shouts. 'I'm sorry,' I say, 'I like it very much.'" The bad temper owed not only to Helen's innate insecurities but to the deep gap—perhaps widening for her then—between her art making and an outside world that, even and especially among friends, could seem maddeningly clueless about her art's special intimacy. The art was a test of those worthy to perceive it, and the constant stress was not only on the test taker—Friedman, in this case—but on the artist who cultivated a broad public for paintings so uncompromisingly personal. By seeking wide recognition, Helen increased the

misunderstandings that enraged her. What she wanted people to see, what she increasingly wanted people to buy, was the remarkable generosity of her art.

Helen's emotional need and professional ambition led to a major event in her personal life. In November 1957 she arrived late in the evening at a dinner party hosted by Friedman and his wife, Abby, at their home on Sutton Place. There she found one of the guests, the painter Robert Motherwell, in a bad state, depressed, down, recently separated from his second wife, Betty. Helen had met Motherwell a few times before—once back in the Clem days, when he had come to Greenberg's apartment, another time at a New Year's Eve party, and again fairly recently, in summer 1957, when she had a short conversation with him and his wife in Provincetown. Thirteen years older than Helen, Motherwell was an established abstract painter, one of the Irascibles, a man of deep book learning who had been a philosophy major at Stanford and had come to New York, back in 1940, originally to study art history. Since the late 1940s, he had been making a series of large black-and-white paintings, collectively titled *Elegy for the Spanish Republic*, that had won him a growing reputation. But on that late fall evening at the Friedmans', he was upset about the failure of his second marriage, and Helen responded to his depression in her most generous manner. Despite her relative youth, she gave him some tough-love advice, "a real perspective, eye-to-eye, directly." Here her reminiscence tails off; she does not say exactly what her advice was. But as they kept drinking beer and talking into the late hours, Motherwell

found himself taking seriously this young woman whom he hardly knew. "I think I put it in such a way, and what came through was this passionate interest, not just a stupid kid," Helen said later. "I mean, I think in one sense he thought who the hell are you to come off with this?" But "he also sort of listened, because it did make sense. And then all kinds of things happened."

Two weeks later, on December 16, Motherwell telephoned Helen at her West End Avenue apartment and asked her to dinner. She said she planned to go to an opening at the Castelli Gallery to see her painting displayed there in a group show. She and Motherwell ended up going together. The place was packed, and among the guests was Helen's then boyfriend, a handsome young painter named Reginald Pollack, displeased that she had come with someone else. A "very neurotic drama" with Pollack in the gallery left her in tears. She told Motherwell that she wanted to get out of there for a drink but not at a bar—"I don't want to go to a place where there are waiters, people, noise." She suggested her apartment instead, and there they talked through the night. Their topic was life, and they conversed "in a way that most people would think profound adolescents might," she recalled. "But it was sort of very accurate and real. . . . this is the way life should be, this is the way I think it could be made, these are the problems, these are the things I don't know about and wonder about, these are the horrors and experiences. And there was a fantastic recognition and a permanent road into each other." Pollack, who happened to be leaving for Europe that evening, disappeared from Helen's life. By late January 1958, she and Motherwell were an established couple.

The relationship grew from the emotional bond of two lonely

souls. Helen's outgoing nature was, according to her, only another expression of her isolation. "Both Bob and I after years of loneliness and a gregariousness that's the result of loneliness find that two things interest us the most and make us feel and live the most: each other and work," she was to say the year after they connected. The gregariousness was partly clear in Helen's dating history: the spiffy "It girl" on evenings out with Clem, then the relationships with three men her own age: Sackler, the bear-hunting playwright; Gold, the handsome novelist; and the ruggedly good-looking Pollack, who had planned to marry her and who soon could be found, head in hands, sobbing: "Why, why did Helen leave me?" But Pollack and the others had never found that sad isolation inside Helen; Motherwell did. He knew sorrow firsthand, having contemplated suicide in 1948 and being a depressive soul generally.

His words about the essentially private act of painting resonated with her own views. "It is our pictures, not ourselves that live the social life and meet the public." So did his views on what art is for: "If a painting does not make human contact, it is nothing." His defense of painting was her own: "The act of painting is a deep necessity," he had written in 1955, "not the production of a hand-made commodity." More even than any of this, however, Motherwell's calm drew Helen to him. Dating Sackler, Gold, and Pollack, like her social life generally, had made for all kinds of exhausting drama: "false kicks, too much booze, restless sleep, telephones." Being with Motherwell was peaceable—a first in Helen's relationship with a man. Up until then, the only bulwark against her demons was in the studio, the sole place where she could gain respite from the "anxieties, beliefs, temptations, frivolities" that popped

up "like little gremlins" if she did not paint for even as short a time as a week. Her romantic life had been part of this tempest. But with Motherwell her gremlins did not appear. She could be with him without the hysteria that plagued her time with her recent boyfriends and with Greenberg. Even many years later, it was clear to onlookers that Motherwell was the love of her life.

But to outsiders, the relationship appeared in another light. Gossips commented on the union as a strategic alliance. The young woman who had become Clement Greenberg's partner almost as soon as she hit town after college and stayed with him for as long as possible, gaining every last advantage—this was the cynical view of their relationship—had now moved on to an arguably even more advantageous partnership. "Helen Frankenthaler and Motherwell have found each other," the painter Herman Cherry wrote to David Smith in early 1958. "I think it is the most perfect match from any angle. For one thing, they are both gentlemen." *Gentlemen*: the word meant money. Motherwell, whose father had been president of Wells Fargo Bank, was among the few other artists besides Helen who came from wealth. When they met, he lived in a town house on East Ninety-fourth Street. He was also an established modern artist—in Nina Leen's *Irascibles* photograph, he appears just behind Rothko and to one side of Clyfford Still, among the nation's knighthood of abstract painters. Joining him, Helen would be a dignified eminence, partner in a union that consolidated art-world power and wealth, trading a mad pursuit of passion for a far more respectable existence. Motherwell loathed one of Helen's dresses—black, sequined, with a white orchid on the shoulder strap—and made her get rid of it soon after they became a couple.

It was too sexy, too flamboyant. Paul Feeley satirically nicknamed the couple Helen Frankenmother and Robert Motherthaler.

With the new liaison, Helen's status began to change. The next year, she shocked her longtime gallerist John Myers when she told him she was leaving Tibor de Nagy. "When I asked her why, what had gone wrong," Myers recounted, "her answer was simply, 'Of course you understand why,' and that was that." Helen moved to a more prestigious gallery, André Emmerich, where the prices were higher and the business transactions less opaque and hopefully more frequent. There was another reason for the departure: according to the flamboyantly gay Myers, Motherwell did not like that Helen was "in the gallery of someone with my kind of private life." Presumably Motherwell meant something about Myers's cruising sexual exploits. For Helen and her new husband, the word "gentlemen" meant a certain regal reserve, a status above the fray, with its gossip and insinuation and sordidness. Helen and Motherwell would be a royal couple. "How wise you were to have waited for Bob . . ." Hartigan wrote to Helen, "when it might have been so comforting to settle for less at certain points in our life. . . . If there are any two people in the world who can manage the 'two artists' thing, it's you and he."

In April 1958, four months after their intense conversation, Helen and Robert Motherwell were married.

AUGUST 1, 1958

Altamira: The Cave

The couple's two-month honeymoon in France and Spain brought them to Altamira, site of one of the most celebrated of the Paleolithic caves. It had been discovered by a hunter in 1868 when his dog disappeared down a hole that turned out to be a long-hidden entrance. Seven years later, the landowner, Marcelino Sanz de Sautuola, explored it and saw some lines but did not think they were made by humans. Then in 1879, while again inspecting the cave, this time with his daughter Maria, he was astounded when, illuminating the cave's roof with a torch, she pointed out painted reliefs depicting bison, red deer, and horses, the ceiling of what has come to be known as the Polychrome Chamber. The following year Sautuola published a pamphlet about the cave, but skeptics doubted the authenticity of his find until gradually—as more and more Paleolithic art was discovered in this region of Europe—the paintings were accepted as genuine. Helen had been to the cave back in 1953 on her solo trip to Spain and been

amazed; now—five summers later—she wanted her husband to see it for himself.

When the couple got to Altamira on August 1, it was lunchtime. The place was temporarily closed while the guide ate, but they tipped him to take them through during his time off. It was just the three of them—"we had the caves to ourselves," Helen wrote—and they spent a long time looking at the pictures by candlelight, the animals dancing in the flickering glow. On her previous trip there Helen had loved the paintings but now she saw that on that rushed occasion, staring with the other tourists, she had "really missed the beauty and meaning of it all." The dark and claustrophobic spaces were nothing compared to the elation they felt.

It was Helen and Bob's second visit to a cave in recent weeks. On July 16, they went to the most famous one, at Lascaux, discovered less than twenty years before, on September 12, 1940, when four boys from the neighboring town of Montignac had been walking on a nearby wooded plateau with their dog when suddenly the dog disappeared down a hole left by the fall of a fir tree knocked over in a storm. Like Maria at Altamira, the boys ended up beholding a startling vision, this time with the aid of an improvised lamp: a great oval room painted top to bottom with huge bulls and horses and deer, then further chambers revealing new splendors—red, yellow, black, and brown ibexes, horses, bulls, cows, deer. With the war on, the cave was closed and work to make it publicly accessible did not begin until 1948. Ten years later, Helen and Bob followed the new roadway up to the cave, then the stairway to the entrance, and sat in a waiting room with other visitors. Their experience was

comparatively rare. A few years after their visit, having been much damaged by tourist traffic, the cave was closed.

At Lascaux, Helen and Bob were surrounded by the murals, "all the lines and colors so deep, light, passionate." Their private candlelit experience at Altamira still two weeks away, they both were dumbfounded. Steady electric lights flattened the paintings, blanching them at points on the bright calcite surfaces, but even without lamplight and solitude Helen and her husband both could summon the aloneness of awe, what Helen had called the week before "the intense discoveries and emotions of isolation." As professional artists and lonely souls, she and Bob carried their solitude with them wherever they went.

Their wedding, back on April 6, a rainy Easter Sunday, had taken place at the home of Helen's sister Gloria, at 888 Park Avenue. A New York State Supreme Court justice presided, with Marjorie as matron of honor and Motherwell's artist friend Fritz Bultman as best man. Three-year-old Ellen Iseman and ten-year-old Beverly Ross, in pretty orange dresses with white piping, were the flower girls. As the doors closed on the elevator to take the newlyweds down from Gloria's home, five-year-old Fred Iseman, Marjorie's middle child, dropped the glass from which he had been throwing the rice.

The celebratory lunch, at L'Armorique, on East Fifty-fourth, included some seventy guests. The celebrants dined on quenelles of white fish, rack of lamb, raspberry sherbet, endive salads, petit

fours, rosé and champagne. Hans Namuth, who had photographed Pollock dancing over his canvases in 1950, took pictures of the ceremony and the banquet. One shows Helen and Bob seated at the table of honor before the first course, his glass full, her glass empty. He looks down and past her, a bit withdrawn, the makings of a close-lipped smile on his face. A string of small pearls at her neck and an unlit cigarette in her hand, Helen looks earnestly into her husband's eyes. Even in the bustling restaurant, they were alone together.

A sign of their union is a large painting she made that spring, all anticipation and delight at the thought of the experience awaiting her that summer. *Before the Caves* flows with life and energy. The number 173—the address of Motherwell's and now Helen's town house on East Ninety-fourth Street—appears at upper right. Anchored by a great stain of rusty orange at the center, the painting's forms spin and pirouette upon themselves, turning in figure eights punctuated by bursts and flaring explosions of paint. At Altamira in 1953 Helen may have been hurried through with other tourists, but she still found the experience memorable, praising the "rich earth & blood colors" and the way the forms of the animals flowed in rhythm with the humped and pocketed contours of the cave's roof, making the painted creatures look three-dimensional. In homage, the large whirling shapes of *Before the Caves* evoke the fissures and cracks the prehistoric artists had incorporated into their representations. Cave art had already fascinated the American abstract painters—back in 1943, Pollock had mixed sand and plaster into the paint in *She-Wolf,* which incorporates a large bison form along with the wolf into a stormy expression of anger and alienation—but *Before the Caves* imagines a union. The large gravi-

tas of Motherwell's distinctive forms—the big black phallic shapes of his many *Spanish Elegy* pictures—lurks in the painting's saturated grandeur, even as it teems with a continuous pulsation of small incident that was Helen's own gift. *Before the Caves* is a threshold work, just like Motherwell's *The Wedding*, also from that spring, which depicts two black anthropomorphic forms—both imposing, both awkward, one stouter, one smaller—standing like a couple in a portrait. Against a golden-brown ground, the two opacities touch each other, overcoming their mutual isolation in a gesture reminiscent of holding hands. The joining of clumsy shapes makes an eloquently negative space.

The couple's main residence on their honeymoon was in the French fishing village of Saint-Jean-de-Luz, on the border with Spain. Although they began their trip in June with stops in Granada, Córdoba, Seville, and Madrid, Motherwell was understandably uneasy about spending time in Franco's country. Recognized for the large *Elegy to the Spanish Republic* paintings he had made for some ten years, he had never been to the country and was not sure how he would be received as the maker of these paeans to Franco's opponents. When the Spanish government asked him to change the title of a painting he planned to exhibit while they were there, altering it from *Elegy for the Spanish Republic XXXV*, his fears were confirmed, and the couple crossed the border into France. The three-story villa they rented in Saint-Jean-de-Luz was run-down—the first day, a pipe burst and a window broke—but still a splendid luxury. A Spanish maid came over daily from the

border town of Irun to keep the place clean, and the couple had plenty of time to work on their art. Helen converted one of the large downstairs bedrooms into a studio, while Motherwell did the same with a series of rooms on the third floor, and the two were inspired by each other's presence. Spain's Fascism, Catholicism, poverty, and cuisine had made them ill at ease, but now they were relaxed. When not painting, they sat on the beach, admiring the blue striped tents, the pale white waterfront houses, and the tanned children playing volleyball. Eating richly (fillet of beef smothered in pâté, truffles on this, truffles on that ("We ate them to the eyeballs but it left me cold," said Helen), they dined with the gusto that led Rudikoff to give them an eighteenth-century French marrow scooper as a present the next year. They tried to cut back on their smoking, shifting to small cigars that Helen indulged in only after dinner, when she would limit herself to no more than three, enjoying them with a glass of Pernod. Motherwell said that they were "eating and living like Lords."

In their separate studios, the couple painted every day and consulted afterward about their respective progress, each supportive of the other's work. Perhaps because of this closeness, Helen found herself confronting a series of self-imposed challenges she was determined to overcome. "I've had many thoughts and perhaps too much brooding about the <u>way</u> I paint," she wrote that August. From the vantage of her marriage to an experienced and acclaimed artist more than ten years older, Helen's days as a single painter looked like a carefree adolescence whose independence she had taken for granted. Now she felt she had "suddenly grown into middle age."

Entering the studio, she felt "an additional weight" and "a more serious complicated attitude." She became self-conscious about "attacking the picture," unsure about how much to put in and how long she should labor on it. She threw out three paintings and many drawings "because they seemed to me to be far too overworked and not me." Greenberg had not caused anything like this self-consciousness. Yet at a certain point that summer Helen overcame her doubt, all the unnecessary buildup of the picture surfaces, and began painting pictures more quickly, with fewer strokes and less paint. Proximity to Motherwell had made her equivocate; but now she emerged stronger than ever. Her new paintings, in which she went back to her own instincts, were "much fuller and deeper in line and content and experience."

One is the magnificent *Hotel Cro-Magnon*, named after the hotel in Les Eyzies where she and Motherwell stayed on their visit to Lascaux. A black line anchors the bright and lively composition, evoking the backbone of a graceful animal, a memory of the deer, bulls, and bovids of the caves. The line's turns and loops suggest the ripple of the walls as much as the creature itself, a register of Helen's sensitivity to the feeling of her sight, as if she could trace her vision with her hands, exploring the hollows and grooves and nobs of rock that made the painted animals' bodies. Almost in an act of ventriloquism, she mimicked the skill of artists dead thirteen thousand years, "quoting" them in a way she did when she based other pictures on Titian, Rubens, Goya, and Picasso.

The real purpose of being immersed underground was to re-emerge into the light of day. In *Hotel Cro-Magnon* Helen transported

the sense of being in the caves outside, to where others could experience something of what she felt in the dark. The painting is not a transcript of an exact emotion, a tour guide's explication of the drama, but a fresh sensation, designed for others. In recognition of the permanent entombment of the one-of-a-kind cave paintings, she exported the feeling they produced in her, taking the sensation out of Spain on a medium—canvas—originally employed by Renaissance artists precisely to help make pictures light and portable. *Hotel Cro-Magnon* radiates with outdoor energy. Bulbous red shapes rise from the foreground, wrapped in green stalks and trunks, while something like a blue sky and a blistering sun rise above an undulating line that might be a distant range of hills. Helen effortlessly blends near and far, flowers underfoot and pale horizon, rhyming all on a flat surface that bursts toward a viewer the artist had the intelligence to keep in mind but also ignore as she worked. It is her vision, through and through. But when the painting was packed up, shipped out, and finally put on display, it became the vision of another, their light, not just hers.

The lightness of *Hotel Cro-Magnon* is also an affair of time. The painting is a string of momentary effects, brisk and quick at all points. The shaken contours and splattered edges bestow the right penumbra of suddenness on all things. Counterintuitively, but with splendid precision, Helen saw the oldest paintings on earth as new and fresh. Not for her to deliberate on the long-moldering darkness of these pictures in their damp caves, as they awaited discovery over thousands of years. Like her friend Frank O'Hara, who wrote a poem called "In Favor of One's Time," Helen was a person of the here and now. Radically, she held to this view even as she anticipated

the long lives of her own paintings, which she imagined might one day become as endangered as the frescoes of Giotto and Piero. "Do I want it to last? Yes. Am I concerned with having it last?" she asked of her art. "Yes, but not when I'm in the throes of painting, because then I think you make yourself an object. I'd rather lose the picture than lose the moment of the art."

Helen restored Motherwell in these months. With her encouragement, his art took on renewed conviction and confidence, again in contact with the ground and the sun. He worked prolifically at Saint-Jean-de-Luz, completing three series of works, which he called *Frontiers*, *Two Figures*, and *Iberias*. *Frontiers*, small and personal and the first pictures he made that summer, refers to crossing emotional borders as much as the one between Spain and France. The paintings were "a release after a long time of sterility," the artist said, "crossing the frontier, so to speak." The *Two Figures* series spoke to the brightening power of Helen's colors upon him. Motherwell was famous for his puritanically restricted black-and-white palette, but the glowing pink ground of his Lascaux-inspired *Two Figures No. 2* shows how soon her chromatic vitality appeared in his art. In later years Helen joked that she had been okay when her husband claimed gaulois blue as his color, but that when he also claimed yellow ocher it was too much. Though Motherwell was unaccustomed to brightness—he was careful even in the sunniest of times to ration his joy—she was lifting his mood. The fact that she could convince her husband to go back into Spain for a day to see Altamira spoke of his relative peace of mind. "Bob has been free,

energetic, prolific, driving, liberated—" Helen wrote, "it's been a real drama to watch the pictures develop and share the talk, the eyes, the images."

At the same time, something dark lurked. It was not anything immediately apparent; the couple's trip was as happy as Helen said. But in hindsight Motherwell was anything but a well man. Peaceable, kind, generous, superbly intelligent, he was also a haunted soul. He had suffered horribly as a child in ways that indelibly shaped his adult life. Back in his affluent childhood homes in San Francisco and other western places, his mother "used to beat the hell out of me," he said in a revelatory interview in 1987. He recalled one episode witnessed by his younger sister Mary: "I was four-and-a-half and she was three, we were cowering in a corner sobbing and my mother was hitting me all over the head until the blood would come out of my nose." His mother could "also be very sexual, very sexually affectionate, and she could smother you with kisses, and ten minutes later, in the middle of a conversation, suddenly say something to you that is the most devastating thing that you can imagine anybody saying to you. Without changing her voice." Margaret Motherwell imparted her artistic soul to her son, helping create his sensitivity to aesthetic forms. She collected eighteenth-century French provincial furniture, and sometimes her young son would accompany her to auctions, where he developed a precocious connoisseur's eye. He later attributed his painterly preference for earth tones and delicate and precise curves to these childhood experiences. But she terrorized him, and he loathed her.

When the young Motherwell received the Christmas present he had asked for, a little toy ship of which he ventured to say he wished

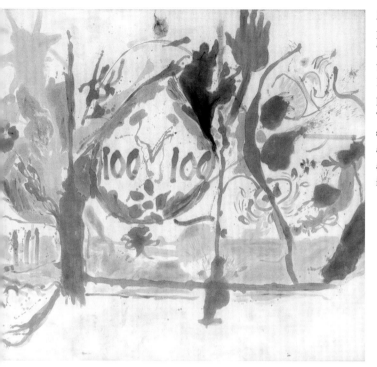

Eden (1956). No painting is good "intellectually," Helen told her friend Sonya Rudikoff. Instead great paintings delivered a "charge" that could stun a viewer with an unforgettable and mysterious first impression.

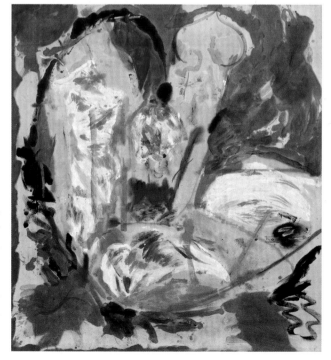

Giralda (1956). The painting was a far cry from the lyrical eroticism of *Mountains and Sea*. As Frank O'Hara put it, "She does not hesitate to deal with her subject with a frankness approaching sordidness."

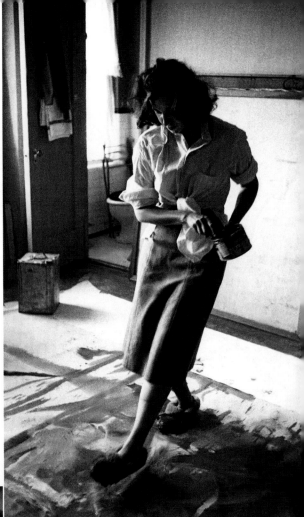

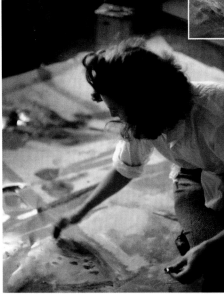

Helen at work in her West End
Avenue studio in 1957. Her art
always mirrored the mobile
intimacy of her body. Even
the conspicuous presence of
the photographer did not
disturb her dancer's poise,
the practiced grace of
her many tasks.

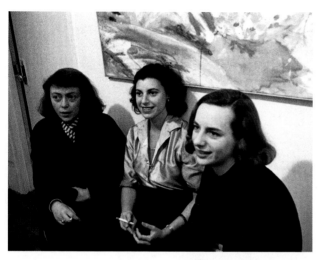

Helen flanked by Joan Mitchell (*left*) and Grace Hartigan (*right*) in a photograph of February 1957. Mitchell privately disparaged Helen's stain technique as the work of "that Kotex painter." Hartigan was a loyal friend over the years, despite tensions and disagreements.

The poet Frank O'Hara in a photograph taken in 1959. He understood Helen's paintings like few other people, praising their "disdain of appearances," their "natural violence evoked in a lofty and immaculate tone." When he died at age forty in 1966, Helen was devastated.

Jacob's Ladder (1957). Even as her art attracted more buyers, Helen stayed true to her private creative impulses. "When the artist reveals his concern for the audience," she said later, "there is something wrong, something cynical, and the creative process is no longer pure."

Hartigan's *Billboard* (1957). The painting addresses the growing public for abstract art—a picture could be difficult yet as welcoming, lively, and engaging as an advertisement.

Bull, Altamira cave, Santander, Spain. On their honeymoon in France and Spain in summer 1958, Helen and Robert Motherwell toured the Altamira cave by the light of a candle, experiencing the prehistoric paintings in a magical present tense.

Before the Caves (1958). A painting Helen made before seeing the cave paintings at Lascaux and Altamira in summer 1958. At upper right is the number 173—the street address of the Upper East Side townhouse she now occupied with her husband.

Hotel Cro-Magnon
(1958). In a painting
inspired by the caves at
Lascaux, Helen mimicked
the skills of artists dead
for thirteen thousand
years. For her, the oldest
paintings on earth were
new and fresh.

Helen and Robert
Motherwell at L'Armorique
in Manhattan on their
wedding day, April 6, 1958.
The couple began courting
only a few months before.
"There was a fantastic
recognition and a perma-
nent road into each
other," Helen recalled.

Motherwell, *The Wedding*
(1958), painted the year
they married. Two black
forms—one stouter, one
smaller, both imposing—
stand like a couple in a
portrait. The joining of
clumsy shapes makes
an eloquently negative
space.

Mother Goose Melody (1959). Helen, like Motherwell, had a deep interest in the formative experiences of childhood. But a critic likened her art to trends in American culture, where "the cult of adolescence is taking over the entertainment world."

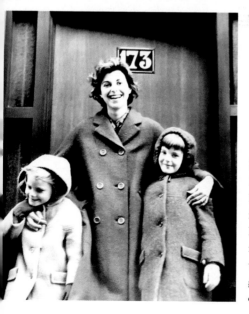

Helen with Lise (*left*) and Jeannie Motherwell (*right*) in front of their home at 173 East Ninety-fourth Street in Manhattan, ca. 1960–62. When her husband's daughters from his previous marriage unexpectedly came to live with them in 1960, Helen felt close to the girls but feared "the enormity of the responsibility."

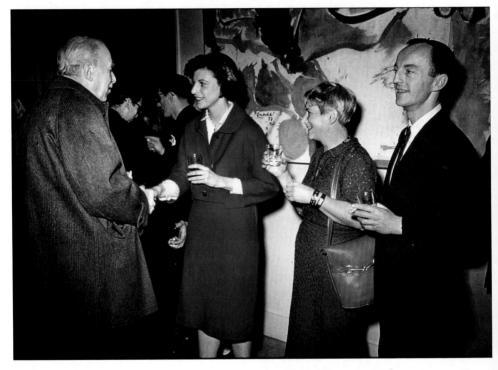

Helen greets a visitor at the opening of her first one-person museum show,
at the Jewish Museum, on January 26, 1960. O'Hara stands to the right. Although
Helen had come a long way from the party at the Hotel Astor ten years earlier,
it would be nearly a decade before she achieved lasting recognition.

his mother had bought him a slightly different model, "she beat me for what seemed like an hour." His father, meanwhile, president of the Wells Fargo Bank, hit him in a different way. Responding to one of his son's perceived transgressions, he would go to the closet, remove a pair of brand-new London-made shoes from its box, tell his son to bend over, and beat him before methodically going back to the closet to replace the shoes and even fold them back into their tissue paper. "What's really devastating," Motherwell said of his father's abuse, "is when somebody beats you in a Protestant way—abstractly." His father was "methodically cruel," his mother "wildly irrational." Motherwell reacted to his father's beatings by simply walking away, storing his hatred, but he wanted to kill his mother, and he became ill. When he developed asthma at about the age of twelve, his mother became convinced that he would die before he was twenty-one and often told him so. He believed her. "From puberty till thirty-five—say, for twenty years—I was haunted by death as though it were outside the window waiting. I had nightmares, hated to go to sleep, thought I might die in my sleep." Eight years after this morbid obsession ended but with many of the underlying causes perfectly intact, he married Helen.

She might have learned some of this, perhaps much of it, as early as that evening in December 1957 when the couple talked all night like "profound adolescents" about "horrors and experiences." Only a few years later she could write that her husband "is apt to sink into terrible depression—which, knowing him, makes perfect sense, and will never change and probably never should." Yes, Motherwell had long since sublimated the horrors, or "shocks" as he called them, into his art: an artist must "absorb the shocks of

reality, whether coming from an internal or external world," he wrote back in 1944, and it was a marvel how the shocks went into his opaque black forms, in picture after picture, gathering in onyx crusts, a never-ending depiction of obscurity and majestic grief. But Helen thought there was a greater strength inside her husband. "With a sense of participation and being 'loved' he is actually far more powerful," she would write, and she sought to protect him. When Margaret Motherwell sent her son Chinese silk pajamas for Christmas in 1959, Helen hated the gift so much that she immediately cut the pajamas into pieces and incorporated a fragment into a collage—an act of destruction she later recalled exultantly. But Motherwell never outlived the experiences of his youth, the cavern of his bedroom, the asthma that would strike at two or three in the morning, the feeling of being trapped and terrified until daylight, when at last he and the world "came back to life again."

To a shrewd observer it might have been an open question, back in the first year of their marriage, if Helen would ultimately lighten Motherwell or if he would darken her. His very contentment—his art—addressed questions far too mordant for Helen to consider in such graveyard terms. "Ivory black, like bone black, is made from charred bones or horns," he wrote in a characteristic rumination. "Sometimes I wonder, laying in a great black stripe on a canvas, what animal's bones (or horns) are making the furrows of my picture." The color white was equally deathly for him, since it was typically made from lead, "extremely poisonous on contact with the body." The last man fun-loving Helen might marry would be Hamlet holding the skull of Yorick. But her gloom touched his. The

newspaper headlines that summer, such as those describing an airplane crashing in fog on Nantucket, brought out their native despair. Even ordinary letters from friends back home—in their very small talk about the weather and social events—made Helen feel threatened.

The mutual loneliness that brought the couple together, not least for its creative potentiality, was a volatile force for any artist to manage. Grace Hartigan, who had gone to Lascaux several months after Helen in 1958, made a painting twenty years later called *I Remember Lascaux*, then consumed dozens of Valium pills and a bottle of vodka, surviving only because her husband found her and called paramedics. The act of painting might avert suicide or lead to it; it could be an escape from futility into purpose and conviction and joy, or a portal to beckoning dark places. A painting Helen made in 1969, *Chatham Light*, with just a sliver of light in its glowingly somber Rembrandt tones, summons this darkness; it is the very work that makes its current owner, Helen's nephew Clifford Ross, think of William Styron's depression memoir, *Darkness Visible*, in relation to his aunt. Even the pleasing way that a body of work emerged suddenly, "out-of-nowhere," as Helen was to say of some later pictures, was uncanny. Where exactly was this "nowhere" the pictures came from, and did they still bear traces of that nonexistent place in their finished state? Perhaps some fantastical notion of looking death in the eye—as a precondition of serious painting, urgent painting—governed the abstract artist's fundamental task of creating something out of nothing. When she complained on her honeymoon summer that Samuel Beckett's plays

made her feel "empty and angry" but "not in a <u>full</u> or meaningful way," Helen made it clear that, Beckett aside, there *was* a full and meaningful emptiness. Her husband's paintings offered just that.

So did her own. A painting she made later that year addresses her own sense of tragedy. In *Winter Hunt* a fox surrounded by bright pools of red seems pinned to the canvas. Evoking the *nature morte* of seventeenth- and eighteenth-century European painting, where a rabbit, fox, or pheasant might splay like Jesus on the cross amid a bounty of food set out for nameless banqueters, *Winter Hunt* also suggests the sadistic hunting scenes of Gustave Courbet, the painterly master of blood on snow. With most of its white ground left untouched, including even an especially raw section at the top that Helen simply cut off from the composition with a horizontal line, the painting generated even its key form—the fox—in a similarly improvised manner. But once the fox took shape, gaining its eye and two triangular ears, it suggested a whole field of brutal energies begging to be portrayed. "There is a ferocity in it," Helen said. The three curving forms to the right, each looping back from the painting's right edge; the stains at lower right; the flecks and spatter that give the whole picture the feel of a crime scene—all impart an aura of murder. The comedy—cartoonish fox, madcap mark-making, a balletic grace of slapstick—is so funny that we do not laugh. O'Hara called the painting "tragic."

A transatlantic ocean voyage was the norm for Helen and her husband, the way they traveled in style. Motherwell feared flying—he would not even go in airports, let alone airplanes—

and the big transatlantic liners were a customary mode of intercontinental travel in the 1950s anyway. For the couple, cruises meant cabins and cabins meant first-class accommodations. And so it was that at the end of August they had packed up the villa at Saint-Jean-de-Luz, sent crated paintings ahead, and reserved rooms at inns along the way to Le Havre, where their liner would depart. The cabin was small but comfortable, and next to Helen in the small space was this person she loved so much and felt so fortunate to have married.

A cabin no less than a cave was a sign of their closeness, and maybe that was why in July 1958 Helen had made a small collage she called *Cabin #118*. A crate label reading "Italian Line" appears upside down amid a broad black-outlined shape reminiscent of a face in profile or a giant keyhole. Token of the voyage, token of the dark, *Cabin #118* suggests the mysterious signs that gather around two people undertaking a journey together.

10

AUGUST 29, 1959

Falmouth, Massachusetts:
A Fairy Tale

Buzzards Bay at low tide reminded Helen of Mallorca—the soft blue-green water, the small rocks jutting out. It was the kind of place she consciously took in, knowing it might emerge later in her art as a feeling, a mood. She and Bob had rented a house in Falmouth, on Cape Cod, and little Jeannie and Lise, Motherwell's two daughters from his previous wife, had just been there for a week, having come up from northern Virginia, where they lived with their mother. Jeannie was six, Lise was four.

The rental house was high on a bluff with a steep wooden staircase skirted by poison ivy leading to the sand. It was done in a modern style, painted in shades of gray. For the previous week Helen and Bob had devoted all their time and energy to showing the little girls a good time, and now that she had a moment she could marvel at the bay through the kitchen's enormous picture window, relishing a quiet so profound that she heard the rasp of her

beach-toughened feet on the vinyl floors. Looking back, Helen reflected that the previous week was worth it. "I find that when one tries hard to make it enjoyable in that situation then it's apt to be fun for everyone. If one <u>wants</u> certain responsibilities there is so much to be gained." For Helen, who knew something about playing with kids because of her nieces and nephews, taking care of Jeannie and Lise for a few days was demanding but also lovely.

One playdate stood out, however, to indicate how little Helen knew of parenting. Her Bennington friend Elizabeth "Chickie" Brown had invited her and Bob and Jeannie and Lise to a barbecue in the backyard of her home, where she lived with her husband and the couple's three small children, Matthew, Elijah, and Abigail. Chickie's husband was Henry Stommel, an acclaimed oceanographer at nearby Woods Hole, who was just back from a three-month research trip in Bermuda. At the party Helen observed the Stommel family scene—perhaps some mixture of ketchup, tears, and exhaustion, all smeared together—with an unsympathetic eye. Chickie, married since 1950, looked the same as in her undergraduate days "but old and empty under her youthful expressions." Her husband, known as Hank, was "one of the most sullen, mad, isolated men I've met in a long time." Chickie said that Hank was shy but Helen thought he was simply antisocial. In 1959 the British scientist C. P. Snow delivered his now-famous lecture, "The Two Cultures," about the increasing split between scientists and humanists, "two groups, comparable in intelligence . . . who had almost ceased to communicate at all." The backyard party in Falmouth in late August of that year might have been an illustration of Snow's point.

Stommel, who had recently published an article called "Toward

a Future Study of the Abyssal Circulation," had little to say to the Helen of *Mountains and Sea*, the Helen nicknamed "Helen Ocean" so many years earlier, and she had even less to say to him, though plenty *about* him afterward. She found it appalling that Stommel had confided to Bob that "he had no particular aptitude at all for science but chose it because it was the only career that would keep him altogether away from people and relationships." The Stommel children all "have the soft angry empty faces of their parents combined," and the parents "can't stand their children." There was an "air of resentment . . . on all five faces." It did not matter that Stommel was a remarkable oceanographer, a pioneer in the study of deep ocean currents, and that his aside to Motherwell may simply have been a way of deprecating his achievements to a person who could hardly be expected to understand his scientific bent of mind. Nor did it matter that—on a hot summer day with three small kids and a husband just returned from a three-month trip—many families might exude an air of resentment and that such stresses were a natural part of parenting, among the difficulties inevitably facing a couple with small children. But Helen saw only "an angry small little knot."

How quickly Helen's perceptions of parenting were to change. Only a little more than a year later, around Thanksgiving 1960, Jeannie and Lise arrived in New York, brought there by their mother, Betty Little. This time there had been some trouble back home. For a while Betty's daughters had noticed that none of the other kids on their suburban cul-de-sac would play with them. Betty noticed, too, and asked a neighbor, who told her what apparently everyone knew except her and Jeannie and Lise. Her husband,

Jack, who claimed to have a job, actually spent his days riding around on a bicycle wearing a trench coat, which he would open to flash adults and children alike. Betty, horrified, filed for divorce immediately—the couple had only recently gotten married—and the divorce was messy, ugly. Betty was near to a nervous breakdown. Fearing for the well-being not only of Jeannie and Lise but their older sister, Cathy, the child of her first marriage, Betty sent Cathy to her father's home on Long Island and Jeannie and Lise to their father's house in Manhattan.

Jeannie and Lise, now seven and five, knew nothing about the real reasons for the trip or anything at all about what was going on. Jack had not been a nice person, that much was clear. He had locked a misbehaving Lise in her bedroom and refused to let her have her favorite stuffed animal, ignoring her bitter tears. But they had no idea that this man who at night watched *Perry Mason* on television in bed with their mother spent his days in the bicycle-bound way he did. Now Jack had left, and their mother was with a new man, Arthur Kimball, nice and decent, a lawyer she had met at a party who offered to help her with the divorce and with whom she had become romantically involved. It was Arthur who arrived with Betty at the East Ninety-fourth Street house, there, Jeannie and Lise assumed, to take them back home after their stay of a few days.

But Betty had some shocking news: She and Arthur were not coming back to pick them up. The girls were going to stay with their father and Helen for a while, an unknown period. Watching their mother leave without them, the girls became hysterical, traumatized. Perhaps Helen was as well. She and Bob knew about the plan beforehand, and Bob had his own reasons for separating his

daughters from their biological mother, who he feared was losing her sanity. But now in the moment, surrogate parenting felt beyond Helen. "She had to grow up very quickly and figure out how to be the best parent she could be," Lise remembers. That night in the kitchen, Helen improvised a response amid the tears, asking Lise, who was weeping inconsolably, if she would like a chocolate milkshake. "What," Lise remembers thinking, "you want to replace my mother with a milkshake?" Jeannie recalls looking at her sister at that moment and thinking, "That's not what's going to make this better." The three of them sat at a round kitchen table made of some Formica-like material, part of a home remodeling Helen had begun late in 1958. To the little girls, the modernist décor—yellow ocher kitchen tiles, a Mondrian-like ceiling on which some of the panels were painted primary colors, a red enamel stove—became an indelible sign of a suddenly alien presence in their lives.

Yet as their stay extended for weeks, months, and finally for nearly two years, the girls came to appreciate Helen. She and Bob quickly hired an Irish nanny, Maureen Lawlor, who was very maternal and helped the girls feel acclimated, freeing the couple up from some of the hardest tasks of child raising: preparing meals, doing laundry, taking them to and from school. But Helen genuinely liked to have fun with Jeannie and Lise. She read to them from Raggedy Ann and Andy books and *Alice in Wonderland*. She brought out Chubby Checker's hit record of 1960 and taught them to do the Twist. She took them to see the Rockettes and to skate at Rockefeller Center, delighting with them in the New York she had known as a child. She encouraged them to paint and draw, letting them make small pictures on brown wrapping paper in her studio

that she then hung on the walls. For refreshment, the trio would go to an Upper East Side location of Schrafft's, a chain restaurant and ice cream parlor, where they would sit at the counter and Helen would request a Moxie soda in a stem glass. When things were not fun, when, for example, Lise awoke with nightmares, Helen brought her sugar-and-butter sandwiches, just as her own father had brought her when she was a girl.

At the same time, Jeannie and Lise recognized that Helen's maternal instincts generally ran cold. The "real milk and honey," as Jeannie puts it, was always their mother. No one could replace her. But something else plagued Helen besides this innate disadvantage. With her competitive nature, she had a way of turning innocuous situations into lessons and occasions. On visits to galleries, she and Bob would ask the little girls which were their favorite paintings and to explain why. When it came to world events, she was annoyed at Jeannie for not caring enough when John Glenn orbited the earth in 1962, failing to understand that a momentous occasion for an adult was of less interest to a nine-year-old. In the grocery store checkout line, Helen mortified Jeannie and Lise by making them count out their change to see that the checker had given them back the correct amount. She was trying to accomplish two things at once—teach the girls math and instruct them in the art of not getting ripped off—but the effect was "shocking," Jeannie remembers. "It was embarrassing, there were people waiting. She did not have the sense that she was holding people up and that was awkward. The way she presented it was uncomfortable for everyone because it wasn't clear what she was doing."

Betty Little addled Helen. She found Betty's attempts to visit

her daughters unnerving, also the way Betty enlisted former maids to call at the house to check on the girls. Betty missed her daughters terribly—she was distraught—but Helen had little sympathy. When Betty finally was permitted to visit three months after the girls moved in, it was only after all parties had consulted various analysts and social workers, and Helen was not pleased. She found Motherwell's ex-wife "so SICK that one can't really be mad at her, only amazed and sorry and FURIOUS." The situation made her reel "from all the thoughts activities, decisions, considerations, and squelched rage" until she began to feel ill. She started experiencing migraines, among the first she'd had in years. The girls were told to wear rubber-soled shoes in the house. Sequestered in the bedroom, she saw flashes of light with shimmering blind spots. Just like when she was a child, she lost the memory of simple words, could not speak correctly, and felt a tingling in her limbs, fingers, tongue, and face. She knew from experience that these headaches, which had started after her father's death, came about because of repressed emotions—when she was "out of touch consciously with my real feelings and reactions, when I am low, perhaps enraged (without knowing it) and often feeling smothered or helpless." Emotionally and physically exhausted, Helen made matters worse by hysterically fearing her symptoms even though she knew how a doctor would explain them.

When she emerged from her bout of migraine, she began to conceive a new plan of action. Upon the girls' arrival she had tried to make the temporary best of a difficult situation before they went back. But only a few months later she came to believe that if Jeannie and Lise returned to Virginia, Betty would destroy them just at a

time when they were blossoming in New York with her as a step-mother. Away from Betty, the kids were "loving, secure, inventive, honest." Looking back on the situation now, Jeannie and Lise affirm that they felt comfortable. They had had so many parents and pseudoparents that they were glad of stability of any kind. Jeannie went to Dalton, where she found that many of the other kids' parents were also divorced, a discovery that amazed and calmed her, making her feel her family was not so abnormal. With the girls' contentment in mind but also feeling more and more attached to them, Helen began to ponder something that would have been un-thinkable to her only a few years earlier and likely had not crossed her mind when she married Motherwell: adoption. Bob was all for it—he trusted Helen far more than Betty—and something had to be done: the stress of the situation had helped reduce this man who had dined on steaks on their honeymoon to an ulcer-induced "Gerberesque" diet. Giving his daughters a stable home environment would calm everyone down, so it seemed. Helen confessed her fright and confusion to her analyst, recognizing the "enormity of the responsibility." More migraines followed. But she went ahead and filed adoption papers in late 1961.

Jeannie and Lise did not respond as Helen had hoped. She had been asking them to call her "Mom." When they refused and continued to call her Helen, she insisted that if that was the case they could not call their father "Dad." Lise recalls how hurtful this was, saying it felt like a barrier between them and their father. Finally Helen asked Jeannie flat out if she and Lise would like her to adopt them, and Jeannie said no. "I loved my mother," she recalls, "and I didn't understand why I would be giving away my mother for

another mother." Helen was "not as maternal. My mother was a mother; all she wanted was her kids. I didn't feel instinctively I was going to get the attention I needed." Helen asked Jeannie to think how her refusal made her, Helen, feel. "That was not a really healthy way to make a child feel," Jeannie reflects now. "Nobody seemed to be very mature. My sister and I had to be the adults." She marvels that of all the players in this difficult situation the only ones not seeing a psychoanalyst were her and Lise.

Betty meantime had married Arthur Kimball, her fourth husband, establishing a sanity and stability to her home life. Motherwell, for his part, was impressed by Kimball and began to change his thinking about the merits of the girls remaining with their mother. With the girls unwilling to be adopted, and her husband now shifting his position, the court fight that Helen had been gearing up for never took place. At the end of summer 1962, Jeannie and Lise went back to northern Virginia. Soon they wrote to Helen to say how excited they were by their mother's new house, their new school, their new friends. Kimball was kind and patient, and he actually liked to play with kids, unlike the girls' biological father. For Helen, the letter was bittersweet—she found the departure difficult. She had lost to Betty Little, and though she and Jeannie and Lise would be friends in future years, she had lost two girls she had become fond of.

Motherwell had his own deep interest in the formative experiences of childhood, not just negative but positive ones. The couple was in Falmouth in August 1959 because the oceanside

reminded him of enchanted childhood summers in the harbor town of Westport, Washington, where as a boy he would look out at lumber ships from around the world and feel deeply at home. He encouraged Helen to see connections between her early years and the artist she had become. It was Motherwell who insisted on the link between the long chalk line she had drawn as a child and her mature work, and between the pouring of her mother's nail polish in the sink and the colored stains of her canvases. Having come of artistic age in the surrealist milieu of New York in the early 1940s, not long after children's drawings had been included in the *Fantastic Art, Dada, Surrealism* show and catalogue of 1936, he shared the surrealist conviction that childhood art contained an inscrutable beguiling power. Just a month before he and Helen decamped to Falmouth, Motherwell had published an essay in *ARTnews* on the Spanish surrealist Joan Miró, a pioneer in the creation of childlike effects in his paintings, whose art he called "the most moving and beautiful now being made in Europe." Helen, who remembered Marjorie taking her as a young girl to the Museum of Modern Art to look at Salvador Dalí's famous melted-watch painting, *The Persistence of Memory*, needed no special persuading on any of these points. She felt that everyone, especially artists, needs to "cherish, use, [and] bear childishness."

That summer in Falmouth, she painted *Mother Goose Melody*, a work featuring a large "goose" form on the right, its red beak down as if preening its feathers, its eye open. On the left, three brown shapes cluster beneath a clock. These were the first marks Helen made on the canvas, and stepping back to survey them she thought of them as "three sister-shapes"—the three Frankenthaler

sisters in their long-ago nursery, some have supposed. The fact that Helen painted this childhood-themed picture in the first full year of her marriage to Motherwell—at a summer place where Jeannie and Lise later visited—may be just a coincidence. But it could also be that the prospect of getting to know these two little girls, and indeed of being newly married, made Helen think more readily than usual of her own girlhood.

But in another sense she hardly needed Motherwell's influence, either aesthetically or personally. The childhood connection was there no matter what, so much so that *every* painting Helen made in her twenties, not just *Mother Goose Melody*, relied on a method and sensibility she first developed as a little girl and adolescent. Not just the lipstick and the chalk—"the first line in my memory," she said—but her time reading kids' magazines; of puzzling over their trick illustrations requiring the reader to find a hidden element or join seemingly unrelated elements of the composition into a miraculous whole; of being fascinated by the different "whoosh" marks denoting speed in the Sunday funnies; of reading the *Katzenjammer Kids* cartoon strip—all inform her art. So does her parents' faith that she was special—"fantastic," in her father's words—a term of praise that amounted to a self-fulfilling prophecy. "If you have some special qualities and they also think you're Super Child," she said of her parents' impact, "it flowers."

Notwithstanding this encouragement, Helen may still never have become a serious artist, speculates the curator and writer John Elderfield, if her father had not died when she was eleven. When she emerged from her extended dark night of the soul some three years later, it was art that saved her, specifically her painting class

at Dalton. From that period on, Elderfield notes, Helen committed herself to being a painter and she clung to it as though her life depended on it, which it is fair to say it did. The studio offered her "an ideal realm of security, omnipotence, and private pleasure," a respite from the outside world that her father's death had proved to be unpredictable and catastrophic. Art afforded her the "'hermetic conditions of private self-preservation'" that a damaged person needed, a place where her painterly aims and fantasies could gather in "tranquil but charged profusion."

The bursting power of Helen's paintings—specifically, the boldness and excitement of her color—perhaps also owes to the childhood sources of her art. Something in her pictures implies that color is a *force*, as if the painter must commit to it as a full-on saturation of the canvas, a power that all but dyes itself on the eye, if it is to have any reason for being there at all. The blazing yellow and aquamarine of *Acres*, another painting of 1959, not to mention its royal blue and red, explode upon the viewer as if the artist were not only committed to their intrinsic beauties but feared that anything less than such a deep-dyed commitment would allow an unspecified but horrible night to return. Only from darkness could brightness come about. The fact that the painting's bursts resemble childlike splotches—that they are "unslick," to use a word of Helen's from 1959 that means a type of mark that is spontaneous, genuine, uncalculated—reinforces their naïve power. Likewise, the fact that *Acres*, like all of Helen's work, is actually a deeply considered picture, that she judged it shrewdly at every step of the way, does not diminish its commitment to a redemptively naïve pleasure. Nor does its relation to the history of art, to, say, the impressionists, who

in their own landscapes back in the 1870s and 1880s had sought, in Greenberg's words, "an art of maximum saturation" that would rely on color alone to shape a picture. Painterly care and pedigree not-withstanding, color in *Acres* and other paintings by Helen *declaims*, it is *loud*, it insists, even over-insists, in the manner of a young person having her way, that there is no night, no darkness, no death, that can hide this brightness the artist equates with life itself.

Few critics were bold enough to name the childlike connotations of Helen's art and fault her for it. One who did, the *ARTnews* critic Anne Seelye, incurred Helen's wrath in 1960 when she designated her a "child of the times" whose hysterical paintings (including *Mother Goose Melody* and *Acres*) displayed a glamorous, ravishing, and petulant temperament. Helen's art was that of a girl-woman, "romantic, hyper-sensitive, sulky," a match for new currents in American culture, "where the cult of adolescence is taking over the entertainment world and shaping our responses to love." The point was apt. Holden Caulfield, in J. D. Salinger's *Catcher in the Rye*, had made his debut in 1951, the year of her first New York show. Young John Gedsudski, the lovestruck raconteur of Salinger's story "The Laughing Man," appeared in 1953, a few months after *Mountains and Sea*. Out in Hollywood, what James Dean's bright red windbreaker and Natalie Wood's red lipstick and Red Riding Hood cloak were to *Rebel Without a Cause*, the color red was to Helen's art, as in *Red Square*, another painting of 1959. Something like Dean's cri de coeur ("You're tearing me apart!") and Wood's plaintive melodrama ("Is this what it's like to love somebody?") came through in the emotional gyrations of her pictures. Seelye acknowledged that Helen's sulky paintings

made for visual thrills, but to a mature intelligence they hardly satisfied. "In a more adult world," they evoke only "certain memories of feeling" rather than present-day desires, the subtle awareness and keen pleasure of a grown-up sensibility.

Seelye drew too neat a link between the painter and her paintings, and she crudely treated the art as a direct revelation of the artist's personality. But she identified something of the youthfulness Helen tapped into in her art. If she and Motherwell had talked like "profound adolescents" on that December night when they connected in 1957, who was to doubt her art's capacity to be adolescently profound in a comparable way? Helen's *Red Square* of 1959 was not a reference to the Soviet Union at the height of the Cold War, to something so adult and stuffily consequential. It referred only to itself, to the capacity of color and shape to produce a feeling such as a child or teenager might experience: to a moment when the world just *is*, when it seems to float luminously independent of meaning and attitudes, free and clear of adult proprieties and judgments, when it is only a pulsation of feeling such as Technicolor teenage lovers feel staring into each other's eyes—when life is, in Helen's favorite word, a "charge."

Helen's way of drawing creative strength from childhood made her unusual among the women she knew. So many of her Bennington friends had long since come to think of childhood primarily in terms of their role as mothers. Chickie Brown had her three kids. Another friend had five. Still another had visited two years earlier with her ten-week-old baby girl, looking very happy

and telling Helen she loved nursing and wanted more babies, an opinion that delighted Helen but that she had no interest in taking up in her own life. Then there were her sisters—Marjorie with her three kids, Gloria with three of her own. The perils of being a mother were all around her, too. In 1953 Marjorie went into a depression—an "extreme slump," Helen called it—while pregnant with her third child, during the time of Martha Frankenthaler's rapidly intensifying illness. Late the next year Helen had lunch with a college friend whose twins had both died at three days old, who then had a miscarriage, and was trying to get pregnant again. "All the girls I know (mostly Benn.) who can't get pregnant or stay pregnant!" she wrote to Rudikoff. Others who did get pregnant regretted it. Grace Hartigan said that her painting *December 2*, the only picture she ever titled with a date, was about "something that was going on in me that day"—December 2, 1959—a cryptic statement her biographer links to an abortion. Helen herself made a painting in 1959 called *Woman's Decision*—a phrase that became a euphemism for abortion apparently only in the 1970s—that may refer to her own thoughts about having children.

One tragedy from those years stands out. On October 1, 1956, Helen's friend Dotty Kahn, age thirty-one, jumped off a bridge, leaving behind her husband and two-year-old daughter in their new home in Chevy Chase, Maryland. Dotty was the wife of Harry Kahn, who had been Marjorie's husband Joe's freshman roommate at Harvard. Helen had gotten to know Dotty and liked her a great deal, appreciating her sense of humor and what a good mother she was. In December 1954, she went down to Washington to see the Kahns and their four-month-old. "I am terribly upset—still sort of

numb and it hasn't registered," Helen wrote to Rudikoff the day after Dotty's death as she readied to travel to Washington the next week. "I was very fond of Dotty and in many ways knew her well and knew many of her problems and desires. . . . I was very concerned about her and I really thought she'd recover. I will miss her. I feel very mixed up now." Looking back on the events, Dotty's daughter, Jenny Kaufmann, now a psychotherapist who writes about suicide and treats family members of suicide victims, says that a botched abortion earlier in 1956 had started her mother into a deep depression—"how quickly you could go into a dark place, a hopeless place"—but also that her mother felt trapped in a traditional marriage. She wanted to work (she was a talented writer with a wry sense of humor), she wanted to go out with friends, but her husband, a kind man in many ways, could not understand why she was not happy with the nice home and child-care help his dependable income provided. Maybe these frustrations were among the "problems and desires" Helen mentioned. Apart from the manner of suicide—Dotty's jump must have recalled in Helen's mind her mother's own jump two and a half years earlier—the death underscored the pressures of motherhood for women of Helen's generation. The red "stop-sign" hand of *Eden*, a painting Helen began making only weeks after her friend's death, may allude to it in some way. Surrounded by such catastrophes and struggles, deeply affected by them, Helen still had a kind of independence unusual among women her age. As a well-to-do and childless wife, she had the free time to remain, in some respects, a kid herself.

There was a downside to this, of course. Helen acknowledged in 1961 that having the two little girls suddenly around had brought

up the question of her own "childish needs." Questioning her maturity, she regretted her selfishness and anger that "came out towards individuals and situations close to me." She acknowledged that she "had reacted so traumatically to the children," that "some of it was a great bother to me and got in the way of many relationships, both in and out of the family world." Plainly, it was hard for Helen when she was not the center of attention, when she did not get her way. The adult Helen was a "big child," in the words of her nephew Frederick Iseman, who, born in 1952, knew her temper as part of his own boyhood. He recalls arguing with Helen constantly when he was young and her always winning because she was the bigger kid and got her way. On a six-hour drive from Manhattan to Bolton Landing in the early 1960s, he and Helen bickered the whole way up, with her repeatedly turning around from the passenger seat to scold him, a verbal combat he experienced as being bested by the biggest and most spoiled child in the car. It would not be until he was in his twenties, when he finally stood up to Helen after she had dressed him down in public, that she backed off and treated him well. In fact, after that, they got on famously. But throughout her life, whether the recipient of her wrath warranted it or not, Helen could display a child's incandescent rage. The later stories about her arguing over trifles—screaming at a hapless department store clerk about a handbag—were no different from the tantrums of her twenties and thirties. When a delivery boy casually dumped her fur coat in the basement of the apartment building next door instead of delivering it properly—this was in 1955—Helen "gave the furrier hell" and raged enough at all possible culprits that every elevator boy in her apartment building felt guilty. She later said that her

parents' adulation—for all that she still appreciated it—had done "terrible things" to her.

I have had so many things mirrored glaringly in my face this winter—health, age, being a woman wife artist; independent and free, attached (and often feeling) trapped," Helen wrote to Hartigan in February 1961. "The truths and choices can get so blurred at times." She was writing at the living room desk after dinner on East Ninety-fourth Street, having finally found a quiet moment to write following a late afternoon in which the phone was ringing, the radio was on, the oven timer went off, Jeannie was reading aloud from *Winnie-the-Pooh*, and her husband was hanging and rehanging pictures that had arrived from the framer's. It was the kind of day that had made her feel "stir-crazy" during those winter months. But amid all the commotion there had been a moment of beautiful poise, maybe something like the days of August 1959 back in Falmouth. Lise was practicing her somersaults. There was nothing to it; effortless, in full command of her body, absorbed in the task, the girl was tossing off effects of remarkable agility and grace with hardly a thought, just a poised attention to the matter at hand. Observing this little girl without a care in the world other than her present endeavor, Helen watched a version of her own immersive delights as an artist.

JANUARY 26, 1960

New York: Curtain Call

A woman lustily hunts a mysterious briefcase-like box that people will kill for. She stops at nothing, unafraid to shoot her competitors to possess it. Once the box is finally hers, gained by subterfuge and murder, she places it on a table and greedily prepares to open it. The box is hot to the touch. She lifts the lid at first just a crack. A bright light emits from within, accompanied by a gasping, ghostly voice not her own. She continues opening the box even as smoke starts wafting out and her uplit chin and neck start glowing in the increased radiance. As she opens the box all the way, she starts screaming but cannot turn from the pure burning light. Her hand seemingly glued to the box's handle, she looks down into the glow as her face and body start to smolder and catch fire. The house starts to shake and begins pulsing with a strobe-like light, the demon illumination of exorcisms accompanied by the hiss of poltergeists. The woman bursts into flame but her body is just a small part of the pyre.

This is the ending of *Kiss Me Deadly*, the one Hollywood film in which Helen's friend Gaby Rodgers played a starring role. As Carver, the secret agent pursuing the box, she memorably dies in the end, her fate suggesting a fifties-style Hollywood lesson to women who strive to know and possess too much. But the film is more than a racy and restrictive commentary on gender roles. Released in 1955, it suggests the manifold terrors of a decade the *New York Times* called, on the eve of New Year's Day 1960, "the anxious years." So much had made those ten years nerve-wracking: the Korean War, the ongoing threat of thermonuclear annihilation, the emergence of China as a Communist power, the rockets and missiles of the space race, the paranoia of McCarthyism, to name a few. With its apocalyptic ending, *Kiss Me Deadly* summons those fears, gathering them in a Pandora's box of nuclear fission that cremates the person curious enough to open it.

Helen, like Rodgers, had not lived through the decade unscathed. The day back in 1950 when the two of them posed bright-eyed in their costumes at the Hotel Astor had little prepared them for the dangers of their respective quests, or indeed for the path, in any decade, of going from the age of twenty to thirty. Rodgers had become a stage actress with that one impressive Hollywood credit. Helen had made a name for herself and her career was on the rise. Her feeling of calm and security and confidence, too, had risen with her marriage. But they both remained as deeply neurotic, as incapable of being "terribly happy in the usual sense," as Rodgers had put it in 1950, as they were in their roommate days. Back when she was Gabrielle Rosenberg, back before her family escaped an increasingly anti-Semitic Europe and moved to America, Rodgers

had been a childhood playmate of Anne Frank; for this Jewish actress who narrowly escaped the Holocaust, there was an eerie aptness to her on-screen incineration. And Helen had her own morbidity, her own pains and sorrows. But the anxious decade of the fifties left its own mark. It was fitting that Helen's first career retrospective, at the Jewish Museum on the Upper East Side, opened as those years ended. It was a time to look back on her career to that point, to look back on the fifties as well, to say what they and she had been and would never be again.

A photograph taken on January 26, 1960, the night of the opening, shows Helen beautiful in a tailored blue dress, her hair perfectly coiffed, as she smiles and greets guests. Behind her as she shakes hands is *Hotel Cro-Magnon*, one of nineteen paintings in the exhibition. *Ed Winston's Tropical Gardens*, *Mountains and Sea*, and *Open Wall* were also there, as were *Eden*, *Giralda*, *Jacob's Ladder*, *Before the Caves*, *Mother Goose Melody*, *Acres*, and *Red Square*. The show concentrated on her work in the second half of the decade, a period of remarkable creativity. No wonder that on opening night she enjoyed the praise of well-wishers like an actress taking a curtain call.

Others helped her look back on what she had accomplished. Near to her in front of *Hotel Cro-Magnon* stands Frank O'Hara, a smile on his face, a cigarette and drink in his left hand. He had written a short essay for the show's small catalogue, among the most perceptive of all writings about her art. He saw how she combined spontaneity and aesthetic calculation—how she could "risk everything on inspiration" but then judge the inspiration with a "very keen and even erudite intelligence." He saw her sentimentality

201

(*Mother Goose Melody*) and her pathos (*Hotel Cro-Magnon* and *Winter Hunt*), and he loved that Helen did not insist that one mode was more important than another. So what if some of her work might be "found silly in the higher-seriousness areas of the city"— that was a loss for those precincts, not for the rest of us. He loved how she attended to the funkier and more inglorious feelings of a day on earth, to whatever mood was upon her when she worked: "She has the ability to let a painting be beautiful, or graceful, or sullen and perfunctory, if these qualities are part of the force and clarity of the occasion." She gave us everything, "the whole psychic figure," in pictures suggesting sadness, joy, vulnerability, and outsized confidence.

O'Hara, after much procrastination, wrote the essay in mid-December 1959, in the decade's final days. Helen's friend B. H. Friedman felt that seeing the show "was like reliving a part of the fifties that meant something." There had been plenty of people, to be sure, who had anointed themselves official historians of the period. The acerbic Chandler Brossard excoriated them as "commentators" who glibly declared the meaning of life even though they knew precious little of it. But Helen was a historian of finer feelings, attuned to what Brossard called "that astonishing phenomenon, the American experience." Greenberg put it similarly, defining the "pedant" as a person "who knows the going rate on everything, but not its use, usefulness, [and] value to one as a human being." Helen, by contrast, understood this private human value. An acute noticer of life, she was a chronicler of the fifties, a guide to its fleeting emotions, a Shakespeare of the Eisenhower era. From the joyous Sinatra songs she loved—"You Make Me Feel So Young," "Swingin'

Down the Lane"—to the despair of her own artistic isolation, she provided a colorful record.

Another aspect of the bygone fifties was on view in Helen's show, though perhaps no one who attended could have known just how soon it would disappear. It was the feeling that art is a religion. Friedman, thinking he knew which building was the Jewish Museum, told the cabdriver to stop at Fifth and Ninety-first on the day he went to see the exhibition. Going right up to the supposed museum, he began pounding on the door, only to find that after a while a little panel slid back and a nun appeared. She told him he had the wrong address. He had mistaken the Convent of the Sacred Heart for the Jewish Museum, but having found the show he realized that "the nun was wrong." It was she who had the wrong address because, he told Helen, "yours is the real convent of the sacred heart." He went on: "Very naked. Very alive. No panels to push. THERE. Both sides of you. Some of the paintings coming on very strong, others very gentle." Friedman, a Jew whose grandfather had come to New York from Budapest in 1875, praised Helen, a Jew whose grandfather had come to New York from Germany in 1857, extolling her work in terms he knew she would appreciate: it was Catholic. As emotionally theatrical as Rubens's art, her paintings made a room full of altarpieces but with no church, no need of one, because the art itself—in its capacity to deliver us into transcendent states—was itself a religion.

To be sure, there was something Jewish in the art as well. The Jewish Museum may have been largely a secular institution, but the connotations of the place, not to mention the Jewishness of Helen's art itself, spoke to another kind of artistic religiosity that had an

equally fifties feel. On the eve of the decade, Greenberg had called it *Innerlichkeit*, or inwardness, the authentic interiority whose cultivation he termed "the real task for the individual Jew in the West." It was the quality that he had perhaps first seen most authoritatively in Helen's art in *Mountains and Sea* and that, long after their relationship had ended, was now so richly on view in the Jewish Museum exhibition. The array of magisterial and fiercely personal paintings showed how Helen had emancipated herself from the world. Some might feel she had made her emotion a commodity; but the paintings always kept faith with an unknowable solitude.

One of them was *Seven Types of Ambiguity*, a picture from 1957 that itself spoke to the religious aura of art that was then imperceptibly starting to decline. Helen named it after a book of literary criticism she knew from college, William Empson's *Seven Types of Ambiguity*, first published in 1930 but reprinted many times since then. Empson, a high priest of literary criticism, wrote on the ways poetry resisted the attempts of critics and students to solve it, how it remained aloof. Of the seven types of ambiguity, the fifth—"a fortunate confusion . . . when the author is discovering his idea in the act of writing, or not holding it all in his mind at once"—most evokes Helen's art. Her painting named after Empson's book shows sensuous pink blobs resembling a seated fleshy female nude—head at the top, arms to either side, large legs below—but it never resolves into a clear representation or statement, likely for the reason that Helen evolved it as she went along, capitalizing on the process as a "fortunate confusion." In one of the poems Empson analyzes, Percy Bysshe Shelley's "To a Skylark," the bird becomes a star, then the moon, and the setting shifts from daylight to dawn to evening,

the associations coming to the poet as he moves along. Helen worked in a similar way. As the skylark's song suggests the otherworldly voice of poetry, its connection to mutable and heavenly sensations, "something absolute, fundamental, outside time, and underlying all terrestrial harmony," Helen's art was comparably religious in character.

The fantasy of being an artist in such exalted terms is to be above criticism. At an artist's retrospective, a feeling of grand and irreproachable accomplishment is even more solemnly in the air. Unlike the atmosphere at a gallery show, a museum survey of an artist's career allows for an armistice, a truce of some kind, wherein even critics and skeptics might examine the art with a due appreciation that, after all, the artist has stayed with her convictions and pursued them with a seriousness worthy of respect. No question that believing in a cease-fire is a form of wishful thinking. Do haters ever really abate their hostility? But the artist can still feel that she has earned a respite, something like a mountain climber who has arrived at last on a nice flat ledge and who can, at least for a while, enjoy the view before embarking on the next phase of the climb.

But it was not to be for Helen. The negative review by Anne Seelye in *ARTnews* deeply affronted her. Seelye went much further than calling Helen a "child of the times." She saw a spirit of "reckless blindness and mad impulse" in Helen's paintings; she thought her "sexual symbology" was coy, both explicit and hidden at the same time, a kind of peekaboo prevarication; and generally she felt the art was not as honest or truthful as it purported to be. "The paintings seem to be making an attempt to tell the truth, but so much is excluded out of reticence that they result in being truthful

in the same sense as were the confessions of Charles Van Doren."
Naming Van Doren, the recently dethroned quiz show champion,
was the ultimate cut. Van Doren had won thousands of dollars and
become a national celebrity on a two-month run in early 1957 as
champion of the television game show *Twenty-One*, then had be-
come host of the *Today* show before being brought down under
allegations that he was given the correct answers by the show's
producers—a charge he at first denied but later admitted. He had
testified before the House Subcommittee on Legislative Oversight
only two months before the opening of Helen's show, and Seelye
hit hard when she likened Helen's "confessions" to Van Doren's
in Washington. Leaving herself a little deniability, praising the
beauty of this picture or that, Seelye nonetheless made her point
clear: Helen was a fraud.

Helen swung back. The letters to the editor section of the next
issue of *ARTnews* includes three expressions of outrage, and the
reader feels Helen cheering the letter writers on. One is from Fried-
man, condemning Seelye's review as "hysterical and dishonest."
Another is from Constance Emmerich, the wife of Helen's gallerist
André Emmerich, who lights into Seelye for projecting "her own
hysterical anxieties into the content of the pictures" and for writing
a "glorified dribble" that the editors somehow thought sufficed as
art criticism. The next month, Helen herself makes an appearance
in the letters page, choosing a separate review of a show of her friend
Alfred Leslie's work to blast *ARTnews* for engaging in vulgar spec-
ulation about the artist's life rather than contemplating the art, the
same parlor psychoanalysis that her friends faulted in Seelye: "Why
must you gossip about the personality of the artist? Some of us are

interested in painting." In the piling on, Helen's friend Sonya Ru-
dikoff is next, her letter about Seelye's review of Helen's show right
below her friend's: "Certainly the art world does not need more
expressions of vendetta, self-indulgence and impotent fury, yet this
tone becomes increasingly evident in your magazine. . . . Where is
editorial responsibility?" Barbara Guest, a poet and another friend
of Helen's, then condemns Seelye's "excessive lack of taste," exco-
riating her as an "amateur sociologist."

The editors, not about to stand by, interpolated their comments,
expressing themselves "bemused" at the level of response, and they
hit back at Helen hard: "Like many distinguished artists, Miss
Frankenthaler seems to believe that: facts one approves of are 'Art
History,' indifferent facts are 'Sociology,' disapproved facts are
'Gossip.'" They also noted how artists such as Helen angrily dispute
that their pictures have only "formal value"—that is, that they are
only a collection of colors, shapes, and lines—while hypocritically
prohibiting analysis of anything more personal. Lowering the
boom, they put the matter squarely: "In electing to have a retro-
spective exhibition in a public museum, Miss Frankenthaler invited
comment of all sorts and, in practice, discarded the cloak of precar-
ious vulnerability" that a person avoiding the public eye could still
wear. For better or worse, Helen had become a public figure, and,
fairly or not, her confessions were now subject to the scrum of pub-
lic opinion in just the way that Charles Van Doren's were. If she
would open the box, then she could be burned, too.

It was true that in more ways than one Helen's attainment was a
mixed blessing. There was no pause, no respite, symbolically or
otherwise. For one thing, new artists were emerging, new young

women, with different values, different pursuits, and though they had nothing against Helen per se, they were out there to compete with her just as Helen had competed with her peers and elders back when she first arrived in New York. All that she had said about that time—about enjoying the heady days of competition—was now turning around on her. And though she was achieving an eminence both in her own mind and in the minds of others, the uncouth vitality of the new competition stung.

Up through the ranks, for example, was a new star student of Paul Feeley's at Bennington, Ruth Ann Fredenthal, who had come to New York postgraduation as a beautiful twenty-one-year-old in 1961. Painting in the hard-edged abstract style that Feeley's work had taken on since Helen's time in college, Fredenthal made pictures that bore no resemblance to Helen's. And her upstart status put her rungs below Helen. Living in a grim cold-water flat on West Twenty-ninth Street in a neighborhood of winos and flophouses, she experienced post-Bennington life in a way that bore little resemblance to Helen's days a decade earlier in the fortress-like grandeur of the London Terrace apartments, only a few blocks to the west. Not in a million years would Fredenthal be a guest at one of Helen's dinners at the East Ninety-fourth Street house, where David Smith and other distinguished artists were among the company. But Smith himself adored Fredenthal, the new girl in town, and others did as well. She was brash, fearless, beautiful, sexy; she took jobs as a couture fashion model. And she had Helen in her sights. "I thought I was a much better painter," Fredenthal puts it now. "I still do." She felt that Helen sensed the competition—the young fellow Bennington alumna never received more than a curt hello from the

older painter. Fredenthal, who wrote down her dreams, recorded one about Helen on September 30, 1964:

> *Garden—at closing time—attendants throwing stones at people hiding in bushes to make them leave. High wire fences—as I leave—crowds shout "Frankenthaler" they rush up to her. She has huge beigy-red bouffant hair do—3' tall off her head.*
>
> *She doesn't grant interview—as she walks away (she's so old!) can see three boards as armature supporting hair do.*

"She's so old": Helen's dowager status was the fantasy of a young rival. Yet Fredenthal's dream was also perceptive. Helen turned thirty-one in December 1959, and the Jewish Museum show that opened the following month closed the youthful period of her life. As much as the paintings on the walls suggested a protean gift that was in no danger of drying up, they also stood a little removed from the glamorous woman in the tailored blue dress and coiffed hair who greeted guests. They were not the pictorial equivalents of embarrassing episodes—drunken reveries and rash choices, giddy laughter and hot tears, sluggish depressions and sentimental ecstasies. They did not suggest an immature youth that adult wisdom had now replaced—in effect, the maundering self-involvement of a person youthful enough to feel that the whole world centered on her. But in another sense they were exactly that, a record of a particularly intense period of Helen's life, an intense period in many people's lives, then or now, that an older and wiser person such as she herself had

now become could not have painted. *Eden*, with its bright colors and fervid joy; *Mountains and Sea*, with its roseate pendulum poise, an erotic letter openly shared and indifferent to public condemnation; *Giralda*, a bacchanal that puts one in mind of satyrs and nymphs enticing one another to the next Manhattan party; *Towards a New Climate*, a tellingly spare picture also in the show that O'Hara recalled was painted in a "low" moment in the artist's life; *Before the Caves*, with its whirling exultation; *Hotel Cro-Magnon*, where it is not the cave but the light outside that rules the day.

The turbulent wind that strokes the forms in the paintings from this ten-year period, that blows them around until sometimes bits flake and stream away in skids and elongations of paint—this wind is as fair a sign as any of the feeling in Helen's art. Wind, a philosopher might say, comes from nowhere; it comes from a set of causes so distant that no rumination could ever determine its origin. It is known by the trees it bends, the hair it blows, the rippling waves, but not as itself, which, being invisible, manifests the inscrutability of its source. It carries along our human voices in its stream, bearing our small gestures and opinions in bigger currents, vaster rhythms, that do not originate with us. Helen seemed to speak on behalf of some energy in the world, to be the representative of a force that occasionally alights in all of us but that had chosen to live within her. Even when she painted a stop sign—the bright red hand of *Eden*—the gesture is open and free, lyric and gaudy, zany and alive. The hand is not a conclusion, let alone a goodbye, more a signal to you and me that the artist who gave us such streams of life could not envision a time when this gift of hers would ever end.

CODA

It would not be until 1967, when she was thirty-eight years old, that Helen would confide that "Middle Age is here" and that it represented a diminution of energies as well as a growth of maturity, worry, and concern. "You can no longer even try to do a number of things well, spreading energies and delaying, and exhausting yourself in compulsive minutiae." Even so, she was feeling these midlife pressures as the decade began. In summer 1960 she and Bob traveled to Europe for a lengthy and regal vacation in the Italian coastal town of Alassio, but she felt "<u>depressed</u>, <u>angry</u>, <u>trapped</u>." A migraine struck savagely. As she put it to Grace Hartigan, "One cannot deny that even though one may be 'happy' or happily married, or have a majority of problems or situations 'solved,' relatively anyway, that these periods happen to people like ourselves." At the time Jeannie and Lise moved into the house on East Ninety-fourth, she was worried about a lump on her breast—the doctors assured her it was nothing—and she had worked herself into such a state of anxiety that she could not sleep. Gorging herself

with food, she fearfully noted how she was not gaining any weight; she became hysterical. Her hypochondriacal fears and sadness from years back were always stirring, no matter how "solved" her problems were.

At first Motherwell was a source of strength, with Helen relying on his calm and reassurance, but her husband's own demons were never far away, and as the decade went on he would drink more and more, mostly at night, to the point where Helen hid the key to the liquor cabinet. But he kept a flask in the glove compartment of the latest car he had purchased in an automotive enthusiasm that was one of his salves for depression. When drunk in previous years, he had been violent with Betty Little. Now, he was less abusive, more despondent, but he raged when drunk, and Helen understood that he was so repressed when sober that he needed the alcohol-fueled anger, even if she bore the emotional brunt of it. She felt as though her home was a hospital ward, her sense of her husband's unhealthiness intensified by her own constant hypochondria, and she and Motherwell divorced in 1971. Possibly before the marriage ended, and certainly soon after, she engaged in a passionate affair with a married man, Andrew Heiskell, the chairman and CEO of Time Inc., which lasted until it became clear that Heiskell would not leave his wife.

The paintings Helen had made in her twenties underwent their own challenges in the new decade. Different forms of "cool" art—detached, ironic, funny in a mirthless way—rose to the fore. Andy Warhol's Campbell's Soup Cans and Coca-Cola Bottles, his Brillo Boxes, not to mention his car crashes and cans of tainted tuna fish—all spoke in deadpan terms of America's consumer culture, its allure and lethal false promises. In his hands art was no longer

an exalted respite from everyday tawdriness; it now matter-of-factly asserted its own status as one commodity among others, the art world having become more and more an art market. Meanwhile, Roy Lichtenstein's tearful blonde heroines and screaming fighter pilots put ironic quotation marks around all the emotional intensities that Helen held dear.

The new "hot" art posed an equal challenge to Helen in those years. The writer and psychologist Timothy Leary, guru of the psychedelic counterculture, issued an aesthetic manifesto to the decade's artists when he described the effects of LSD: "I discovered that beauty, revelation, sensuality, the cellular history of the past, God, the Devil—all lie inside my body, outside my mind." "Ecstasy" was Leary's key word—"The open cortex produces an ecstatic state. . . . Man's natural state is ecstatic wonder, ecstatic intuition, ecstatic, accurate movement"—and various artists and writers, including Helen's friend Paul Jenkins, took up the mantle. The one who had telephoned her in Paris in August 1956 to ask that she come over to his place to help him console Lee Krasner, Jenkins in the next decade became a leading painter in the new psychedelic-abstract mode. His vast poured acrylic paintings, such as *Yonder Near* and *Phenomena*, spin hallucinatory rhymes—the veils of Salome and the shimmer of iridescent insect wings—that made them veritable banners of the Summer of Love. Meanwhile, B. H. Friedman, who thought Helen's work evoked the 1950s so well, met Leary in spring 1961 and began experimenting with psilocybin and then LSD. Describing his experiences, he implicitly set a standard for the quicksilver effects a Jenkins-like artist might strive for: "bursts of laughter, an occasional tingling of the jaw,

words lost in the surf, the burrowing of sandcrabs, the rustling of leaves, the way a school of tiny fish would be dispersed by the waves and then get back together in formation . . ."

Helen's 1960s art pursued ecstasy in another form. Against the new mysticism—with its way of opening the doors of perception—her scenes of imagination and dream could seem old, square. Traveling her own path, resisting both the hot and cool art of the sixties, she made sensuous but austere pictures. Having moved on from the riotous unpredictable effects that came from some deep place within her when she was younger—the pendulous crazy "apple" of *Eden*, the great phallic stalk at the heart of *Giralda*—she now worked in broad planes and great swaths of pure color. In new paintings such as *Blue North*, of 1968, so far from the spinning gossamer of Paul Jenkins and other groovy painters of the new elation, two pillars of blue flank a bare white ground. There is nothing "unslick" here, no scabs to rip, no dire revelations to unfold. Amid the new calm, her earlier paintings came to seem like tokens of a rambunctious adolescence, the party years of a painter who had gone on to these Olympian powers. In the new art, the azures and watermelon reds interlock, the plinths of orange and yellow rest upon each other—it sounds psychedelic, but these paintings suggest rippling flags, bold insignia, the brilliant heraldry of a land Helen invented, a country of the imagination.

A funny thing happened all the while. As Helen grew older, she grew younger. John Blee, who met her when he was a twenty-one-year-old art student in 1969, remembers that the

openly gay poetry editor at the *New Yorker*, Howard Moss, said to him once that he thought Helen *became* beautiful as she grew older, that when she was young she lacked the stunning physical presence that she grew into with age. The woman who was born an "old soul," in the words of the doctor who delivered her, was becoming disarmingly youthful. Blee recalls meeting Helen in Baltimore in 1969, when she came to visit the art class taught by Grace Hartigan that he, a painter himself, was given permission to attend: "When I first met her (and I remember exactly) she had on her leopard skin coat and she was incredibly beautiful. And her voice was very much tuned to that beauty." That did not change as he got to know her. "I saw her many times in all sorts of settings and I always found real beauty in her being. She had a beauty in her movements and how she placed herself, whether standing, walking or sitting." The beauty was "physical, yes," but also that of a radiant soul.

That radiance was not always there in the 1950s. In her paintings back then, Helen quested after the mercurial feelings of youth, but she herself was older than she became, Blee thinks. "She was not so girlish when young. She became freer with age." Back then the death of her father oppressed her, and her ambition weighed her down. Agitation, anger, and sadness intermittently rocked her as she contemplated the discrepancy between her gifts and what—then—was the limit of her achievement. With the insight of a fellow artist, Blee speculates that she fretted that all she had inside her—the fulfillment of her destiny as a painter—might never come to fruition. He likens her youthful situation to a memory he has of meeting the composer John Cage a long time before Cage

became famous. "He was extremely weird and on edge to the point of scary," he recalls. "He couldn't light his own cigarette as his hands trembled so." Many years later in New York Blee would frequently see Cage, who by then was always calm and benign. He could not understand the discrepancy until a mutual friend told him, "John had to become famous." As Helen became more and more well-known, perhaps she, too, found peace, now that she needed to worry less about failing to achieve a self-appointed destiny.

On January 26, 1960, that relaxation was still a work in progress. As Seelye's review suggests, the jury was out on the nature of Helen's achievement. It would not be until the end of the decade, in 1969, when she had another and bigger retrospective, this time at the Whitney Museum of American Art, that she would truly make it, becoming an unmistakable name among painters. The Whitney show was, in fact, her first major retrospective—a far more significant event, in art-world terms, than the one at the Jewish Museum. It encompassed more work and more years, and it took place at a major art venue, before traveling to the Whitechapel Gallery in London, the Orangerie Herrenhausen in Hanover, and the Kongresshalle in Berlin. If it was all long overdue, Helen was not resentful. Onlookers noticed her sheer pleasure. "Helen glowed because she was happy, and she glowed because she had looked frankly beautiful," Gabrielle Smith wrote about the artist's fortieth birthday party, which took place two months before the Whitney show. Helen's marriage was then falling apart, but she joyously cut the huge five-foot-long mocha cake that said HELENFRANKENTHALER-MOTHERWELL that Marjorie had ordered. She savored the runny

Brie, the crisp potato salad, the wine, and she smiled. "When Helen smiles at someone she likes, she purrs," Smith wrote. Her laugh was even more remarkable. "Her friends know it as the 'Helen laugh.' It comes out like the spoken word, modulated and high at first, sometimes explosive, to settle into a throaty conversational breathlessness." That night she wore a deep red velvet pantsuit with a gold braid—"Sgt. Pepper," Helen called it, joking that if she just put on a little hat she could go outside and hail cabs. Her eyes were "sparkling with sheer excitement."

Acknowledgments

elen Frankenthaler's sister Marjorie Iseman spent years researching the history of 55 Water Street, recovering a whole hidden history from this one Manhattan location then being excavated to build a new version of the city. I have thought of her project while writing this book, imagining that I, too, am digging in one place, delighting in the treasures I find and the mysteries they intensify. The time when Marjorie and her younger sisters, Gloria and Helen, were young is now as ancient, or so it might seem, as the eighteenth- and nineteenth-century Manhattan that Marjorie loved to investigate. But far from a funereal tale, the eventual antiquity of my protagonist's youth has been for me a source of fascination, less a discovery of relics and outmoded customs than a meditation on the way youth replenishes itself, the way it lives again once uncovered. Amid the many things Marjorie kept from the excavations of 55 Water Street are old smoked green

glass bottles, thick and cloudy with the soot and the very saliva of the long-gone people who drank from them and tossed them away. But the things are beautiful, very much a present-tense affair, and so I have conceived the writing of this book, this message in a bottle, a legacy of the person it tells of.

So many people have helped me get to this point. At the Helen Frankenthaler Foundation, Elizabeth Smith, the executive director; Douglas Dreishpoon, the director of the catalogue raisonée; Maureen St. Onge, the director of collections; Sarah Haug, the archivist; and Cecelia Barnett, the collections and visual resources manager, have all been unfailingly helpful. Among Helen's relatives, I wish to thank Ellen and Frederick Iseman, two of Marjorie's three children, for their candor and kindness, and for putting me in touch with the family's genealogist, Karen Franklin; and especially Clifford Ross, one of Gloria's sons, for the many hours he has spent with me talking about his aunt. Others who knew Helen have likewise kindly offered their reflections, not least Jeannie and Lise Motherwell, little girls when they first met her; Gillian and Jennifer Feeley, kids when their father taught Helen; Michael Hecht, her accountant and friend starting in 1959; Daisy Friedman, daughter of Helen's friend B. H. Friedman; Jenny Kaufmann, daughter of Helen's friend Dotty Kahn; Rick Klauber, who worked for Helen as a studio assistant in late 1969 and for Robert Motherwell in the early 1970s; the painter Ruth Ann Fredenthal, who came to know Helen in the 1960s; the art historian and critic Barbara Rose, a friend of Helen's starting in the 1960s who wrote the first monograph on her work; the critic Phyllis Tuchman; the curator and critic Karen Wilkin, who has written extensively on Helen since the 1980s; and John

Elderfield, the art historian whose extensive writing on the artist includes the large monograph of 1989 as well as recent publications. I am also grateful to Heidi Colsman-Freyberger and Monica Crozier of the Barnett Newman Foundation. Among my correspondents, I owe special gratitude to my friend the painter John Blee, who has generously shared with me his extensive and detailed memories of Helen in the 1970s, when she would frequently describe to him in detail her life back when she was starting out.

Few of Helen's contemporaries who knew her in the fifties remain. I have talked to two: the novelist Herbert Gold, who dated her for a while in 1956; and the artist Alfred Leslie, who met Helen early in the decade. I thank them for sharing their memories with me.

The writing of the book has been a great experience for me. I thank Ann Godoff, editor in chief at Penguin Press, for believing in this project from the first. Emily Cunningham, my editor, has been nothing short of great as a patient, sympathetic, and tough reader who has taught me a lot about myself as a writer. Elias Altman, my agent, is the person who started this all: he thought I could write a book of this kind, and now it appears he was right. He is a person I feel I knew before I knew him, maybe because we are both from Vermont, maybe for a lot of other reasons, too.

To my family—my wife, Mary, our teenage daughters, Lucy and Anna—I say thank you for showing me what love is.

Notes

Introduction

xv "mediocre": Helen Frankenthaler, "Did We Spawn an Arts Monster," *New York Times*, July 17, 1989, p. A17.

xv "Raise the level": Frankenthaler, "Did We Spawn an Arts Monster," p. A17.

xvi "spawn an arts monster": Frankenthaler, "Did We Spawn an Arts Monster," p. A17.

xvi "square and bourgeois": Frankenthaler, quoted in Deborah Solomon, "Artful Survivor: Helen Frankenthaler Stays Loyal to Abstract Expressionism," *New York Times Sunday Magazine*, May 14, 1989, p. SM31.

xvi "an Edith Wharton novel": Solomon, "Artful Survivor," p. SM31.

Chapter One: May 19, 1950

3 Spring Fantasia: For this ball and the photograph of Helen and Gaby Rodgers, see "Life Goes to an Artists' Masquerade: New Yorkers Dress Up for a Bohemian Ball," *Life* (June 12, 1950), pp. 144–46, 149.

4 painter Yasuo Kuniyoshi: For Kuniyoshi's role as president of the Artists Equity Association, see David M. Sokol, "The Founding of Artists Equity Association after World War II," *Archives of American Art Journal* 39, no. 1–2 (1999): 17–29.

4 Gypsy Rose Lee: Noralee Frankel, *Stripping Gypsy: The Life of Gypsy Rose Lee* (Oxford: Oxford University Press, 2009), pp. 160–66.

5 looking sweet and sedate: The photograph is in the Helen Frankenthaler Foundation Archives, New York.

6 Alfred's father, Louis: Conversation and email correspondence with Karen Franklin, July 19, 2018. Franklin is the family's genealogist.

7 slipped on the courthouse steps: Clifford Ross, interview with author, May 28, 2018.

7 learning how to use the toilet: Barbara Rose, interview with author, August 20, 2018.

8 Saks Fifth Avenue drawing contest: Frankenthaler, interview with Barbara Rose, Archives of American Art, Smithsonian Institution, Washington, D.C.

8 nail polish into the basin: Frankenthaler, interview with Rose, Archives of American Art.

8 a continuous chalk line: Frankenthaler, interview with Rose, Archives of American Art.

8 "Watch that child": Frankenthaler, interview with Rose, Archives of American Art.

8 Alfred underwent an operation: "A. Frankenthaler, Jurist, Dies at 58," *New York Times*, January 8, 1940, p. 15.

8 $900,000: "Justice's Widow Killed: Mrs. Frankenthaler Plunges from 14th-Floor Window," *New York Times*, April 24, 1954, p. 7.

9 "look at a chair": Frankenthaler, interview with Rose, Getty Research Institute, Los Angeles.

9 When her mother would go to the grocery store: Frankenthaler, interview with Rose, Getty Research Institute.

9 sympathetic headmistress: Frankenthaler, interview with Rose, Getty Research Institute.

9 first proper art training: Frankenthaler, interview with Rose, Getty Research Institute.

10 "Those Bennington girls": Frankenthaler, interview with Rose, Archives of American Art.

10 Martha was proud: Frankenthaler, interview with Rose, Archives of American Art.

10 he would tack color illustrations: Frankenthaler, interview with Rose, Archives of American Art.

11 "Matisse is your daddy": Rosalind Bernheimer, Bennington alumna, conversation with author, June 2, 2017.

11 Hubert Humphrey: *The College Week* 16:17 (July 1, 1949), p. 1.

13 Brando gave them an insider's view: Helen Frankenthaler and Cynthia Lee, "A Brando Named 'Desire,'" Bennington *Beacon*, June 24, 1948, p. 4.

14 "intellectual and artistic accelerant": Clifford Ross, interview with author, September 30, 2018.

14 "fresh and spontaneous perception": Erich Fromm, *Escape from Freedom* (New York: Holt, Rinehart and Winston, 1941), p. 260.

15 Elegant yet earthy: Frankenthaler, interview with Barbara Rose.

15 "childish expectancy": Marjorie F. Iseman, "My Father and Mrs. Roosevelt's Dogs," *American Heritage* 25 (August 1974), https://www.americanheritage.com/my-father-and-mrs-roosevelts-dogs.

15 "wearing on a day-to-day basis": Iseman, "My Father and Mrs. Roosevelt's Dogs."

15 Helen's career choice: Frederick Iseman, email to author, May 7, 2019.

16 "Bon Voyage Helen": The photograph is in the collection of the Helen Frankenthaler Foundation Archives, New York.

16 St. Patrick's Day Parade: Frankenthaler, letter to Rudikoff, March 22, 1986, Sonya Rudikoff Papers, Princeton University. See also Rudikoff to Frankenthaler, May 19, 1954, Helen Frankenthaler Foundation Archives.

16 Sara Delano Roosevelt: Iseman, "My Father and Mrs. Roosevelt's Dogs."

17 "The beam of the projector": Anatole Broyard, *Kafka Was the Rage: A Greenwich Village Memoir* (New York: Carol Southern Books, 1993), p. 60.

17 "except in my own terms": Frankenthaler, interview with Rose, Archives of American Art.

18 Eleventh Avenue freight train: Frankenthaler, letter to Sonya Rudikoff, January 31, 1951.

18 "steady, endless poverty": Grace Hartigan, journal entry, March 6, 1953, in William T. La Moy and Joseph P. McCaffrey, *The Journals of Grace Hartigan, 1951–1955* (Syracuse, NY: Syracuse University Press, 2009), p. 72.

18 "Helen will never know": Hartigan, journal entry, March 6, 1953, *Journals of Grace Hartigan.*

18 MacLevy's: Frankenthaler, letter to Rudikoff, October 21, 1950, Sonya Rudikoff Papers.

18 "Jean de Chump": Frankenthaler, letter to Rudikoff, March 2, 1953, Sonya Rudikoff Papers.

18 employed a maid: Frankenthaler, letter to Rudikoff, January 22, 1952.

18 black-and-white television: Frankenthaler, interview with Rose, Archives of American Art.

19 thanked Leslie: Alfred Leslie, interview with author, February 13, 2019.

19 with a steak: Alfred Leslie, email to author, May 27, 2019.

19 "Oh, I love Bennington!": Frankenthaler, interview with Rose, Archives of American Art.

20 "I don't like that one": Frankenthaler, interview with Rose, Archives of American Art.

20 Born in 1909: For the details of Greenberg's life, I am indebted to Florence Rubenfeld, *Clement Greenberg: A Life* (New York: Scribner, 1997).

20 Faulkner and Melville: Clement Greenberg, "The Present Prospects of American Painting and Sculpture" (1948), in John O'Brian, ed., *Clement Greenberg: The Collected Essays and Criticism*, v. 2 (Chicago: University of Chicago Press, 1988), p. 165.

20 existential alienation: Greenberg, "The Situation at the Moment," in O'Brian, ed., *The Collected Essays and Criticism*, v. 2, pp. 192–96.

20 big brown eyes: For the look and feeling of Helen's eyes up close, I have relied on accounts of two people who knew her starting in 1969–70: John Blee and Rick Klauber (Blee, email to author, August 10, 2019; Klauber, interview with author, September 3, 2019).

21 "We had a long phone call": Frankenthaler, interview with Rose, Archives of American Art.

21 Martha Frankenthaler was not pleased: Alfred Leslie, interview with author, February 13, 2019.

22 "these friends of Clem's": Gaby Rodgers, letter to Frankenthaler, July 24, 1950, Helen Frankenthaler Foundation Archives.

Chapter Two: November 12, 1951

23 Helen was a nervous wreck: Frankenthaler, letter to Rudikoff, November 23, 1951, Sonya Rudikoff Papers.

23 the San Remo: Frankenthaler, "Memories of the San Remo," *Partisan Review* 49, no. 3 (1982): 412–14.

24 Myers's lover: Alfred Leslie, interview with author, February 13, 2019.

24 a traveling marionette theater: John Myers, *Tracking the Marvelous: A Life in the New York Art World* (New York: Random House, 1983).

24 up-and-coming serious painters: Frankenthaler, interview with Rose, Archives of American Art.

24 By March Myers offered: Frankenthaler, letter to Rudikoff, March 19, 1951, Sonya Rudikoff Papers. See also Frankenthaler, postcard to Rudikoff, February 26, 1951, Sonya Rudikoff Papers.

24 "pretty odd": Frankenthaler, letter to Rudikoff, March 19, 1951, Sonya Rudikoff Papers.

24 "the new 'avant-garde' spot": Frankenthaler, letter to Rudikoff, March 19, 1951, Sonya Rudikoff Papers.

25 at twenty-two: Mary Gabriel, *Ninth Street Women: Lee Krasner, Elaine de Kooning, Grace Hartigan, Joan Mitchell, and Helen Frankenthaler: Five Painters and the Movement That Changed Modern Art* (New York: Little, Brown, 2018), p. 9. For the story of the Ninth Street show, see Gabriel, pp. 5–15.

25 "the fairy princess": Hartigan, journal entry, March 31, 1951, *Journals of Grace Hartigan*, p. 2.

26 added the title as a "gag": Frankenthaler, letter to Rudikoff, March 30, 1952, Sonya Rudikoff Papers.

26 high-minded "genuine culture": Greenberg, "The Plight of Our Culture" (1953), in John O'Brian, ed., *The Collected Essays and Criticism*, v. 4 (Chicago: University of Chicago Press, 1993), p. 140.

27 the pompous grandeur: Chandler Brossard, *Who Walk in Darkness* (New York: Herodias, 2000 [1952]), p. 134.

28 "Pollack": Frankenthaler, letter to Rudikoff, January 31, 1951, Sonya Rudikoff Papers.

28 "a very 'American' charming grump": Frankenthaler, letter to Rudikoff, November 28, 1950, Sonya Rudikoff Papers.

NOTES

28 Nervous, ready, focused: Frankenthaler, interview with Rose, Archives of American Art.

28 "Walk in": Frankenthaler, interview with Rose, Archives of American Art.

28 "I was overwhelmed and puzzled": Frankenthaler, interview with Rose, Archives of American Art.

29 "I don't paint nature": Lee Krasner, interviews with Dorothy Seckler, November 2, 1964, December 14, 1967, April 11, 1968, Archives of American Art, Smithsonian Institution, Washington, D.C., https://www.aaa.si.edu/collections/interviews/oral-history-interview-lee-krasner-12507#transcript.

30 topographical maps: Howard Devree, "Artists of Today: Water-Colors Poles Apart in Current Culture," *New York Times*, December 3, 1950, X9.

30 "a life of its own": Jackson Pollock, interview with William Wright, 1950, digitized and edited by Maria Caamano, http://homepages.neiu.edu/~wbsieger/Art201/201Read/201-Pollock.pdf.

30 "one's own inventiveness": Frankenthaler, interview with Rose, Archives of American Art.

31 "easel cuisine": Frankenthaler, interview with Rose, Archives of American Art.

31 a cooking term: John Blee, email to author, August 24, 2017.

31 "Aesthetically, socially": Frankenthaler, interview with Rose, Archives of American Art.

31 "when to stop": Frankenthaler, interview with Rose, Archives of American Art.

31 "totally silent": Frankenthaler, interview with Rose, Archives of American Art.

32 "a strong aggressive": Frankenthaler, letter to Rudikoff, January 31, 1951, Sonya Rudikoff Papers.

32 "We were so moved": Frankenthaler, interview with Rose, Archives of American Art.

32 "the most schmaltzy, pathetic": Frankenthaler, interview with Rose, Archives of American Art.

33 "notoriously hostile": "The Metropolitan and Modern Art: Amid Brickbats and Bouquets the Museum Holds Its First U.S. Painting Competition," *Life* (January 15, 1951), p. 35.

33 "some Renaissance revivalist": Frankenthaler, letter to Rudikoff, October 14, 1950.

34 latterly named "zip" paintings: For the designation of Newman's paintings by this term, see Sarah K. Rich, "The Proper Name of Newman's Zip," in Melissa Ho, ed., *Reconsidering Barnett Newman: A Symposium at the Philadelphia Museum of Art* (Philadelphia: Philadelphia Museum of Art, 2005), pp. 96–114.

34 "Rembrandt, Rothko": Quoted in James Breslin, *Mark Rothko: A Biography* (Chicago: University of Chicago Press, 1993), p. 339.

34 Clyfford Still, who in his teaching days: Susan Landauer, *The San Francisco School of Abstract Expressionism* (Berkeley: University of California Press, 1996), p. 89.

34 "Let no man under-value": Clyfford Still, quoted in *Ad Reinhardt* (Los Angeles: Museum of Contemporary Art, 1991), p. 115.

35 "To serve your vision": Hedda Sterne, quoted in Ann Gibson, *Abstract Expressionism: Other Politics* (New Haven: Yale University Press, 1997), p. 156.

35 punching a sniveling-nosed poet: Joe LeSueur, *Digressions on Some Poems by Frank O'Hara* (New York: Farrar, Straus and Giroux, 2003), p. 104.

36 peppering her speech: See for example LeSueur, *Digressions*, p. 161.

36 painters' letter of complaint: "18 Painters Boycott Metropolitan; Charge 'Hostility to Advanced Art,'" *New York Times*, May 22, 1950, p. 1.

36 surplus parachute cloth: Frankenthaler, interview with Rose. In an interview with the author on February 13, 2019, Alfred Leslie specified that the repurposing took three days.

37 "True artistic creation": Helen Frankenthaler with Julia Brown, "A Conversation," in *After* Mountains and Sea*: Frankenthaler 1956–1959* (New York: Guggenheim Museum, 1998), p. 47.

37 his nipples were mosquito bites: Frankenthaler, letter to Rudikoff, June 4, 1951, Sonya Rudikoff Papers.

37 "something out of the ordinary": Frankenthaler with Brown, "A Conversation," p. 46.

37 "I'm not at all close to her": Frankenthaler, interview with Rose, Getty Research Institute, p. 27.

38 reproductive organs and appendix: Frankenthaler, letter to Rudikoff, October 29, 1950, Sonya Rudikoff Papers.

38 "Mother has one of the greatest wills": Frankenthaler, letter to Rudikoff, November 14, 1950, Sonya Rudikoff Papers.

38 Parkinson's: Clifford Ross confirms that Martha Frankenthaler suffered from Parkinson's (Ross, interview with author, June 23, 2018).

39 lunch with her on July 10: Clement Greenberg, appointment book, 1950, Box 19, Clement Greenberg Papers, Getty Research Institute, Los Angeles.

39 fresh from Penn Station: Greenberg, appointment book, 1950, Clement Greenberg Papers.

39 hours going to galleries: B. H. Friedman, *Jackson Pollock: Energy Made Visible* (New York: McGraw-Hill, 1972), p. 137.

39 Viola Wolff School: Myers, *Tracking the Marvelous*, p. 179.

39 shrimp creole: Frankenthaler, postcard to Rudikoff, January 2, 1951, Sonya Rudikoff Papers.

39 contentedly watch Clem: Frankenthaler, letter to Rudikoff, undated [November 7, 1950], Sonya Rudikoff Papers.

39 a "campy" hug: Frankenthaler, "Memories of the San Remo," *Partisan Review*, pp. 413–14.

39 "neurotic corners": Frankenthaler, letter to Rudikoff, October 11, 1950, Sonya Rudikoff Papers.

40 "Jewish self-hatred": Greenberg, "Self-Hatred and Jewish Chauvinism: Some Reflections on 'Positive Jewishness,'" in John O'Brian, ed., *The Collected Essays and Criticism*, v. 3 (Chicago: University of Chicago Press, 1993), pp. 45–58.

40 her analyst every day for a month: Frankenthaler, letter to Rudikoff, December 27, 1950, Sonya Rudikoff Papers.

40 "a psychopathic liar": Frankenthaler, letter to Rudikoff, October 5, 1950, Sonya Rudikoff Papers.

40 persisted in calling him: Frankenthaler, letter to Rudikoff, undated [November 7, 1950], Sonya Rudikoff Papers.

40 "strange moods": Frankenthaler, letter to Rudikoff, January 17, 1951, Sonya Rudikoff Papers.

40 "what a dreadful error": Frankenthaler, letter to Rudikoff, October 11, 1950, Sonya Rudikoff Papers.

40 "breaking up, going back": Frankenthaler, letter to Rudikoff, December 27, 1950, Sonya Rudikoff Papers.

40 "unhappy, unsettled, and disturbed": Frankenthaler, letter to Rudikoff, June 4, 1951, Sonya Rudikoff Papers.

40 "despite his neurosis": Frankenthaler, letter to Rudikoff, October 11, 1950, Sonya Rudikoff Papers.

40 American illustrator Norman Rockwell: Helen told this story to John Blee in the 1970s (Blee, interview with author, July 14, 2017). In his appointment book on August 16, 1951, Greenberg notes "Norman Rockwell's at 5." See also Frankenthaler, letter to Rudikoff, August 21, 1951, Sonya Rudikoff Papers.

41 "a finer eye": Frankenthaler, letter to Rudikoff, December 17, 1951, Sonya Rudikoff Papers.

42 "Don't say that again": John Blee, email to author, August 25, 2017.

42 "a grave mistake": Frankenthaler, letter to Rudikoff, undated [November 7, 1950], Sonya Rudikoff Papers.

42 aggressive, flamboyant: William Phillips, *A Partisan View: Five Decades of Literary Life* (New York: Stein and Day, 1983), p. 271. Rahv regarded each essay he wrote as a "tactical exercise in a continuing war of ideas," according to Mark Krupnick; see Krupnick, *Jewish Writing and the Deep Places of the Imagination* (Madison: University of Wisconsin Press, 2005), p. 159. For more on Rahv, see Milton Hindus, "Philip Rahv," in Arthur Edelstein, ed., *Images and Ideas in American Culture: The Function of Criticism, Essays in Memory of Philip Rahv* (Hanover, NH: Brandeis University Press, 1979), pp. 171–203.

42 timorous and insecure: Phillips, *A Partisan View*, p. 274.

42 *Partisan Review* parties: Phillips, *A Partisan View*, p. 272.

42 "most tortured": Phillips, *A Partisan Review*, p. 76.

42 courtly, gracious: Phillips, *A Partisan View*, p. 74.

42 constantly alert: Alfred Kazin, *New York Jew* (New York: Alfred A. Knopf, 1978), p. 46.

42 "quiet ferocity": Kazin, *New York Jew*, p. 42.

42 "blew up when criticized": Greenberg, journal entry, November 1989, Clement Greenberg Papers.

43 "positive delight": Kazin, *New York Jew*, pp. 67–68.

43 she had an affair with Greenberg: Mary McCarthy, letter to Hannah Arendt, May 9, 1960, in Carol Brightman, ed., *Between Friends: The Correspondence of Hannah Arendt and Mary McCarthy, 1949–1975* (New York: Harcourt Brace, 1995), pp. 71–73.

43 shy and "much less articulate": Phillips, *A Partisan View*, p. 89.

43 "at every turn": Frankenthaler, letter to Rudikoff, undated [November 7, 1950], Sonya Rudikoff Papers.

43 "utter lack of delicacy"; "coarse": Greenberg, diary, June 4, 1955, Notebook 17, Box 16, Folder 2, Clement Greenberg Papers.

44 "She was the artist he wanted to be": Barbara Rose, interview with author, August 20, 2018.

44 berated his sons: Rubenfeld, *Clement Greenberg*, pp. 34–35.

44 "morality and honesty as a club": Greenberg, diary, June 8, 1955, Notebook 17, Box 16, Folder 2, Clement Greenberg Papers.

44 "Nothing preserved": Greenberg, diary, May 16, 1951, Box 15, Clement Greenberg Papers.

45 "neurotic, peevish, weighty": Frankenthaler, letter to Grace Hartigan, June 16, 1951, Grace Hartigan Papers, Special Collections Research Center, Syracuse University Libraries.

45 a small portrait of Danny: John Blee, email to author, September 8, 2017.

45 "deep but brief depressions"; "work out eventually": Frankenthaler, letter to Hartigan, June 16, 1951, Grace Hartigan Papers.

45–46 A photograph taken by Jerry Cooke: This photograph is in the collection of the Helen Frankenthaler Foundation Archives.

46 Greenberg loved and had asked Helen to give to him: Frankenthaler, interview with Rose, Getty Research Institute.

46 "very upset and unhappy": Frankenthaler, letter to Rudikoff, October 21, 1951, Sonya Rudikoff Papers.

46 "I wonder if": Hartigan, journal entry, October 23, 1951, *Journals of Grace Hartigan*, pp. 15–16.

47 Helen ended up enjoying the event: Frankenthaler, letter to Rudikoff, November 23, 1951, Sonya Rudikoff Papers.

47 "the worst of the human animal": Tibor de Nagy, letter to Frankenthaler, undated [1987], photocopied, in Frankenthaler, letter to Hartigan, September 27 [1987], Grace Hartigan Papers.

47 "A work is great when": Frankenthaler with Brown, "A Conversation," p. 44.

Chapter Three: October 26, 1952

49 moaning and groaning: Friedel Dzubas, interviews with Charles Millard, August 5 and 17, 1982, Archives of American Art.

49 skylighted loft: Frankenthaler, letter to Rudikoff, October 6, 1952, Sonya Rudikoff Papers.

49 she had carried the screens: Frankenthaler, interview with Rose, Archives of American Art.

49 his wife having kicked him out: Frankenthaler, interview with Rose, Archives of American Art.

49 she paid $25: Frankenthaler, letter to Rudikoff, October 6, 1952, Sonya Rudikoff Papers.

50 "lazy": Dzubas, interviews with Millard, August 5 and 17, 1982.

50 "very impatient to paint": Frankenthaler, interview with Rose, Archives of American Art.

50 "came from him no doubt": Frankenthaler, interview with Rose, Archives of American Art. Frankenthaler also tells Rose in this interview: "I know that Pollock's pictures and his method and material affected me greatly."

50 So now on October 26, 1952: For Frankenthaler's description of the making of the picture, see Gene Baro, "The Achievement of Helen Frankenthaler," *Art International* 2, no. 7 (September 1967): 35.

51 After three hours: Dzubas, interviews with Millard, August 5 and 17, 1982.

51 Angry detractors: Frankenthaler with Brown, "A Conversation," p. 35.

51 in her arms: Frankenthaler, quoted in John Elderfield, *Frankenthaler* (New York: Abrams, 1989), p. 66.

52 "The point is, the point is": Dzubas, interviews with Millard, August 5 and 17, 1982.

52 "somewhat puzzled": Frankenthaler with Brown, "A Conversation," p. 35.

52 Her sister Marjorie: Frederick Iseman, email to author, May 1, 2019.

52 "I've seen three people": Frankenthaler, letter to Rudikoff, October 6, 1952, Sonya Rudikoff Papers.

52 "brisk, alert, 'sophisticated'": Frankenthaler, letter to Rudikoff, October 6, 1952, Sonya Rudikoff Papers.

53 "Once you work for *Life*": Frankenthaler, letter to Rudikoff, October 6, 1952, Sonya Rudikoff Papers.

53 "This way, if and when": Frankenthaler, letter to Rudikoff, October 6, 1952, Sonya Rudikoff Papers.

53 "I'm not sure": Frankenthaler, letter to Rudikoff, October 6, 1952, Sonya Rudikoff Papers.

53 "schmaltzy": Frankenthaler, letter to Rudikoff, October 6, 1952, Sonya Rudikoff Papers.

53 "I feel discouraged": Frankenthaler, letter to Rudikoff, November 5, 1952, Sonya Rudikoff Papers.

54 Both Helen's sisters were having babies: Frankenthaler, letter to Rudikoff, October 6, 1952, Sonya Rudikoff Papers.

54 "I felt that my own life": Frankenthaler, letter to Rudikoff, October 6, 1952, Sonya Rudikoff Papers.

54 "I feel full of hope": Frankenthaler, letter to Rudikoff, October 6, 1952, Sonya Rudikoff Papers.

55 Greenberg, who loved the painting: Elderfield, *Frankenthaler*, p. 66.

55 "emancipate himself from the world": Greenberg, diary, November 14, 1949, Clement Greenberg Papers.

56 "withdrawing into lonely thought": Kazin, *New York Jew*, pp. 24–25.

56 "lovable, fantastical Jewish genius": Greenberg, "Two of the Moderns: Review of *Chagall* by Jacques Lassaigne and *Soutine* by Raymond Cogniat," in O'Brian, ed., *The Collected Essays and Criticism*, v. 3, p. 159.

56 "to withhold, to keep things": Chandler Brossard, "Plaint of the Gentile Intellectual," in Brossard, ed., *The Scene Before You: An Approach to American Culture* (New York: Rinehart, 1955), pp. 87–88.

57 "more subtle, undefined emotions": Wassily Kandinsky, *On the Spiritual in Art* (New York: Solomon R. Guggenheim Foundation, for the Museum of Non-Objective Painting, 1946), pp. 10–11.

57 "a cloud of smoke": Kandinsky, *On the Spiritual in Art*, p. 53.

58 "when I mention Kandinsky": Frankenthaler, letter to Rudikoff, October 6, 1952, Sonya Rudikoff Papers. Helen mentions that the interview with her will be broadcast on October 27.

59 "The light touch": Frankenthaler, letter to Hartigan, September 6, 1962, Grace Hartigan Papers.

59 "pettinesses and bickerings": Hartigan, journal entry, March 31, 1952, *Journals of Grace Hartigan*, pp. 28–29.

60 "an artist could see": Frankenthaler, interview with Rose, Getty Research Institute, p. 44.

60 "paint searchingly": Hartigan, journal entry, October 23, 1951, *Journals of Grace Hartigan*, pp. 15–16.

61 "I'm not saying": Larry Rivers, letter to Frankenthaler, February 17, 1953, Helen Frankenthaler Foundation Archives.

61 "with no immediate demands": Rivers, letter to Frankenthaler, February 17, 1953, Helen Frankenthaler Foundation Archives.

61 "I don't think struggle": Frankenthaler, letter to Rivers, February 1953, Helen Frankenthaler Foundation Archives. Mary Gabriel, in *Ninth Street*

Women (New York: Little, Brown, 2018, p. 812), notes that it is not clear if Frankenthaler sent this letter.

61 "whisper": Frankenthaler, letter to Rivers, February 1953, Helen Frankenthaler Foundation Archives.

61 "Helen's new work is terribly depressing": Hartigan, journal entry, February 2, 1953, *Journals of Grace Hartigan*, p. 68.

61 "cocktails and dinner": Hartigan, quoted in Cindy Nemser, "Grace Hartigan: Abstract Artist, Concrete Woman," *Ms.* (March 1975), p. 34. Helen took exception to the jibe when she first learned of it, writing to Hartigan: "Then I saw the magazine article in Ms. on you and was frankly taken a-back, hurt" (Frankenthaler, letter to Hartigan, March 12, 1975, Grace Hartigan Papers). Hartigan, for her part, tried to retract the quotation prior to publication, couldn't, and apologized to Helen: "I confirm to love and respect you as ever through all these as you said—25 years. . . . I will try to be more wary in the future and hope that you will understand that I am truly sorry this has happened" (Hartigan, letter to Frankenthaler, March 14, 1975, Helen Frankenthaler Foundation Archives).

62 a storm to be braved: Hartigan, journal entry, March 14, 1952, *Journals of Grace Hartigan*, p. 28. For Hartigan's outrage at Greenberg's dismissal of her work, see Hartigan, letter to Greenberg, April 1, 1954, Helen Frankenthaler Foundation Archives.

62 frosting her relationship with Helen: "I have no real quarrel with Helen," Hartigan wrote in a letter of protest to Greenberg on April 1, 1952. "Each time I see her I am reminded of the affection I had for her, and it makes me sad" (Hartigan, letter to Greenberg, April 1, 1952, Helen Frankenthaler Foundation Archives).

62 Harry Jackson: Hartigan, journal entry, March 29, 1952, *Journals of Grace Hartigan*, p. 28.

62 a "mess": Hartigan, journal entry, March 14, 1952, *Journals of Grace Hartigan*, p. 26.

63 "forthright & therefore un-Jewish way": Greenberg, journal entry, January 31–February 1, 1952, Clement Greenberg Papers.

63 "awful, awful Jewish intellectuality": Greenberg, journal entry, [1955], Clement Greenberg Papers.

63 "change of name": Greenberg, journal entry, January 31–February 1, 1952, Clement Greenberg Papers.

63 "avuncular academician": Brossard, "Plaint of a Gentile Intellectual," p. 89. Chandler's essay originally appeared in 1950 in *Commentary*.

63 "the most cowardly of us all": Hartigan, journal entry, May 20, 1951, *Journals of Grace Hartigan*, p. 8.

63 "dialogue and healthy competition": Frankenthaler, interview with Brown, p. 28.

63–64 "relatively trusting": Frankenthaler, quoted in Elderfield, *Frankenthaler*, p. 48.

64 "a knife": Nemser, "Grace Hartigan," p. 34.

64 Dinty Moore: Frankenthaler, letter to Rudikoff, January 11, 1953, Sonya Rudikoff Papers.

64 including her favorite: Frankenthaler, letter to Rudikoff, February 7, 1953, Sonya Rudikoff Papers.

64 "fresh, pale, and pleasant": Stuart Preston, "Diverse Showings: Realism and Surrealism—'Collectors' Finds,'" *New York Times*, February 8, 1953, p. X9.

64 "nothing mattered very much": Frankenthaler, letter to Rudikoff, February 7, 1953, Sonya Rudikoff Papers.

64 "not taking myself": Frankenthaler, letter to Rudikoff, February 20, 1953, Sonya Rudikoff Papers.

65 "The sleep": Frankenthaler, letter to Rudikoff, February 20, 1953, Sonya Rudikoff Papers.

65 "forcing oneself to take action": Frankenthaler, letter to Rudikoff, October 6, 1952, Sonya Rudikoff Papers.

65 "powerless"; "wasting time": Frankenthaler, letter to Rudikoff, February 7, 1953, Sonya Rudikoff Papers.

65 "child-like state"; "adult poise": Frankenthaler, letter to Rudikoff, February 7, 1953, Sonya Rudikoff Papers.

65 "sinking and swimming": Frankenthaler, letter to Rudikoff, February 7, 1953, Sonya Rudikoff Papers.

65 "Helen really battled depression": Clifford Ross, interviews with author, June 23, 2018, May 28, 2018.

65 Ross mentions William Styron's depression memoir: Clifford Ross, conversation with author, February 14, 2019.

66 "keen alert minds": Gaby Rodgers, letter to Frankenthaler, July 20, 1950, Helen Frankenthaler Foundation Archives.

66 "the nuisance of melancholia": Myers, *Tracking the Marvelous*, p. 155.

66 "a sad view of life": Myers, *Tracking the Marvelous*, p. 155.

66 *Daisy Miller*: Frankenthaler, letter to Rudikoff, February 7, 1953, Sonya Rudikoff Papers.

67 "touching in spots"; Claire Bloom: Frankenthaler, letter to Rudikoff, February 7, 1953, Sonya Rudikoff Papers.

68 *defeat the darkness*: John Blee, email to author, October 12, 2017.

Chapter Four: July 27, 1953

69 on the steps of the Prado: Frankenthaler, postcard to Rudikoff, July 27, 1953, Sonya Rudikoff Papers.

69 "everything was wonderful": Frankenthaler, letter to Rudikoff, May 26, 1953, Sonya Rudikoff Papers.

69 banality of her sibling's tourism: Frankenthaler, letter to Rudikoff, May 26, 1953, Sonya Rudikoff Papers.

70 "a very sick, helpless, hopeless woman": Frankenthaler, letter to Rudikoff, May 26, 1953, Sonya Rudikoff Papers.

70 S.S. *Constitution*: Frankenthaler, letter to Rudikoff, June 26, 1953. Helen sketches out her forthcoming itinerary in this letter.

70 Francisco Franco: For Franco's changing tourist policies, see Neal M. Rosendorf, *Franco Sells Spain to America: Hollywood, Tourism and Public Relations as Postwar Spanish Soft Power* (London: Palgrave Macmillan, 2014), pp. 13–47.

70 "unreal, showplace character": Frankenthaler, postcard to Rudikoff, July 30, 1953, Sonya Rudikoff Papers.

71 "the political life in Spain": Rudikoff, letter to Frankenthaler, August 2, 1953, Helen Frankenthaler Foundation Archives.

71 American Legion was boycotting Chaplin: "Hughes Asks R.K.O. to Ban 'Limelight': Supports Efforts of American Legion to Prevent Showing of Picture Made by Chaplin," *New York Times*, January 28, 1953, p. 23.

71 banned from some theaters: "'Limelight' Run Curtailed," *New York Times*, February 13, 1953, p. 17.

71 Julius and Ethel Rosenberg: Frankenthaler, letter to Rudikoff, April 26, 1952, Sonya Rudikoff Papers. Helen mentions the spy trial, saying a book she has been reading is "fantastic," but Rudikoff paid much more attention to political situations.

71 death of Joseph Stalin: Rudikoff, letter to Frankenthaler, March 10, 1953, Helen Frankenthaler Foundation Archives.

71 "The police come first": Saul Bellow, "Spanish Letter," *Partisan Review* (1948): 217–30.

72 "an art student can examine": André Malraux, *The Voices of Silence* (Garden City, NY: Doubleday, 1953), p. 16.

73 loved the atmosphere: Frankenthaler, letter to Rudikoff, May 26, 1953, Sonya Rudikoff Papers.

73 "with disdainful ease": Anton Mengs, quoted in Svetlana Alpers, *The Vexations of Art: Velázquez and Others* (New Haven: Yale University Press, 2005), p. 149.

74 "the greatest painter of all": Friedman, letter to Frankenthaler, August 13, 1956, Helen Frankenthaler Foundation Archives. Friedman quotes Helen's own phrase back to her. Frankenthaler held Rubens to a high standard; if he did not meet it, she was not shy in saying so; the work of his she saw in Philadelphia in 1952, for example, left her "pretty cold" (Frankenthaler, letter to Rudikoff, March 30, 1952, Sonya Rudikoff Papers).

75 "a 'charge'"; "Of course I do!": Frankenthaler, letter to Rudikoff, December 17, 1951, Sonya Rudikoff Papers.

75 "no painting is good 'intellectually'": Frankenthaler, letter to Rudikoff, December 17, 1951, Sonya Rudikoff Papers.

75 "really helped me to see": Frankenthaler, letter to Rudikoff, December 17, 1951, Sonya Rudikoff Papers.

75 "thrilling feeling": Frankenthaler, letter to Rudikoff, March 30, 1952, Sonya Rudikoff Papers.

75 "isn't great painting": Frankenthaler, letter to Rudikoff, November 23, 1951, Sonya Rudikoff Papers.

76 "the meal in the firkin": Ralph Waldo Emerson, "The American Scholar" (1837), in *The Works of Ralph Waldo Emerson*, v. 2 (London: George Bell and Sons, 1882), p. 187.

76 a "real depression": Frankenthaler, letter to Rudikoff, November 23, 1951, Sonya Rudikoff Papers.

76 "Shakespeare is greater": Frankenthaler, letter to Rudikoff, November 23, 1951, Sonya Rudikoff Papers.

76 "the only ones of a particular school": Frankenthaler, letter to Rudikoff, November 23, 1951, Sonya Rudikoff Papers.

77 "The artist is a free agent": Jane Freilicher, "A Lecture by Jane Freilicher," p. 2, undated, Jane Freilicher additional papers, Houghton Library, Harvard University, reproduced in *Jane Freilicher: '50s New York* (New York: Paul Kasmin Gallery, 2018), n.p.

77 "Because I create the painting": Jane Freilicher, Oral History Interview with Barbara Shikler, August 4–5, 1987, p. 41; Jane Freilicher Papers, Archives of American Art, Smithsonian Institution, Washington, D.C.

77 a dim view: Frankenthaler, letter to Rudikoff, March 2, 1953, Sonya Rudikoff Papers.

78 "an arena in which to act": Harold Rosenberg, "The American Action Painters," *ARTnews* 51 (December 1952): 22.

79 "tense, knotty areas": Hartigan, journal entry, March 6, 1953, *Journals of Grace Hartigan*, p. 72.

79 "what each thing 'is'": Hartigan, journal entry, July 9, 1952, *Journals of Grace Hartigan*, p. 38.

79 "subject-matter avant-gardists": Frankenthaler, letter to Rudikoff, March 2, 1953, Sonya Rudikoff Papers.

80 "a world whose depth": Greenberg, "The Necessity of the Old Masters" (1948), in O'Brian, ed., *The Collected Essays and Criticism*, v. 2, p. 250.

80 "interested in the texture": Greenberg, notebook, 1939–40, Box 14, Clement Greenberg Papers.

81 Philadelphia Museum of Art: Frankenthaler, letter to Rudikoff, March 21, 1952, Sonya Rudikoff Papers. Helen describes how she and Greenberg spent the whole day at the museum, seeing a show of Old Master paintings from Vienna as well as the permanent collection.

82 to see her off: Frankenthaler, postcard to Annalee and Barnett Newman, July 31, 1953, Barnett Newman Foundation.

82 "helping me to feel at home": Frankenthaler, letter to Barnett Newman, December 16, 1957, Barnett Newman Foundation.

83 "a richer, slower sense": Clifford Ross, interview with author, June 23, 2018.

Chapter Five: February 13–14, 1954

85 on the road by eight o'clock: Greenberg, appointment book, 1954, Clement Greenberg Papers.

85 welcome change: Frankenthaler, letter to Rudikoff, February 12, 1954, Sonya Rudikoff Papers.

86 "the best bit of contemporary play-writing": Frankenthaler, letter to Rudikoff, February 12, 1954, Sonya Rudikoff Papers.

86 "the strangest feeling about you": Jane Bowles, *In the Summer House*, in Millicent Dillon, ed., *Jane Bowles: Collected Writings* (New York: Library of America, 2017), p. 181.

86 "You'll have everything you want": Bowles, *In the Summer House*, pp. 231, 235.

86 admitted to Mount Sinai: Frankenthaler, letter to Rudikoff, undated [late 1953], Sonya Rudikoff Papers.

86 doing "better": Frankenthaler, letter to Rudikoff, February 12, 1954, Sonya Rudikoff Papers.

86 whole experience was depressing: Frankenthaler, letter to Rudikoff, undated [late 1953], Sonya Rudikoff Papers.

86–87 "full of really felt drama": Frankenthaler, letter to Rudikoff, February 12, 1954, Sonya Rudikoff Papers.

87 extraordinary fourteen-month period: Harold Bloom, *Shakespeare: The Invention of the Human* (New York: Riverhead, 1998), p. 578.

87 "boring"; "Hollywood jerk": Frankenthaler, letter to Rudikoff, February 12, 1954, Sonya Rudikoff Papers.

87 "lost his stuff": Quoted in Rosalind Krauss, *The Optical Unconscious* (Cambridge, Mass.: MIT Press, 1993), pp. 251, 322; Krauss's source is Steven Naifeh and Gregory White Smith, *Jackson Pollock: An American Saga* (New York: Clarkson Potter, 1989), pp. 698, 731, 895.

87 A macabre recent event: details about the murder scene and the victims are from Wayne Phillips, "Maxwell Bodenheim, Wife Slain in Dingy Bowery Room," *New York Times*, February 8, 1954, p. 1; see also Emanuel Perlmutter, "Confession Cited in Poet's Murder," *New York Times*, February 11, 1954, p. 43.

88 Helen had followed: Frankenthaler, letter to Rudikoff, February 12, 1954, Sonya Rudikoff Papers.

88 "a gin-sodden community": Meyer Berger, "Greenwich Village, Bodenheim's 'Coney Island of the Soul,' Now a Shadow of Its Past," *New York Times*, February 10, 1954, p. 31.

88 "only dusty": Berger, "Greenwich Village, Bodenheim's 'Coney Island of the Soul.'"

89 "really dreadful"; "so low": Frankenthaler, letter to Rudikoff, February 12, 1954, Sonya Rudikoff Papers.

89 "his least good show": Frankenthaler, letter to Rudikoff, February 12, 1954, Sonya Rudikoff Papers.

89 "I see it over and over": Frankenthaler, letter to Rudikoff, February 12, 1954, Sonya Rudikoff Papers.

90 "After years and years of hypochondria": Frankenthaler, letter to Rudikoff, February 12, 1954, Sonya Rudikoff Papers.

90 "so nutty": Frankenthaler, letter to Rudikoff, February 12, 1954, Sonya Rudikoff Papers.

90 "fears of being stopped": Hartigan, journal entry, May 13, 1953, *Journals of Grace Hartigan*, p. 81.

91 A man of contradictions: Howard Nemerov, "Paul Terence Feeley," 1966, p. 1, Special Collections, Crossett Library, Bennington College.

91 embroidery called a *shisha*: Gillian Feeley-Harnik now owns the *shisha*.

91–92 "something of the giver with it": Gillian Feeley-Harnik, email to author, July 28, 2017.

92 "weren't too hot": Frankenthaler, letter to Rudikoff, February 12, 1954, Sonya Rudikoff Papers.

92 escape from the city: This was the opinion of my mother, Margaret Nemerov, who with my father lived in Bennington from 1948 to 1966.

92 Helen had first visited Smith's place: Lauren Mahony, "A Silence of Understanding: Helen Frankenthaler and David Smith, 1950–1965," in *Helen Frankenthaler and David Smith* (New York: Craig F. Starr Gallery, 2014), n.p.

93 the previous September: Mahony, "A Silence of Understanding," n.p.

93 4:00 p.m.: Greenberg, appointment book, 1954, Clement Greenberg Papers.

94 mesmerized: Gillian and Jennifer Feeley do not recall specifics about that day, only a general feeling of awe.

94 She already owned: Mahony, "A Silence of Understanding," n.p.

94 "True artistic creation": Frankenthaler with Brown, "A Conversation," p. 47.

96 "You can't decide": Frankenthaler with Brown, "A Conversation," p. 45.

97 697 West End Avenue: Frankenthaler, card to Rudikoff, undated [late February 1954]; and Frankenthaler, letter to Rudikoff, March 15, 1954, Sonya Rudikoff Papers.

97 on April 23, 1954: Details of Martha Frankenthaler's death are drawn from "Justice's Widow Killed: Mrs. Frankenthaler Plunges from 14th-Floor

Window," *New York Times*, April 24, 1954, p. 7; and "Justice's Widow Dies in Plunge," New York *Herald Tribune*, April 24, 1954, p. 15.

98 "broken"; "very negative about Helen": Clifford Ross, interview with author, June 23, 2018.

98 "a very angry tone": Michael Hecht, interview with author, July 24, 2019. Hecht was Marjorie's longtime accountant (and Helen's).

98 talking about her mother's death: "I remember when I spoke to you on the phone you said, as well you might, that the whole subject of your mother had become a tiring one" (Rudikoff, letter to Frankenthaler, May 19, 1954, Helen Frankenthaler Foundation Archives).

98 "She did not deal": Clifford Ross, interview with author, May 28, 2018.

99 "she buried it": Clifford Ross, interview with author, January 13, 2019.

99 one time Helen mentioned her mother: John Blee, interview with author, July 14, 2017.

99 "mini–Helen Frankenthalers": Clifford Ross, interview with author, January 13, 2019.

99 Helen was defensive: Clifford Ross, interview with author, January 13, 2019.

100 "My mother was beautiful": Frankenthaler, interview with Rose, Archives of American Art.

100 Photographs from Marjorie's wedding: These are in the collection of Ellen M. Iseman.

100 excited by the paintings she was making there: Frankenthaler, letter to Rudikoff, July 2, 1954, Sonya Rudikoff Papers.

100 The couple also spent time: Frankenthaler, letter to Rudikoff, November 8, 1954, Sonya Rudikoff Papers.

101 her mother's furniture: Frankenthaler, letter to Rudikoff, December 14, 1954, Sonya Rudikoff Papers.

101 "It was a horrible job": Frankenthaler, letter to Rudikoff, December 14, 1954, Sonya Rudikoff Papers.

101 "Go": Bowles, *In the Summer House*, p. 235.

Chapter Six: August 2, 1955

103 "I have changed my life": Frankenthaler, letter to Rudikoff, April 19, 1955, Sonya Rudikoff Papers.

104 the painter Conrad Marca-Relli: For a description of the home and studio, see Parker Tyler, "Marca-Relli Pastes a Painting," *ARTnews* 54 (November 1955). For photographs of the Marca-Relli home on Fireplace Road, see *Conrad Marca-Relli: The Springs Years, 1953–1956* (East Hampton, NY: Pollock-Krasner House, 2011).

104 swatting flies; solitude: Frankenthaler, letter to Rudikoff, August 2, 1955, Sonya Rudikoff Papers.

104 "a real one": Frankenthaler, letter to Rudikoff, April 19, 1955, Sonya Rudikoff Papers.

105 complained, attacked, and upbraided: Greenberg, journal entry, June 9, 1955, Clement Greenberg Papers.

105 Helen's remoteness: Greenberg, journal entry, June 8, 1955, Clement Greenberg Papers.

105 he grew suspicious: Greenberg, journal entry, June 8, 1955, Clement Greenberg Papers.

105 could not find parking: Greenberg, journal entry, June 8, 1955, Clement Greenberg Papers.

105 how much he cared for her: Greenberg, journal entry, [1955], Clement Greenberg Papers.

106 Helen's bloom: Greenberg, journal entry, June 8, 1955, Clement Greenberg Papers.

106 "toughness" and "honesty": Greenberg, journal entry, June 7, 1955, Clement Greenberg Papers.

106 He missed Helen terribly: Greenberg, journal entry, June 5, 1955, Clement Greenberg Papers.

106 wandered around Greenwich Village: Greenberg, journal entry, June 6, 1955, Clement Greenberg Papers.

106 "power struggle": Greenberg, journal entry, June 9, 1955, Clement Greenberg Papers.

107 "infinite sadness": Greenberg, journal entry, June 7, 1955, Clement Greenberg Papers.

107 Sparing no details: Greenberg, journal entry, [1955], Clement Greenberg Papers.

107 "marriage-like" intimacy: Greenberg, journal entry, September 18, 1955, Clement Greenberg Papers.

107 "put over": Greenberg, journal entry, September 18, 1955, Clement Greenberg Papers.

107 "What always got me about Helen": Greenberg, journal entry, June 4, 1955, Clement Greenberg Papers.

107 "lack of delicacy": Greenberg, journal entry, June 4, 1955, Clement Greenberg Papers.

107 "beautiful, rich, cultured": Greenberg, journal entry, [1955], Clement Greenberg Papers.

108 "declaration, an announcement": Greenberg, journal entry, September 16, 1955, Clement Greenberg Papers.

108 "My first look": Greenberg, journal entry, June 4, 1955, Clement Greenberg Papers.

NOTES

108 "confused and painful": Frankenthaler, letter to Rudikoff, August 2, 1955, Sonya Rudikoff Papers.

108 to stay with Friedel Dzubas: Frankenthaler, letter to Rudikoff, August 2, 1955, Sonya Rudikoff Papers.

108 "I felt lonelier because I was lonelier": Frankenthaler, interview with Rose, Archives of American Art.

108–9 drinks on August 6; Helen's dinner party: Greenberg, appointment book, 1955, Clement Greenberg Papers.

109 "*en menáge*": Greenberg, journal entry, September 16, 1955, Clement Greenberg Papers.

109 "You think I have contempt": Greenberg, journal entry, September 16, 1955, Clement Greenberg Papers.

109 "Beware of those": Greenberg, journal entry, September 29, 1955, Clement Greenberg Papers.

109 he slapped her: This story is recounted in Janice Van Horne, *A Complicated Marriage: My Life with Clement Greenberg* (Berkeley, CA: Counterpoint, 2012), pp. 3–7.

109 "a tall beautiful magnet": Van Horne, *A Complicated Marriage*, p. 6.

110 "two suffering hellos": Greenberg, journal entry, October 12, 1955, Clement Greenberg Papers.

110 "baiting the bull": Greenberg, journal entry, October 12, 1955, Clement Greenberg Papers.

110 crashing waves: Greenberg, journal entry, October 12, 1955, Clement Greenberg Papers.

110 "slap H. soundly": Greenberg, journal entry, October 18, 1955, Clement Greenberg Papers.

110 "to strangle Helen": Greenberg, journal entry, November 7, 1955, Clement Greenberg Papers.

110 "howl of pain"; "furtive sadism": Greenberg, journal entry, October 17, 1955, Clement Greenberg Papers.

111 gigolo: John Baxter, *Stanley Kubrick: A Biography* (New York: Carroll and Graf, 1997), pp. 25–26.

112 "sacramentalized": Greenberg, journal entry, September 17, 1955, Clement Greenberg Papers.

112 reapplying her makeup: Karen Wilkin, interview with author, May 16, 2018, New York.

112 morose and glum: Greenberg, journal entry, December 3, 1955, Clement Greenberg Papers.

112 "Howard is on top": Greenberg, journal entry, December 3, 1955, Clement Greenberg Papers.

112 "sad and painful": Frankenthaler, letter to Rudikoff, December 14, 1955, Sonya Rudikoff Papers.

112 back together: Frankenthaler, postcard to Rudikoff, late December 1955, Sonya Rudikoff Papers.

112 the chaise longue: This story, including the quotations from Howard Sackler, is in Larry Rivers, with Arnold Weinstein, *What Did I Do? The Unauthorized Autobiography of Larry Rivers* (New York: HarperCollins, 1992), pp. 187–88.

113 "a lot of French crap": Frankenthaler, letter to Rudikoff, April 20, 1953, Sonya Rudikoff Papers.

113 "women are not simply 'women'": De Beauvoir's thesis as summarized by Elizabeth Hardwick, "The Subjection of Women" (1953), *The Collected Essays of Elizabeth Hardwick* (New York: New York Review Books, 2017), p. 25.

114 "women have much less experience": Hardwick, "The Subjection of Women," p. 35.

114 "didn't much care for": Frankenthaler, letter to Rudikoff, May 26, 1953, Sonya Rudikoff Papers.

114 *Ulysses*; "Sistine chapel": Hardwick, "The Subjection of Women," pp. 35–36.

114 "sacrificing with ambiguities": Frankenthaler, letter to Rudikoff, May 26, 1953, Sonya Rudikoff Papers.

115 menstruation: Lisa Saltzman, "To Figure or Not to Figure: The Iconoclastic Proscription and Its Theoretical Legacy," in Catherine M. Soussloff, ed., *Jewish Identity in Modern Art History* (Berkeley: University of California Press, 1999), pp. 67–84.

116 Mary McCarthy had published: Mary McCarthy, "Dottie Makes an Honest Woman of Herself," *Partisan Review* 21, no. 1 (January–February 1954): 43–52.

116 "gimmick"; "Everyone was asking": Frankenthaler, letter to Rudikoff, February 12, 1954, Sonya Rudikoff Papers.

117 "inner amorphous worlds or depths": Frankenthaler, Artist's Questionnaire, *Trojan Gates*, August 1957, Museum Collection Files, Department of Painting and Sculpture, Museum of Modern Art, New York.

117 "I don't think anything anybody does": Cindy Nemser, "Interview with Helen Frankenthaler," *Arts* 46 (November 1971): 53–54.

118 "the generous inclination": Simone de Beauvoir, *The Second Sex*, trans. Constance Borde and Sheila Malovany-Chevallier (New York: Vintage, 2011 [1949]), p. 684. Helen mentions this chapter, "The Woman in Love," as "clever" and as making her "wonder about S. de B." (Frankenthaler, letter to Rudikoff, April 20, 1953, Sonya Rudikoff Papers).

119–20 "value and supreme reality": De Beauvoir, *The Second Sex*, p. 684.

120 the "absolute": De Beauvoir, *The Second Sex*, p. 684.

Chapter Seven: August 12, 1956

123 **Les Deux Magots:** "Sat at Deux Magots again for old times sake" (Frankenthaler, letter to Hartigan, undated [1989], Grace Hartigan Papers).

123 **Lee Krasner accompanied her:** Gabriel, *Ninth Street Women*, pp. 608–9.

123 **On August 12:** Gabriel, *Ninth Street Women*, p. 611.

124 **telephoned American friends:** Friedman, *Jackson Pollock: Energy Made Visible*, p. 247.

124 **"De Kooning turned on B. Newman":** Herman Cherry, letter to David Smith, December 3, 1956, David Smith Papers, Archives of American Art.

124 **"opened up":** Frankenthaler, interview with Rose, Archives of American Art.

124 **"drunken, wild, angry"; "two different people":** Frankenthaler, interview with Rose, Archives of American Art.

124 **"inevitable":** Friedman, letter to Frankenthaler, August 13, 1956, Helen Frankenthaler Foundation Archives.

125 **"I do this, I do that":** LeSueur, *Digressions*, p. 109.

126 **"Did Pollock call":** LeSueur, *Digressions*, p. 111.

126 **keep silent; "extravagantly":** LeSueur, *Digressions*, p. 111.

127 **"thought it was awful":** Frankenthaler, letter to Rudikoff, April 29, 1952, Sonya Rudikoff Papers.

127 **"'deadening and obscuring'":** O'Hara, quoted in Mark Ford, "Introduction," in *Frank O'Hara: Selected Poems* (New York: Alfred A. Knopf, 2015), p. xii.

127 **"pansy-ish":** Frankenthaler, letter to Rudikoff, December 14, 1954, Sonya Rudikoff Papers.

127 **"the power of their impact"; "fact of experience":** Frank O'Hara, "Helen Frankenthaler," *ARTnews* 53 (December 1954): 53.

127–28 **"your nerve"; "avoid being logical":** O'Hara, "Personism: A Manifesto" (1959), in *Frank O'Hara: Selected Poems*, p. 247.

128 **"Thank god for my nerve":** Frankenthaler, letter to Hartigan, February 23, 1961, Grace Hartigan Papers.

128 **"preoccupied":** O'Hara, "Personism: A Manifesto," in *Frank O'Hara: Selected Poems*, p. 249.

128 **"Now please":** O'Hara, letter to Frankenthaler, April 8, 1957, Helen Frankenthaler Foundation Archives.

128 **"Dear Helen—I loved your party":** O'Hara and Frankenthaler [early 1966], Helen Frankenthaler Foundation Archives.

128 **reached him on the phone:** Brad Gooch, *City Poet: The Life and Times of Frank O'Hara* (New York: Alfred A. Knopf, 1993), p. 464.

129 **"Your remarks about Frank":** Peter Schjeldahl, letter to Frankenthaler, August 2 [1966], Helen Frankenthaler Foundation Archives.

129 **Helen suddenly broke into tears:** John Blee, email to author, July 27, 2017.

130 *"clumsy or puzzled"*: Frankenthaler, quoted in Nemser, "Interview with Helen Frankenthaler," p. 54.

130 Pollock exploited accidents, too: For Frankenthaler's revision of Pollock, see Anne M. Wagner, "Pollock's Nature, Frankenthaler's Culture," in Kirk Varnedoe and Pepe Karmel, eds., *Jackson Pollock: New Approaches* (New York: Museum of Modern Art, 1999), pp. 181–99.

130 "Despite their immense size"; "response to existence": Sonya Rudikoff, "Helen Frankenthaler," *School of New York* (New York: Grove Press, 1959), p. 12.

131 "environment of a space": Frankenthaler with Brown, "A Conversation," p. 45.

131 "windowless rooms": Frankenthaler with Brown, "A Conversation," p. 45.

131 in the same weeks: LeSueur, in *Digressions on Some Poems of Frank O'Hara* (p. 112), gives the date of the poem as October 22, 1956.

132 "everyone I've talked to": Frankenthaler, letter to Rudikoff, October 30, 1956, Sonya Rudikoff Papers.

132 "a non-human distance": Parker Tyler, "Jackson Pollock: The Infinite Labyrinth," *Magazine of Art* (March 1950).

132 "the painter's body": Frank O'Hara, *Jackson Pollock* (New York: George Braziller, 1959), p. 28.

132 "the physical reality": O'Hara, *Jackson Pollock*, p. 29.

133 "emergent forms": Tyler, "Helen Frankenthaler," *ARTnews* 54 (February 1956): 49.

134 "diffuse and sketchy": Dore Ashton, "Art: Metal Sculpture: Uhlmann's Work on View at Kleeman—Paintings by Helen Frankenthaler," *New York Times*, February 12, 1957, p. 55.

134 "immense delicacy": Rudikoff, "Helen Frankenthaler," p. 16.

135 "Life as it is lived": Rudikoff, "Helen Frankenthaler," *School of New York*, p. 16.

135 Harold Rosenberg and his wife, May, introduced him to Helen: Herbert Gold, interview with author, September 9, 2018, San Francisco.

135 schoolgirl tones: Frankenthaler, letter to Rudikoff, October 30, 1956, Sonya Rudikoff Papers.

136 "candy store": Herbert Gold, interview with author, September 9, 2018.

136 "not my type"; "did not meet": Herbert Gold, interviews with author, September 9, 2018, January 16, 2019.

136 "I saw her"; "promote her": Gold, interview with author, January 16, 2019.

136 he lovingly described: Herbert Gold, *The Man Who Was Not With It* (Boston: Little, Brown, 1954), pp. 303–5.

137 Bellow; Ellison: Gold, interview with author, September 9, 2018.

137 "tried to jam": Frankenthaler, letter to Rudikoff, undated [1953], Sonya Rudikoff Papers.

NOTES

138 "pale and pleasant": Stuart Preston, "Diverse Showings: Realism and Surrealism—'Collectors' Finds,'" *New York Times*, February 8, 1953, p. X9.

138 "She does not hesitate": O'Hara, "Helen Frankenthaler," *ARTnews* 53 (December 1954): 53.

138 "gentle winds": Ashton, "Art: Metal Sculpture," p. 55.

138 "colored gas": E. P., "Helen Frankenthaler," *Arts* 31, no. 6 (March 1957): 54.

138 "a cloud the wind detaches": James Schuyler, letter to Frank O'Hara, March 27, 1956, quoted in William Corbett, ed., *The Letters of James Schuyler to Frank O'Hara* (New York: Turtle Point Press, 2006), p. 53.

138 "drifts like wind": James Schuyler, "Helen Frankenthaler," *ARTnews* 55, no. 10 (February 1957): 11.

139 "billowing": Barbara Rose, *Helen Frankenthaler* (New York: Abrams, 1971), p. 64.

139 "explosive landscapes": *Young America 1957: Thirty American Painters and Sculptors under Thirty-five*, exh. cat. (New York: Whitney Museum of American Art, 1957).

139 "'hold' an explosive gesture": Frankenthaler, statement in John I. H. Baur, "New Talent in the U.S.," *Art in America* 45, no. 1 (New Talent Annual, March 1957): 29.

140 "Who cares": O'Hara, "Personism: A Manifesto," in *Frank O'Hara: Selected Poems*, p. 247.

140 "You want clues?": Frankenthaler, quoted in "The Younger Generation," *Time* (March 11, 1957), p. 82.

Chapter Eight: May 13, 1957

143 The sorrowful trip: For the story of the train trip to Nashville, and of Parks's experience generally on the assignment to the South, see Gordon Parks, *Voices in the Mirror: An Autobiography* (New York: Doubleday, 1990), pp. 164–69. For his photographs of the South, see Peter W. Kunhardt, Jr., and Paul Roth, eds., *Gordon Parks: Collected Works*, v. 3 (Göttingen, Germany: Steidl, 2012), pp. 20–43.

143 gorgeous photographs of white fashion models: For Parks's photographs of New York fashion, see Kunhardt and Roth, eds., *Gordon Parks: Collected Works*, v. 3, pp. 102–25.

145 "being sought": "Women Artists in Ascendance: Young Group Reflects Lively Virtues of U.S. Painting," *Life* (May 13, 1957), p. 75.

146 $30: Frankenthaler, letter to Rudikoff, November 5, 1952, Sonya Rudikoff Papers.

146 "something about his great friend": Myers, *Tracking the Marvelous*, pp. 155–56.

146 owned a modestly sized Pollock: Paul Cummings, interview with B. H. Friedman, November 10, 1972, Archives of American Art, Smithsonian Institution.

146–47 Uris Buildings Corporation; at Cornell: Cummings, interview with Friedman, Archives of American Art.

147 "synonymous": Friedman, *Jackson Pollock: Energy Made Visible*, p. xi.

147 $8,000: Frankenthaler, letter to Rudikoff, August 2, 1955, Sonya Rudikoff Papers.

147–48 "act of faith"; "vital an experience": "A Collector's Viewpoint," in *The Collection of Mr. and Mrs. Ben Heller* (New York: Museum of Modern Art, 1961), n.p.

148 attended a party: Herman Cherry, letter to David Smith, February 1, 1957, Archives of American Art.

148 "500 to 600 square feet of paintings": Sidney Janis to Phyllis Lambert, June 6, 1958; quoted in Breslin, *Mark Rothko*, p. 373.

148 "topsy-turvy": Cherry, letter to Smith, February 1, 1957, Archives of American Art. The saying, "It is risky business to send a painting into the world" is Rothko's: see Breslin, *Mark Rothko*, p. 373.

149 "discredit reality": Greenberg, diary, October 26, 1955, Clement Greenberg Papers.

149 "rapid-fire prose"; "unbelievably moronic": Marshall McLuhan, "The Psychopathology of 'Time' and 'Life,'" in Chandler Brossard, ed., *The Scene Before You: A New Approach to American Culture* (New York: Rinehart, 1955), pp. 149, 158.

149 "intellectual bohemian": Philip Rahv, "Our Country and Our Culture," *Partisan Review* 19 (May–June 1952): 306. For an excellent essay on this shift, see Hugh Wilford, "The Agony of the Avant-Garde: Philip Rahv and the New York Intellectuals," in David Murray, ed., *American Cultural Critics* (Exeter: University of Exeter Press, 1995), pp. 33–48.

150 "admired it, admired me": Frankenthaler, interview with Rose, Getty Research Institute, p. 44.

150 "can you believe this?"; "the recognition": Michael Hecht, interview with author, July 24, 2019.

151 "cagy operator": Alan Solomon, *Leo Castelli: Ten Years* (New York: Castelli, 1967), n.p.

151 Heller owned: "Frankenthaler List of Collectors and Museums," typescript, 1960, Jewish Museum. The painting is identified as *First Blizzard* in Series 5: Inventory Records, Subseries 5.1: Artist Cards, Box 34, Folder 3, Box 35, Folder 14, Tibor de Nagy Gallery records, 1941–1993, Smithsonian Institution Archives of American Art. My thanks to Sarah Haug for identifying this painting.

152 *Esquire* **and** *Playboy***:** See Bill Osgerby, *Playboys in Paradise: Masculinity, Youth and Leisure-Style in Modern America* (Oxford: Berg, 2001), pp. 152, 176n3.

152 **"the** *Esquire* **cover":** Hartigan, letter to Frankenthaler, June 10, 1957, Helen Frankenthaler Foundation Archives.

152 **"Helen's all over the place":** Hartigan, letter to Frankenthaler, July 10, 1957, Helen Frankenthaler Foundation Archives.

152 **"that Kotex painter":** Joan Mitchell, quoted in Patricia Albers, *Joan Mitchell, Lady Painter: A Life* (New York: Alfred A. Knopf, 2011), p. 169.

152 **"provincial sorority":** Friedman, diary, February 16, 1957, Archives of American Art.

153 **"Barney, the paranoiac":** Friedman, diary, February 13, 1957, Archives of American Art.

153 **"Dear Helen: Art is cunning":** Barnett Newman, letter to Frankenthaler, February 15, 1957, Helen Frankenthaler Foundation Archives.

154 **writing several drafts:** The drafts are in the collection of the Barnett Newman Foundation in New York.

154 **"I've been generally tearing all day":** Frankenthaler, letter to Rudikoff, February 16, 1957, Sonya Rudikoff Papers.

154 **"mad," in her word:** Blee, email to author, June 11, 2019.

154 **"Old Testament":** Friedman, diary, February 13, 1957, Archives of American Art.

154 **"avoidance of the chic":** Friedman, diary, February 13, 1957, Archives of American Art.

154 **"compulsive attraction" to fame:** Friedman, diary, February 13, 1957, Archives of American Art.

154 **"choosing careerism":** Friedman, letter to Frankenthaler, September 10, 1992, Helen Frankenthaler Foundation Archives.

155 **"sucking up to him":** Herbert Gold, interview with author, September 9, 2018.

155 **Alice Baber, Gold's new girlfriend:** Herbert Gold, interview with author, January 16, 2019.

155–56 **Hyman Nathan Glickstein; "highly irregular":** See Wolfgang Saxon, "Hyman Glickstein, 91, Dies; Lawyer and Political Leader," *New York Times*, February 17, 1998, p. B11; "Police Are Stoned in Shipyard Strike; 8 Injured in Melee," *New York Times*, July 17, 1937, p. 1; "San Juan Track Opening Put Off; Horsemen Call Strip Dangerous," *New York Times*, December 31, 1956, p. 18.

156 **toothpaste:** For the creation of *Billboard*, see Cathy Curtis, *Restless Ambition: Grace Hartigan, Painter* (Oxford: Oxford University Press, 2015), p. 152.

156 **new class of clients:** See Charles L. Baldwin, letter to Hartigan, April 18, 1972, Grace Hartigan Papers. Baldwin wrote to the artist of *Essex Street*, a painting as bright as *Billboard*, that it is "so crowded with life giving images"

and that it "makes waking up a celebration" (quoted in Curtis, *Restless Ambition*, p. 151).

156 "vulgar and vital": Hartigan, quoted in Vicki Goldberg, "Grace Hartigan Still Hates Pop," *New York Times*, August 15, 1993, section 2, p. 30.

157 "concern for the audience": Frankenthaler with Brown, "A Conversation," p. 46.

158 a crucifix of dollar bills: Blee, conversation with author.

158 analyst's office as a temple: Blee, conversation with author.

159 "so defensive": Friedman, diary, February 10, 1957, Archives of American Art.

160 "a real perspective": Frankenthaler, interview with Rose, Getty Research Institute.

161 "come off with this": Frankenthaler, interview with Rose, Getty Research Institute.

161 "he also sort of listened": Frankenthaler, interview with Rose, Getty Research Institute.

161 "neurotic drama": Frankenthaler, interview with Rose, Getty Research Institute.

161 "waiters, people, noise": Frankenthaler, interview with Rose, Getty Research Institute.

161 "profound adolescents": Frankenthaler, interview with Rose, Getty Research Institute.

161 "very accurate and real": Frankenthaler, interview with Rose, Getty Research Institute.

161 established couple: Cherry, letter to Smith, January 28, 1958, Archives of American Art.

162 "loneliness and a gregariousness": Frankenthaler, letter to Rudikoff, August 20, 1958, Sonya Rudikoff Papers.

162 "Why, why": Myers, *Tracking the Marvelous*, p. 199.

162 contemplated suicide in 1948: Dedalus Foundation, Chronology, Late Autumn–Early December 1948, https://www.dedalusfoundation.org/moth erwell/chronology/detail?field_chronology_period_tid=27.

162 "our pictures, not ourselves": Robert Motherwell, "The Painter and the Audience" (1954), in Stephanie Terenzio, ed., *The Collected Writings of Robert Motherwell* (New York: Oxford University Press, 1992), p. 104.

162 "it is nothing": Motherwell, "A Painting Must Make Human Contact" (1955), in *Collected Writings*, p. 108.

162 "deep necessity": Motherwell, "A Painting Must Make Human Contact" (1955), in *Collected Writings*, pp. 108–9.

162 "false kicks": Frankenthaler, letter to Hartigan, November 17, 1963, Grace Hartigan Papers.

163 "like little gremlins": Frankenthaler, letter to Hartigan, November 17, 1963, Grace Hartigan Papers.

163 "both gentlemen": Cherry, letter to Smith, January 28, 1958, Archives of American Art.

163 black, sequined: Frankenthaler, letter to Hartigan, March 4, 1989, Archives of American Art.

164 Frankenmother: Ruth Ann Fredenthal, email to author, May 6, 2019.

164 "what had gone wrong": Myers, *Tracking the Marvelous*, p. 199.

164 "my kind of private life": Myers, *Tracking the Marvelous*, p. 199.

164 "How wise you were": Hartigan, letter to Frankenthaler, July 14, 1958, Helen Frankenthaler Foundation Archives.

Chapter Nine: August 1, 1958

166 "caves to ourselves": Frankenthaler, letter to Rudikoff, August 20, 1958, Sonya Rudikoff Papers.

166 "really missed the beauty": Frankenthaler, letter to Rudikoff, August 20, 1958, Sonya Rudikoff Papers.

166 Lascaux, discovered less than twenty years before: Annette Laming, *Lascaux* (London: Penguin, 1959), pp. 54–57.

167 "colors so deep": Frankenthaler, postcard to Rudikoff, July 17, 1958, Sonya Rudikoff Papers.

167 "intense discoveries": Frankenthaler, letter to Hartigan, July 8, 1958, Grace Hartigan Papers.

167 lonely souls: That summer Helen wrote of the "years of loneliness and the gregariousness that's the result of loneliness" that characterized her and her husband (Frankenthaler, letter to Rudikoff, August 20, 1958, Sonya Rudikoff Papers).

167 rainy Easter Sunday: Frankenthaler, letter to Hartigan, April 7, 1962, Grace Hartigan Papers.

167 dropped the glass: Frederick Iseman, conversation with author, April 30, 2019.

167 L'Armorique: Marcel Gosselin, to Robert Motherwell, April 1, 1958, Helen Frankenthaler Foundation Archives.

168 large painting she made that spring: Elderfield, *Frankenthaler*, p. 122.

168 hurried through with other tourists: Frankenthaler, letter to Rudikoff, August 20, 1958, Sonya Rudikoff Papers. Helen was recalling the earlier trip at this later point.

168 "rich earth & blood colors": Frankenthaler, letter to Rudikoff, August 10, 1953, Sonya Rudikoff Papers.

169 pipe burst: Frankenthaler, letter to Rudikoff, June 30, 1958, Sonya Rudikoff Papers.

170 Fascism, Catholicism, poverty, and cuisine: Frankenthaler, letter to Rudikoff, August 20, 1958, Sonya Rudikoff Papers.

170 **"eyeballs":** Frankenthaler, letter to Rudikoff, August 20, 1958, Sonya Rudikoff Papers.

170 **French marrow scooper:** Frankenthaler, letter to Rudikoff, undated [1958], Sonya Rudikoff Papers.

170 **small cigars:** Frankenthaler, letter to Rudikoff, August 20, 1958, Sonya Rudikoff Papers.

170 **"eating and living like Lords":** Frankenthaler, letter to Rudikoff, August 1, 1958, Sonya Rudikoff Papers.

170 **"I've had many thoughts":** Frankenthaler, letter to Rudikoff, August 20, 1958, Sonya Rudikoff Papers.

170 **"suddenly grown into middle age":** Frankenthaler, letter to Rudikoff, August 20, 1958, Sonya Rudikoff Papers.

171 **"additional weight"; "more serious":** Frankenthaler, letter to Rudikoff, August 20, 1958, Sonya Rudikoff Papers.

171 **"attacking the picture":** Frankenthaler, letter to Rudikoff, August 20, 1958, Sonya Rudikoff Papers.

171 **"because they seemed":** Frankenthaler, letter to Rudikoff, August 20, 1958, Sonya Rudikoff Papers.

171 **"much fuller and deeper":** Frankenthaler, letter to Rudikoff, August 20, 1958, Sonya Rudikoff Papers.

173 **"Do I want it to last?":** Frankenthaler, interview with Rose, Getty Research Institute. This interview contains additional material beyond the transcript in the Archives of American Art.

173 **"a release":** Jack Flam, *Motherwell: 100 Years* (New York: Rizzoli, 2015), p. 154.

173 **gaulois blue:** Karen Wilkin, interview with author, May 16, 2018.

173 **"Bob has been free":** Frankenthaler, letter to Rudikoff, August 20, 1958, Sonya Rudikoff Papers.

174 **suffered horribly as a child:** All of the stories of Motherwell's parents beating him when he was a child are from James Breslin, "Robert Motherwell: From WASPism to Modernism," *Threepenny Review* 61 (Spring 1995): 24–25.

174 **earth tones:** Bernard Jacobson, *Robert Motherwell: The Making of an American Giant* (London: 21 Publishing, 2015), p. 36.

175 **"she beat me":** Motherwell, quoted in Breslin, "Robert Motherwell," p. 25.

175 **"What's really devastating":** Motherwell, quoted in Breslin, "Robert Motherwell," p. 25.

175 **he wanted to kill his mother:** "With my mother I really wanted to kill her, and I think if I could have, I would have" (Motherwell, quoted in Breslin, "Robert Motherwell," p. 25).

175 **"From puberty till thirty-five":** Motherwell, quoted in Breslin, "Robert Motherwell," p. 25.

175 **"terrible depression":** Frankenthaler, letter to Grace Hartigan, November 17, 1963, Grace Hartigan Papers.

175–76 **"absorb the shocks of reality":** Robert Motherwell, "The Modern Painter's World" (1944), in *Collected Writings*, p. 28.

176 **"With a sense of participation":** Frankenthaler, letter to Hartigan, November 17, 1963, Grace Hartigan Papers.

176 **Chinese silk pajamas:** Helen told this story to John Blee (Blee, email to author, August 26, 2017).

176 **"came back to life again":** Motherwell, quoted in Breslin, "Robert Motherwell," p. 25.

176 **"Ivory black":** Robert Motherwell, quoted in Robert Hobbs, *"The Tomb of Captain Ahab,"* in *Masterworks of American Art from the Munson-Williams-Proctor Institute* (New York: Abrams, 1989), p. 199.

176 **"extremely poisonous":** Motherwell, quoted in Hobbs, *"The Tomb of Captain Ahab,"* p. 199.

177 **made Helen feel threatened:** Frankenthaler, letter to Rudikoff, August 20, 1958, Sonya Rudikoff Papers.

177 *I Remember Lascaux:* Curtis, *Restless Ambition*, p. 259.

177 *Chatham Light:* Clifford Ross, conversation with author, February 14, 2019, New York.

177 **"out-of-nowhere":** Frankenthaler, letter to Hartigan, May 3, 1987, Grace Hartigan Papers.

178 **"empty and angry":** Frankenthaler, letter to Rudikoff, August 20, 1958, Sonya Rudikoff Papers.

178 **"There is a ferocity in it":** Frankenthaler, quoted in E. A. Carmean, Jr., *Helen Frankenthaler: A Paintings Retrospective* (New York: Abrams, 1989), p. 20.

178 **"tragic":** Frank O'Hara, "Helen Frankenthaler," *Helen Frankenthaler Paintings* (New York: Jewish Museum, 1960), p. 7.

178 **he would not even go in airports:** Jeannie Motherwell, conversation with author, May 15, 2019.

Chapter Ten: August 29, 1959

181 **reminded Helen of Mallorca:** Frankenthaler, letter to Hartigan, August 4, 1959, Grace Hartigan Papers.

181 **high on a bluff:** Jeannie Motherwell, email to author, May 14, 2019.

181 **done in a modern style:** Frankenthaler, letter to Hartigan, August 4, 1959, Grace Hartigan Papers.

182 **"when one tries hard":** Frankenthaler, letter to Rudikoff, August 29, 1959, Sonya Rudikoff Papers. See also Frankenthaler, letter to Hartigan, August 4, 1959, Grace Hartigan Papers.

182 "old and empty"; "sullen, mad": Frankenthaler, letter to Rudikoff, August 29, 1959, Sonya Rudikoff Papers.

182 "two groups": C. P. Snow, *The Two Cultures* (Cambridge: Cambridge University Press, 1993), p. 2.

182–83 "Toward a Future Study of the Abyssal Circulation": Henry M. Stommel, "Toward a Future Study of the Abyssal Circulation" (privately printed, 1957) in Nelson G. Hogg and Rui Xin Huang, eds., *Collected Works of Henry M. Stommel*, v. 1 (Boston: American Meteorological Society, 1995), pp. 161–69.

183 "he had no particular aptitude": Frankenthaler, letter to Rudikoff, August 29, 1959, Sonya Rudikoff Papers.

183 "soft angry empty faces": Frankenthaler, letter to Rudikoff, August 29, 1959, Sonya Rudikoff Papers.

183 "air of resentment": Frankenthaler, letter to Rudikoff, August 29, 1959, Sonya Rudikoff Papers.

183 "angry small little knot": Frankenthaler, letter to Rudikoff, August 29, 1959, Sonya Rudikoff Papers.

183 Jeannie and Lise arrived in New York: The story of the Motherwell sisters' time in New York is from Jeannie Motherwell, interviews with author, August 18, 2017, and May 16, 2019; and Lise Motherwell, interview with author, February 2, 2018.

184 trench coat: Jeannie Motherwell, interview with author, May 15, 2019.

184 Betty, horrified, filed for divorce: Jeannie Motherwell, interview with author, May 15, 2019.

184 near to a nervous breakdown: Jeannie Motherwell, interview with author, May 15, 2019.

184 Betty sent Cathy: Jeannie Motherwell, interview with author, May 15, 2019.

184 ignoring her bitter tears: Jeannie Motherwell, interview with author, May 15, 2019.

184 *Perry Mason*: Jeannie Motherwell, interview with author, May 15, 2019.

184 Arthur Kimball: Jeannie Motherwell, interview with author, May 15, 2019.

185 "She had to grow up very quickly": Lise Motherwell, interview with author, February 2, 2018.

185 "you want to replace my mother with a milkshake?": Lise Motherwell, interview with author, February 2, 2018.

185 "That's not": Jeannie Motherwell, interview with author, May 15, 2019.

185 Raggedy Ann; Chubby Checker's hit: Jeannie Motherwell, interview with author, August 18, 2017.

186 "milk and honey": Jeannie Motherwell, interview with author, August 18, 2017.

186 John Glenn orbited the earth: Frankenthaler, letter to Hartigan, February 22, 1962, Grace Hartigan Papers.

186 "It was embarrassing": Jeannie Motherwell, interview with the author, August 18, 2017.

187 analysts and social workers; "FURIOUS": Frankenthaler, letter to Hartigan, February 23, 1961, Grace Hartigan Papers.

187 reel "from all the thoughts": Frankenthaler, letter to Hartigan, December 19, 1960, Grace Hartigan Papers.

187 shimmering blind spots: Frankenthaler, letter to Hartigan, April 7, 1962, Grace Hartigan Papers.

187 felt a tingling: Frankenthaler, letter to Hartigan, April 7, 1962, Grace Hartigan Papers.

187 "out of touch <u>consciously</u>": Frankenthaler, letter to Hartigan, April 7, 1962, Grace Hartigan Papers.

187 Helen made matters worse: Frankenthaler, letter to Hartigan, April 7, 1962, Grace Hartigan Papers.

188 "loving, secure, inventive, honest": Frankenthaler, letter to Hartigan, February 23, 1961, Grace Hartigan Papers.

188 other kids' parents were also divorced: Jeannie Motherwell, interview with author, May 15, 2019.

188 Bob was all for it: Jeannie Motherwell, email to author, July 11, 2019.

188 "Gerberesque": Frankenthaler, letter to Hartigan, February 23, 1961, Grace Hartigan Papers.

188 "enormity of the responsibility": Frankenthaler, letter to Hartigan, February 23, 1961, Grace Hartigan Papers.

188 adoption papers: Frankenthaler, letter to Hartigan, November 30, 1961, Grace Hartigan Papers.

188 call her "Mom"; call their father "Dad": Lise Motherwell, interview with author, February 2, 2018.

188 "I loved my mother": Jeannie Motherwell, interview with author, May 15, 2019.

189 "That was not a really healthy way to make a child feel": Jeannie Motherwell, interview with author, May 15, 2019.

189 Motherwell, for his part: Jeannie Motherwell, email to author, July 11, 2019.

189 the letter was bittersweet: Frankenthaler, letter to Hartigan, September 6, 1962, Grace Hartigan Papers.

190 Westport, Washington: Jacobson, *Robert Motherwell*, pp. 35–36.

190 It was Motherwell who insisted: Frankenthaler, interview with Rose, Archives of American Art.

190 "the most moving": Robert Motherwell, "The Significance of Miró," *ARTnews* 58 (May 1959), in *Collected Writings*, p. 115.

190 *The Persistence of Memory*: Frankenthaler, interview with Rose, Archives of American Art.

190 "cherish, use": Frankenthaler, letter to Hartigan, July 28, 1961, Grace Hartigan Papers.

190 *Mother Goose Melody*: Carmean, *Helen Frankenthaler*, p. 26.

190 "three sister-shapes": Frankenthaler, quoted in Carmean, *Helen Franken-thaler*, p. 26.

191 "the first line in my memory": Frankenthaler, interview with Rose, Archives of American Art.

191 her time reading kids' magazines: Frankenthaler, interview with Rose, Archives of American Art.

191 "it flowers": Frankenthaler, interview with Rose, Getty Research Institute, p. 24.

192 "ideal realm": Elderfield, *Frankenthaler*, pp. 12–13.

192 "tranquil but charged profusion": Elderfield, *Frankenthaler*, p. 13.

192 "unslick": Frankenthaler, quoted in Irving Sandler, ed., "Is There a New Academy?" Part I, *ARTnews* 58 (Summer 1959): 34.

193 "an art of maximum saturation": Greenberg, "Impress of Impressionism," *ARTnews* 55 (May 1956): 40.

193 "child of the times": Anne Seelye, "Helen Frankenthaler," *ARTnews* 59 (March 1960): 57. For Helen's wrath, see the discussion of her response and that of her friends to Seelye's writing in the following chapter.

193 "romantic, hyper-sensitive, sulky": Seelye, "Helen Frankenthaler," p. 39.

193 "cult of adolescence": Seelye, "Helen Frankenthaler," p. 57.

194 "In a more adult world": Seelye, "Helen Frankenthaler," p. 57.

194 Another friend had five: Frankenthaler, card to Rudikoff, April 9, 1959, Sonya Rudikoff Papers.

194 ten-week-old: Frankenthaler, letter to Rudikoff, April 27, 1957, Sonya Rudikoff Papers.

195 Marjorie went into a depression: Frankenthaler, letter to Rudikoff, undated [1954], Sonya Rudikoff Papers.

195 "extreme slump": Frankenthaler, letter to Rudikoff, undated [1953], Sonya Rudikoff Papers.

195 lunch with a college friend; "or stay pregnant!": Frankenthaler, letter to Rudikoff, December 14, 1954, Sonya Rudikoff Papers.

195 *December 2*: Curtis, *Restless Ambition*, pp. 178–79.

195 her own thoughts about having children: For a meditation on this aspect of the work, see Elderfield, *Painted on 21st Street: Helen Frankenthaler from 1950 to 1959* (New York: Gagosian Gallery, 2013), pp. 37, 42–43.

195 Dotty Kahn: Frankenthaler, letter to Rudikoff, October [2,] 1956, Sonya Rudikoff Papers.

196 "a dark place, a hopeless place": Jenny Kaufmann, interview with author, July 17, 2019. For a beautiful meditation on her mother's suicide and the effects of it on her life, see Kaufmann, "In the Shadow of Suicide," in Brent Willock, Lori C. Bohm, and Rebecca Coleman Curtis, *Loneliness and Longing: Conscious and Unconscious Aspects* (New York: Routledge, 2012), pp. 175–85.

196 **"problems and desires":** Frankenthaler, letter to Rudikoff, October [2,] 1956, Sonya Rudikoff Papers.

197 **"childish needs":** Frankenthaler, letter to Hartigan, July 28, 1961, Grace Hartigan Papers.

197 **"came out towards individuals":** Frankenthaler, letter to Hartigan, July 28, 1961, Grace Hartigan Papers.

197 **"reacted so traumatically":** Frankenthaler, letter to Hartigan, July 28, 1961, Grace Hartigan Papers.

197 **"big child":** Frederick Iseman, conversation with author, April 30, 2019.

197 **department store clerk:** A story told to me about Helen by an art historian who witnessed the scene, which took place at a Henri Bendel store in Manhattan in the late 1980s.

197 **"gave the furrier hell":** Frankenthaler, letter to Rudikoff, November 14, 1955, Sonya Rudikoff Papers.

198 **"terrible things":** Frankenthaler, interview with Rose, Getty Research Institute.

198 **"so many things mirrored":** Frankenthaler, letter to Hartigan, February 23, 1961, Grace Hartigan Papers.

198 **finally found a quiet moment:** Frankenthaler, letter to Hartigan, February 23, 1961, Grace Hartigan Papers.

198 **"stir-crazy":** Frankenthaler, letter to Hartigan, February 23, 1961, Grace Hartigan Papers.

Chapter Eleven: January 26, 1960

200 **"the anxious years":** "Into the Sixties," *New York Times*, December 27, 1959, p. E1.

200 **"happy in the usual sense":** Gaby Rodgers, letter to Frankenthaler, July 20, 1950, Helen Frankenthaler Foundation.

201 **"risk everything on inspiration":** O'Hara, "Helen Frankenthaler," p. 5.

202 **"found silly":** O'Hara, "Helen Frankenthaler," p. 7.

202 **"She has the ability":** O'Hara, "Helen Frankenthaler," p. 7.

202 **"the whole psychic figure":** O'Hara, "Helen Frankenthaler," p. 7.

202 **"reliving a part":** Friedman, letter to Frankenthaler, February 8, 1960, Helen Frankenthaler Foundation Archives.

202 **"commentators"; "American experience":** Brossard, "Preface," in *The Scene Before You*, p. xi.

202 **"pedant":** Greenberg, diary, October 1, 1955, Clement Greenberg Papers.

203 **Convent of the Sacred Heart; "very gentle":** Friedman, letter to Frankenthaler, February 8, 1960, Helen Frankenthaler Foundation Archives.

203 **from Budapest in 1875:** Friedman, "Choosing a Name," in *Coming Close: A Novella and Three Stories* (New York: Fiction Collective, 1982), p. 160.

NOTES

204–5 "fortunate confusion"; "terrestrial harmony": William Empson, *Seven Types of Ambiguity* (London: Chatto and Windus, 1956), pp. vi, 155–59.

205 "reckless blindness": Seelye, "Helen Frankenthaler," p. 39.

205 "sexual symbology": Seelye, "Helen Frankenthaler," p. 57.

205 "The paintings seem": Seelye, "Helen Frankenthaler," pp. 57–58.

206 Helen's "confessions": Seelye, "Helen Frankenthaler," p. 58.

206 the beauty of this picture or that: Seeley, "Helen Frankenthaler," p. 39.

206 "hysterical and dishonest": Friedman, letter to the editor, *ARTnews* 59 (April 1960): 10.

206 "hysterical anxieties": Constance Emmerich, letter to the editor, *ARTnews* 59 (April 1960): 10.

206 "Why must you gossip": Frankenthaler, letter to the editor, *ARTnews* 59 (May 1960): 6.

207 "Certainly the art world": Rudikoff, letter to the editor, *ARTnews* 59 (May 1960): 6.

207 "excessive lack of taste": Barbara Guest, letter to the editor, *ARTnews* 59 (May 1960): 6.

208 "a much better painter": Ruth Ann Fredenthal, email to author, April 25, 2019.

209 *Garden—at closing time:* Fredenthal, diary, September 30, 1964.

210 "low" moment: O'Hara, "Helen Frankenthaler," p. 7.

210 Wind, a philosopher might say: See Daniel Defoe, "Of the Natural Causes and Origins of Winds," in *The Storm* (London: Penguin, 2003 [1704]), pp. 11–18.

Coda

211 "Middle Age is here": Frankenthaler, letter to Hartigan, September 3, 1967, Grace Hartigan Papers.

211 "depressed, angry, trapped": Frankenthaler, letter to Hartigan, April 7, 1962, Grace Hartigan Papers.

211 "One cannot deny": Frankenthaler, letter to Hartigan, April 7, 1962, Hartigan Papers.

211 lump on her breast: Frankenthaler, letter to Rudikoff, November 21, 1960, Sonya Rudikoff Papers.

211–12 Gorging herself with food: Frankenthaler, letter to Rudikoff, November 21, 1960, Sonya Rudikoff Papers.

212 drink more and more; liquor cabinet: Lise Motherwell, interview with author, February 2, 2018.

212 violent with Betty Little: Lise Motherwell, interview with author, February 2, 2018.

212 he raged when drunk: John Blee, email to author, August 26, 2017.

212 hospital ward: John Blee, email to author, August 26, 2017. The relation of Helen's hypochondria to her perception of Motherwell's alcoholism is from Ross, interview with author, May 14, 2020.

212 passionate affair: Ross, interview with author, June 23, 2018.

213 "The open cortex produces an ecstatic state": Timothy Leary, quoted in James Penner, ed., *Timothy Leary, the Harvard Years: Early Writings on LSD and Psilocybin with Richard Alpert, Huston Smith, Ralph Metzner, and Others* (New York: Simon & Schuster, 2014).

213 met Leary in spring 1961: B. H. Friedman, *Tripping: A Memoir* (Provincetown, MA: Provincetown Arts Press, 2006), p. 3.

213 "bursts of laughter": Friedman, journal entry, no date, Archives of American Art.

215 *became* beautiful: John Blee, interview with author, July 14, 2017.

215 "old soul": Frankenthaler, interview with Rose, Archives of American Art.

215 "leopard skin coat": John Blee, email to author, August 26, 2017.

215 "physical, yes": Blee, email to author, August 26, 2017.

215 "freer with age": Blee, email to author, August 26, 2017.

216 "John had to become famous": Blee, email to author, August 26, 2017.

216–17 "Helen glowed"; "When Helen smiles"; "sheer excitement": Gabrielle Smith, "Helen Has a Show," *New York* magazine, February 17, 1969, p. 46.

Image Credits

Rights Society (ARS), New York. Photos by Rob McKeever, courtesy Gagosian (top and bottom).

p. 2: Magnum Photos, photographs by Burt Glinn (top and bottom). Artwork © 2020 Helen Frankenthaler Foundation, Inc. / Artists Rights Society (ARS), New York.

p. 3: Magnum Photos, photograph by Burt Glinn. Artwork © 2020 Helen Frankenthaler Foundation, Inc. / Artists Rights Society (ARS), New York (top); Magnum Photos, photograph by Fred McDarrah (bottom).

p. 4: *Jacob's Ladder* (1957): The Museum of Modern Art / Licensed by SCALA / Art Resource, NY. © 2020 Helen Frankenthaler Foundation, Inc. / Artists Rights Society (ARS), New York (top); Minneapolis Institute of Art / Bridgeman Images (bottom).

p. 5: Art Resource, NY (top); *Before the Caves* (1958): Berkeley Art Museum. © 2020 Helen Frankenthaler Foundation, Inc. / Artists Rights Society (ARS), New York (bottom).

p. 6: *Hotel Cro-Magnon* (1958): Milwaukee Art Museum. © 2020 Helen Frankenthaler Foundation, Inc. / Artists Rights Society (ARS), New York (top); Helen Frankenthaler Foundation Archives, New York, photograph by Hans Namuth. © 1991 Hans Namuth Estate, Courtesy Center for Creative Photography (middle); The Dedalus Foundation / Artists Rights Society (ARS), New York (bottom).

p. 7: *Mother Goose Melody* (1959): The Virginia Museum of Fine Arts. © 2020 Helen Frankenthaler Foundation, Inc. / Artists Rights Society (ARS), New York (top); Courtesy Jeannie Motherwell, photograph by Alan Shayne (bottom).

p. 8: Helen Frankenthaler Foundation Archives, New York. Artwork © 2020 Helen Frankenthaler Foundation, Inc. / Artists Rights Society (ARS), New York.

Index

INDEX

INDEX

INDEX